Photographs and the Practice of History

Photographs and the Practice of History

A Short Primer

Elizabeth Edwards

BLOOMSBURY ACADEMIC
LONDON • NEW YORK • OXFORD • NEW DELHI • SYDNEY

BLOOMSBURY ACADEMIC
Bloomsbury Publishing Plc
50 Bedford Square, London, WC1B 3DP, UK
1385 Broadway, New York, NY 10018, USA
29 Earlsfort Terrace, Dublin 2, Ireland

BLOOMSBURY, BLOOMSBURY ACADEMIC and the Diana logo
are trademarks of Bloomsbury Publishing Plc

First published in Great Britain 2022

Cover design: Terry Woodley
Cover images: Farmyard, northern England, 1950s (author's collection).
Treaty of Versailles in Trianon Palace, May 7th 1919
(photo by Keystone-France/Gamma-Keystone via Getty Images)

A catalogue record for this book is available from the British Library.

A catalog record for this book is available from the Library of Congress.

ISBN: HB: 978-1-3501-2064-8
 PB: 978-1-3501-2065-5
 ePDF: 978-1-3501-2066-2
 eBook: 978-1-3501-2067-9

Typeset by Integra Software Services Pvt. Ltd.
Printed and bound in Great Britain

To find out more about our authors and books visit www.bloomsbury.com
and sign up for our newsletters.

*For the wonderful women of the
Floating Republic …*

Contents

Preface ix

Acknowledgements xiii

Introduction 1

1 Inscription 17

2 Distance 29

3 Scale 43

4 Event 57

5 Presence 71

6 Context 83

7 Materiality 97

8 Digital 113

Bibliographic Afterword 129

Selected Reading 141

List of Images 145

Notes 147

Index 163

Preface

Photographic technology belongs to the physiognomy of historical thought ... there can be no thinking of history that is not the same as thinking of photography.[1]

What is it to write history or indeed be involved with wider forms of history making in an age in which photographs exist? This is the starting point of this book. The book is not about how to use photographs as historical sources, nor a volume on historical method, nor on the philosophy of history. Rather it looks quite pragmatically at the intersection of photographs with a series of values and assumptions that underpin the practice of history, often unarticulated, except in the recesses of theory of history. Historian Peter Gordon has noted that '[m]any historians would ... be disinclined to back themselves up out of their actual activity as historians to reflect upon the meta-presuppositions of what they do'.[2] This certainly reflects, with a few exceptions, the general approach to photographs within history. But no practice is metaphysically innocent: nor, therefore, are the implications of the intersection of history and photographs, and the ways in which the latter do indeed belong to the physiognomy of both historical thought and historical practice. With the increasing interest in photographs as historical sources, in the methods and historiography of visual histories, and in the related studies of archives and museums, it seems timely to explore these most fundamental of questions. What do photographs *do* to history? What are the implications of the very existence of photographs for other forms of historical representation? What disturbances do they cause? What are the patterns of embrace and resistance to photographs within the wider practice of history? These are the questions that weave their way through this short book. Thus, as I say, what follows is not about the 'meaning' of photographs, but about how their very presence, as entities, infiltrates our ideas of what it is to 'do' history. I want to heighten sensibilities and provide food for thought.

A couple more comments on aims: although broadly addressed to the practices of academic history, this book is for everyone interested in the implications of the intersections of history and photographs and what photographs might do to how we go about our historical business. It is not necessarily for historians of photography or even visual historians, although I hope they will find it interesting and useful. In particular, it is for students,

the discipline's new generation, who are starting to think with photographs within historical studies. It is also for 'traditional', perhaps 'text-heavy', historians, be they of empiricist or postmodernist or post-postmodernist inclinations: those who haven't really engaged with photographs because, for whatever reason, they didn't think they needed to. Perhaps they are unaware of the ways that photographs might open up what has been taken for granted for years: how photographs actually change the whole relationship with the past, and contribute to changes in the discipline that aims to make sense of that relationship.

Broadly speaking, this book could have been written in two ways: as a small, short, essayistic and even gestural text, or as dense and weighty volumes of closely footnoted theory or philosophy of history. Each of the topics of my short chapters could be the focus of a whole book. As the densely theoretical and heavily footnoted option would probably try the patience of all concerned, I have taken the former essayistic route, and hope that someone out there will pick up the gauntlet and produce that latter. In any case, I make no claims to be a philosopher. Rather, I am pulling together thoughts that, as I work in the borderlands between anthropology and history, have shaped my questioning of the wider relationship between photographs and the practice of history for many years. In many ways the shorter the book, the tighter and more difficult it is to write, and these are topics with a pronounced tendency to sprawl. The essays, as my title suggests, are a primer, offering key elements, as I see them, and that we might like to ponder at the intersection of method and theory. I make no claims to be comprehensive. Many questions are left answered and inevitably weighty topics make all too brief appearances. They invite further analysis. But given the multitudinous forms of both history and photography, it was never my intention to 'provide answers'; but rather to bring a set of ideas into the frame, and to lay out a set of sensibilities and an experimental space. I hope these will mingle creatively with our established practices as historians, in the broadest sense, as we attempt to address the ways in which photography does indeed belong to the very physiognomy of historical thought. As Mark Salber Phillips has noted 'the deepest reforms [in practices and beliefs] trace a path back to the heart of a discipline and find new challenges in its oldest traditions'.[3]

Some might be surprised by the sparse use of images. But as I have stated, this is not a 'how-to' book. It is not concerned with how photographs work, or not, as historical evidence, or what they might 'mean' on the ground, so I am not providing that kind of example. Many others have done this admirably. Also, I have long been disturbed by the cavalier use of photographs as illustration. So I have resisted the temptations of gratuitous decoration beyond the inter-chapters which, in addition to providing a

sense of the visual within the book, are intended to work metaphorically with their chapters – metaphors always have work to do. They point, especially, to the ambiguity and possible unknowability of photographs. Their work and intention here is to present readers with a positioning think-space rather than 'meaning'.

Why not consider film, a number of people have asked me? Certainly, an exercise such as this would be a valid undertaking in relation to film, video and digital modes of inscription, transmission and communication. But it is necessary to understand the specific nature and action of a medium as a mode of transmission, and thus its impact on the practice of history. Despite surface similarities and a bracketing as 'visual', my argument applied to film would be related but different. Film, the long quotation of linked moments, carries a wider contextual framing within it, as opposed to photography's short quotation of the single moment, a fragment of time. While film shares some characteristics with photography, notably temporal construction, representation and immediacy, it lacks the temporal and spatial density of photographs or their particular forms of scale and legibility. As Christian Metz put it, if film 'lets us believe in more things' photographs allow us to 'believe more in one thing' – that is long quotations of related moments as against short quotations of the fragment. While, as we'll see, photographs have their own forms of movement, they focus our attention in different ways.[4] Photography offers its own forms of accuracy, knowability and memory which inflect and intersect with history in different ways. In the digital age with its blurring of stillness and movement, and the fact that many millions of 'photographs' feed digital sources of all kind, to look at 'the photograph' might seem somewhat restricting. There is, nonetheless, a sense in which historians have yet to get to grips with the implications of photographs for their practice, never mind the digital. The intersections I talk about are equally applicable in their disturbances in the digital age, so their discussion as 'photographs' merely become more urgent. Whatever we work on, it is becoming increasingly imperative to think about the visual in history, and the ways in which thinking about photographs is also thinking about history.

Acknowledgements

I am hugely grateful to Emily Drewe and Abigail Lane at Bloomsbury for their tireless support and efficiency through this project, as we worked from kitchen tables, sheds and attics through various COVID lockdowns. Thanks go too to Darcy Ahl at Integra for her patience in seeing this book through to press. I am grateful to my anonymous reviewers for their constructive engagement and pertinent comments which have undoubtedly enhanced what follows. Many colleagues and friends have read, suggested and discussed with me over the years, often beyond the call of duty, for which I am eternally grateful: Tom Allbeson, Frances Arnold, Paul Basu, Paul Betts, Estelle Blaschke, Tim Boon, the late François Brunet, Steve Edwards, Simon Fleury, Duncan Forbes, Haidy Geismar, Gillian Grant, Liz Hallam, Clare Harris, Patricia Hayes, the late Peter James, Nina Lager-Vestberg, Elizabeth Lambourn, Chris Morton, Gil Pasternak, Laura Peers, Christina Riggs, James Ryan, Lucie Ryzova, Joan Schwartz, Julia Smith, Colin Sterling, Veronica Strang, Elaine Tierney, Jennifer Tucker and seminar participants at universities of Birmingham, Durham, Nottingham, Gothenburg, Queen's Belfast, and the Sorbonne/Humboldt CIERA seminar of 2019, deep in the Normandy countryside.

I am grateful to the following for permissions for my chapter epithets: Eduardo Cadava, Columbia University Press, Duke University Press and Verso Press.

Faughmand Abbey"

Introduction

[T]he profound technological mutation of the archive [on which historians might base their work] necessitates questioning the very concept of history, and exposing the collusion between representation and the time it has long presupposed.[1]

This book asks, in simple and direct terms, what photographs do to the practices of history? In what ways do its mutations of time, space, or scale, for instance, go to the heart of the discipline's representational practices? It addresses what underlies history's demands of photographs, but also, and crucially, what the existence of photographs demands of history. There are many ways to cut these questions. There are many views on what constitutes the practice of history, and equally many views on how photographs work as a mode of representation and communication. It would be very tedious to wade through them all. Instead, I am taking a step back to suggest a sensibility about what history and photographs do to each other and the demands they make of one another. I am doing this through a series of short essays that explore particular strands of historical thinking and practice as they intersect with photographs. What I present here is not a method as such, in that it cannot necessarily be applied directly, but rather it aims to create a think-space. I hope it will have implications for the ways in which methods are evaluated and developed, and provide some interpretative background noise as historians, whatever their persuasion, go about their business. What follows is far from exhaustive, but it's a start.

In recent decades history has experienced something of a 'visual turn'. While this has largely been concerned with historiographical validity, sources and evidence, the visual turn within history has both expanded and become increasingly sophisticated in analytical terms, as studies bring photographs into the very centre of historical analysis. As a gathered field, much of the methodological advice is both admirable and sensible, advocating the using photographs more extensively and to greater analytical effect, while also discussing the advantages and pitfalls. Substantial attention has been given, as source criticism, to questions of, for instance, visual perception and

the apprehension of the world through the visual, the perils and politics of representation, the 'truthfulness' (or not) of photographs, or questions of 'reading' photographs – as if they were texts. One does not hesitate to put such books into the hands of one's students – it is all fine and necessary. But at the same time, there seems to be something missing – namely a consideration of what the very presence of photographs in historical landscapes does to the practice of history itself? We are not talking here simply of 'influences', but how objects of knowledge and the historian's parameters of understanding take shape. What happens when we look not at how we might or might not use photographs as historical sources, but at what happens when we allow photographs to insinuate themselves into the commonplaces of historical apparatus.

The saturating existence of photographs also means that whatever their interests, historians are inhabitants of the photographic universe and become photographically minded actors with an ongoing photographic [sub-]consciousness. Even if photographs are not being used as sources but merely as aides-memoire – perhaps that photograph of a manuscript or an archaeological specimen on the historian's file – those photographs are historically located in the ways in which they perform their content. Photographs shift the shape of the historical endeavour. As Hayden White observed, 'the historiography of any period of history for which photographs and films exist, will be quite different if not more accurate, than that focused on periods known primarily by verbal [textual] documentation', a condition he terms *historiophoty*.[2]

Throughout, my argument is concerned largely with historical practices as they occur in the broad shape of the Western academy. Text, as an historical mode is now, for better or worse, the predominant output of global histories. However, this position is being increasingly challenged, as oral, visual, literary, autobiographical and material forms, re-enactment and arts practice become prisms and foci for multiple histories. These are also linked to histories of emotion, the senses and affect which are becoming increasingly prevalent. Not only do these form an underlying current throughout my account but they make an address to the intersection of photographs and historical practice all the more pressing. This is because many 'alternative' (an awkward assumption) and experimental histories are driven by photographs, for instance Tina Campt's engagement with the black diasporic archive as an act of historical 'counterintutition', where photographs are excavated through the acoustic and metaphorical, rather than solely visual, patterns of thinking. Likewise, others have considered the ways in which touch, voice, or song, in relation to photographs, enhance historical modalities and interpretations.[3] Such studies use the presence of

photographs to open up differently figured accounts of the subject matter and different levels and forms of attention for historians.

Further, my basic premise, that the existence of photographs disturbs and shifts categories of practice, how which histories are told, and the conditions under which they are taken seriously, is equally applicable to different ways of doing history: for instance, their impact on oral histories and memory transmission. Study after study has demonstrated the saliency of photographs in the forms, expectations and performances of such histories. This is exemplified by Alison Brown and Laura Peer's work at Kainai in Canada, or Chris Wright in the Solomon Islands, both of which explored the role of photographs in constructing or reconstructing oral pasts.[4] Roslyn Poignant, working at Maningrida in Australia, recounts a voice coming out of the dark one evening, 'Are you the lady with our memories?' 'No' she replied 'they are only photographs. You have the memories.' Unperturbed by such historiographical niceties, the voice replied 'No worries. I'll look at them tomorrow.'[5] Overall, such studies have brought new registers of apprehension to historiographical landscapes, ones that allow Tina Campt, noted above, to talk about listening to the everyday hum of photographs, or Ariella Azoulay to talk about 'watching' them and their political work as a 'civic skill', rather than simply 'looking at' them.[6] While these particular histories have conventional textual outputs, many do not, as I shall discuss in my final essay on the digital. In addition, I have deliberately kept my examples broad, from Africa or the Pacific, for instance, to demonstrate the wider applications of my argument. Yet, despite the nuance and sophistication of analyses such as these, and their evident methodological importance, in the broader field, photographs are often understood historiographically as a means to an end, rather than being a pressure on the way histories are excavated.

So what is the effect of photographs, how do they destabilize the deep-held categories and assumptions of historical practice? This is clearly a huge question that sprawls over philosophy, theory of history, historiography and visual theory. The concepts and modes through which I address these questions have been extensively debated in intellectual history for several decades now, so what follows is inevitably only a sketch. It is also very much a position of theoretical eclecticism, in which theoretical purity is perhaps sacrificed in the service of interpretative potential. The philosopher of history, Eelco Runia, has called this 'creating a mess' in that thinking theoretically about what we are doing is not merely a body of concepts but 'the process of quarrelling with the tools of the trade.'[7] What kind of mess do photographs make of the tools of the trade, and how might they open thinking beyond the preconceptions and categories of historical practices?

New technologies and tools of knowledge production shape and leave marks not only on the knowledge so produced but on the very conceptualization, categories and assumptions that frame a given field of knowledge – its epistemes. We are seeing this in current debates over digital futures, AI and robotics for example. What are the disturbances which these new forms might cause, what changes? The practice of history is no exception. It is not merely a matter of acknowledging and engaging new sources and new ways of doing things, but the implications of their absorption into mainstream discourse and its practices. So, as I have already stressed, my discussion is not 'merely' about photographs as sources, though of course it is that too. The question is how the intersection of photographs with history, their existence within both the landscapes of the past and the landscapes of sources available to historians, might benefit from more ambitious and expanded terms of references in relation to what they might actually be able to do. Consequently, what photographs 'do' in the historical sphere is, or should be, integral to how source criticism is conceptualized. To achieve this, it is necessary to loosen the constraints around the ways in which photographic significance is thought about within the wider historical landscape. These short essays are intended to be part of the range of sensibilities that might be brought to source criticism and reflexive practice as historical norms. They also suggest how photographs might help us reconsider those broader, more conventional or established, modes and categories of analysis.

My deliberations are, consequently, heuristic, in that they offer an analytical framework for investigation, not a prescriptive theory of methodological regulation. They are a set of sensibilities and reflexive critical reflections on what we are doing as historians. How these might manifest themselves within key historiographical functions and have an impact on actual and specific historical problems and their evidences? As I have already suggested, these become more pressing in the light of increasingly experimental forms of historical thinking and historical writing over the last few decades, around questions of, for example, affect, emotion, memory and experience, rather than (and I am aware that I simplify here) a linearity of happenings and causal links – that this or that happened.

However, while few historians these days would view photographs (or indeed any other historical source) as unmediated windows onto a past world, many nonetheless take a largely uncritical, illustrative, and even careless approach to photographs that they would not countenance with other source types. Sequestrated at the margins of analysis, rather than engaged with in an intellectually creative way which places them at the centre of historical endeavour, logo-centric practices predominate. Small wonder then that photographs are not understood in terms of the impact

they might have on the very practices of history itself. However, photographs have changed the historiographical stakes as they 'form a point of peculiar friction and discomfort across a broad range of intellectual inquiry'.[8]

At base is a sense that photographs are, as historical sources, strange and different. They are dynamic, difficult, slippery, ambiguous, incongruous and contradictory. It is easier to say what they are not, than what they are. Much has been said on this difficult relationship. Just to quote some of the language used by commentators: photographs have a 'double consciousness' vacillating 'between magical beliefs and sceptical doubts, naïve animism and hard-headed materialism, mystical and critical attitudes'; they are 'flirtatious', leading on seductively, they are visceral yet discursive, instinctive yet interpretative, sensuous yet cognitive, voluptuous yet analytical, that they 'possess a distinctive treachery' analytically.[9] Perhaps photographs are the historical discipline's 'Other' and, as such, are subject to the familiar cultural processes of othering: typifying, fetishizing and pathologizing. Perhaps too, the methodological fear of the photograph indicates a deep-seated unease lurking within the practice of history itself; how does it record, represent, interpret? For debates around photographs as historical sources and their lacunae offer insights into the nature of historical study itself, as photographs become a site of historiographical disturbance.

The beginning of the nineteenth century is often seen as the emergent moment of a modern historical outlook that ultimately cohered into the academic discipline of history. This moment was also the moment of photographic emergence, for the conceptual possibility of photography was already in place, to be publicly announced in 1839. Leopold von Ranke's famous and idealist statement of nineteenth-century historiography, 'wie es eigenlich gewesen' (how things actually were) was published in 1824, only 15 years before the official 'invention' of photography. Likewise, that other major formative historiographical figure, Jules Michelet, placed the visual at the very heart of his conception of the past.[10] It informed his 'resurrectionalist' ideas of history. And it is worth noting that both von Ranke and Michelet lived well into the photographic age: indeed, we have their photographic portraits. Consequently, the presence and potential of photography have now saturated the consciousness of the past for the best part of 200 years. It constituted a new kind of knowledge that impinged on, infringed and disturbed forms of historical knowledge and historical imagination.

As numerous commentators have noted, our vision of, and sense of, the past has been transformed by photographs. It has sharpened our eyes and sensibilities in certain ways, even if we do not consider them sources in the kind of work we do – those files full of photographs I mentioned. We have become accustomed to the visual vocabularies of articulating the past,

even to the layout of text, the styles of book covers, the placing of images, the positioning of captions and footnotes – yet their conventions are seldom registered. The arrival of photography was not simply a new form of evidential source, but a prism for a fundamental rethinking of history's conceptual base. The connective tissue provided by photography constituted one of the new nodes within shifting temporal perspectives. If an accelerated 'primacy of the visual' has marked memory construction, from at least antiquity on, it is hard now to imagine a sense of the past without photography, so integrated is it into the relations between past, present and future. It is no coincidence, for instance, that the nineteenth, and now early twentieth centuries, are in many ways the default heritage value, manifested through reconstructed streets, house interiors, and photographic murals in museums. It is the age within photographic reach.

Historical method and historical theory are far from static, nor is history a unified methodological field. History's powers of, for instance, representation and objectivity are continually, and often radically, challenged – as I write this, in the wake of the Black Lives Matter movement, questions of race, memory, colonial aphasia and national narratives are being challenged and refigured on a daily basis. However, it remains that the very existence of photographs has patterned the ways in which it is possible to think about the past; they have knowledge effects. I always asked my undergraduate historians: imagine, and tell me, what does the Second War World look and feel like if you had never seen any photographs of it – no Holocaust photographs, no bomb-damage photographs, no Omaha beach photographs, no Japanese war photographs, no refugee photographs, no home-front propaganda photographs – none? The question was usually met by a stunned and stunning silence, which is of course the right answer – it is literally unimaginable. It would be possible to know – but on entirely different terms.

Photographs, as a source, representation and communication, have become a discursive locus for what it is to do history, accentuating both the transmissive and visceral elements of history over time. Further, the ubiquity of photographs in the historical and contemporary world makes them a privileged site for a wide range of investigations and debates. Their presence defines the age, even for those who ostensibly have no interest in photographs as sources or anything else. Yet, as I have noted, that presence is seldom acknowledged historiographically, let alone acted upon. The commonplaces of historiography and apparatus that underpin the processes of historical understanding – time, distance, agency, event, fragment, context, voice and presence – have been extensively critiqued over the years, from the Annales school, through constructivism, postmodernism, post-foundationalism and so forth. But what is strangely absent in almost all cases

(there are some exceptions) is anything more than cursory consideration of photographs. Conversely, though, it is worth noting the ubiquity of photographic metaphors in historical writing: the snapshot, close-up or frame, for instance, suggests the penetration of photographic forms into the metaphorical language of the representation of the past.

Nonetheless, metaphors apart, an awareness of the impact of photographic presence has been around for some time, often quietly productive in pockets of historical debate. Almost since the inception of the medium, there has been an awareness of the impact of this mimetic technology, with its reality effects, on the way history might be thought about. Tracing, stilling, holding, bridging, even eliminating time, photography and photographs were part of modernity's management of time and its emerging historical consciousness. In many ways, the debates around photographs have mirrored the debates about the relationship between history and memory, a relationship in which photography itself is deeply imbricated. Yet it is interesting to note how photographs are privileged in memory studies but largely marginalized within history itself. This debate, on the history/memory borderlands, asks what are the boundaries – epistemic, qualitative, or methodological, what is the nature of its social function and production, for instance? A number of scholars, in both historical and photographic studies, have attempted to answer these questions. Widely cited writers in photographic studies such as Walter Benjamin and Siegfried Kracauer writing in the mid-twentieth century, or later Roland Barthes, have been simultaneously seduced and appalled by the historical potential of photographs. For them, in that inalienable yet mutable and unstable relationship between the photograph and the past, the photograph becomes not so much a source for historical investigation, but a philosophical engagement with, and metaphor of, the historical process and historical relationship.[11] While the desire to hold and have direct access to the past has a very long history, medieval pilgrim mirrors are often cited as examples, photography was, it is worth reiterating, one of the technologies of the modern world which brought about changes of scale, pace and pattern to human affairs.

Scholars from Kracauer to Jacques Le Goff and Raphael Samuel have posited the advent of photography as the turning point in historical consciousness from which there is no return. Likewise, the relationship between past and future held in photographs became a formative strand in the writing of theorists in particular, as noted, Walter Benjamin and, again, Kracauer for whom photography formed a mass assault on the 'crucial traits' of historical understanding and of memory itself, as it trespassed onto history's ground.[12] So anxieties about photographs in history are not new. Photography was seen to revolutionize memory and thus history: 'it

multiplies and democratizes it, gives it a precision and a truth never before attained in visual memory, and makes it possible to preserve the memory of time and of chronological evolution.[13] The scale and abundance of this photographic saturation is to such an extent that being informed, in any cultural sense, means having an almost photographic sense of the look and feel of things. Whether the world and historians like it or not, they are photographically minded. Given these very reasonable and well-grounded claims, it is difficult to know how the impact of photographs has been so neatly side-stepped by so many historians for so long.

It is significant that historical interest in photographs emerged in the social and cultural upheavals of the 1960s and 1970s. Photographs were active in, for instance, debates about the ownership of history and expanded historical voices, such as class, gender or colonial legacies. Likewise they came to stand for, and articulate, a distrust of authority and an alternative historical truth-telling in relation to wars and injustice. Consequently, though a site for disciplinary reflection, much of the rise of photographic interest emerged not in mainstream academic history but in community, local and 'bottom-up' histories in the 1970s. Indeed, their association with such historical practices, barely recognizable as such to many academic historians at the time,[14] is another reason for the continued reticence about photographs – somehow they weren't quite serious enough. It was in connection to popular histories that British historian Raphael Samuel famously articulated the work of photographs as the 'Eye of History' and 'The Discovery of Old Photographs' in his *Theatres of Memory*.[15] In this he explored the work of photographs in engaging popular historical imagination, their presence in the everyday, and in numerous community projects run out of public libraries, adult education classes and the like. Photographs were part of unofficial historical knowledge and active players in the 'memory boom' of the 1980s and 1990s. Photographs also, in part, fired the engines of alternative historical narratives that were articulated by publications such as *History Workshop Journal* or *Ten-8*. It was also no coincidence that the works of photographic thinkers such as Benjamin, Kracauer, and Barthes, were translated and became more widely disseminated at this moment of photographic attention. They formed a double helix of historiographical concern around archival and historical visibility. Academic historians might not necessarily have been keen on the idea, fearing the subjectivities, lack of restraint, inconclusiveness and slipperiness of photographs, but they were there to stay on the historical landscape.

Yet despite the rise and rise of social history, microhistory, oral histories and even visual histories of the kind I noted above, patterns of resistance remain. One doesn't want to overstate this, as different kinds of history have different

kinds of relationships with photographs. The catalogue of excellent historical studies working through the prism of photographs now expands rapidly; for example, Jane Lydon's study of colonial humanitarianism or Erika Hanna's of social history in Ireland through everyday photographic albums.[16] However, despite the firm presence of such studies in the historical universe, there remains, still, resistance to seeing photographically centred studies as serious history as rather than photographic studies: that is thinking visually is, at best, an eccentric way of going about things. Would we call a study of medieval legal reforms or seventeenth-century witchcraft trials manuscript studies as their primary category? Probably not.

One of the main themes to work its way through the chapters that follow is that it is the very nature of photographs, as inscriptions of the past, that enable us to think about historical questions differently. On precipitating different thinking, they cause a disturbance to what we think we know. Cultural theorists Robert Hariman and John L. Lucaites, in discussing the public work of photographs, have stated that 'if one sees photography only as records of a particularity, then one is not seeing photographically'.[17] I would add to this that one is not seeing historiographically. Further, in relation to photographs, questions have clustered around concerns about how capable the fragmentary, still, unstable image is of carrying historical information of importance or even relevance? To what extent can it accord with the critical credibility, accuracy and even truth that are fundamental to professional history writing? These are points to which I shall return.

A recurrent concern is that photographs are too subjective and stimulate emotion, not analysis, although such an accusation could be made of most historical sources in one way or another. Many years ago, Robert Levine writing on Latin America, and in an early attempt to assess the impact of photographs as historical sources, suggested that this subjectivity underlies the historian's 'othering' of photographs, 'fearing that analysis of historical photographs must, by definition, be fatally subjective, scholars have tended to tiptoe lightly over photographic content'.[18] There is a sense in which photographs are so normalized and naturalized within the everyday that they become perceived as being only supplementary to the serious business of history and historiographical debate. That they are perhaps a distraction leads the historian away from more weighty concerns and narrative force of sober historical enterprise. This is despite the fact that many photographs have subject matters of profound seriousness – atrocity, violence, dispossession and genocide, and much excellent work has been done in this field. But doubts remain as to the efficacy and adequacy of representations in such enormity. Historians are likewise warned of photograph's claims to authenticity on emotional grounds and the dangers of, as Ludmilla Jordanova

puts it, 'unthinking sentimentality' and the 'emotional impact of photographs is both treacherous and seductive ... the capacity of photographs to work on the emotions has been growing since the middle of the nineteenth century ... which renders it at once an alluring and also dangerous historical source'.[19] This voluptuousness is, like many constructions of the 'Other', both enticing and dangerous and must be controlled by other sources, a question to which I return in Chapter 6 on context.

A result of these anxieties is a fear or nervousness of moving photographs into the very centre of historical analysis, of letting them lead that analysis from information and ideas that emerge from the photographs themselves. Too often there is a tendency is to embed them within other sources to the extent that they are left with little to do but illustrate conclusions reached by other means, rather than using photographs in a way that might provide the basis from which to build new hypotheses or test older ones – surely the purpose of all historical engagements. As a result, photographs get pasted into histories we think we know from other sources and thus into particular kinds of historical understanding. That said, photographs have, however, little historical closure, their work and meaning is radically open-ended, and never fully resolved. This is not a reason to shun them, but rather embrace their suggestiveness as they compel the historical imagination. I always used to tell my PhD students to feel the analytical fear and go with it; it will open interpretative doors, because photographs encapsulate the tensions and double partialities of history as construction, and history as a search for objective fact and explanation. It is a fertile intersection. As such, photographs both contribute to, and disturb, standard historiographical tropes and add to their complexities as they address time, distance, scale and presence.

A few words need to be said about photographic theory. Historians have often, quite reasonably, turned to photographic theory to 'explain' photographs for them. This is fine as far as it goes. Debates around the nature of photographs, such as I discuss in the next chapter, are helpful, and certainly some of the ideological assumptions about the instrumentality of photographs, their unstable meanings, or their representational violence, undoubtedly have their place. However, fluid historiographical thinking about history/photograph relations has in some ways been constrained by the discourse within photographic theory. The latter has often been concerned, in one way or another, with questions of medium specificity, and tends towards the self-referential and inward looking, in ever more abstract, even obscure, terms. These abstract tendencies of photographic theory have frequently resulted in reductive and hostile positions on, for example, realism as a practice of representation, intentionality or agency, in ways that

often sit uncomfortably with the practices of history. Moreover, the situated particularities, and historical and ideological dynamics of photographic theory itself, are often overlooked in their application by both historians and photographic studies. These lacunae have tended to result in a constrained historical analysis and fostered anxieties which are seen as insuperable partialities and historiographical stumbling blocks, rather than being in need of a healthy dose of historical source criticism. Theory after all is not evidence. As literary historian Franco Moretti expressed it neatly: 'Theories are nets and we should evaluate them, not as ends in themselves, but for how they concretely change the way we work, for they allow us to enlarge the ... field, and redesign it in a better way.'[20] Historians should mark this in relation to photographic theory, but also, as I advocate here, to be receptive to the ways in which photographic thinking might intersect with their own abstract categories.

In many ways then, fluid historiographical thinking between history and photographs has been constrained by thinking about their differentness as 'sources' and seeking explanation within photographic theory and photographic studies. For as Didi-Huberman has argued, in the context of Holocaust photographs, we expect too much of photographs and too little. Ask the whole truth and we will be disappointed, for photographs are messy and inexact, or we ask too little, reducing them to mere simulacra.[21] By implication the role photographs might legitimately play in historical practice and imagination has again been constrained. While there are many twists, turns and exceptions to this, the upshot is that thinking photographically has not been included in historical thinking as it should. Perhaps it is easier to rest this as a photographic problem that does not necessarily impinge on the core values of the discipline, rather than a historiographical, even methodological, one that cannot be so neatly marginalized.

At the same time, the marginalization of photographic potential in history has been ensured by normalized historiographies, their categories, assumptions and practices, which have acted as gatekeepers that have too often excluded photographs from serious historical consideration. Photographs seem to fail the test of methodological rigour and thus acceptability. The net result is the same, an inattention to photographs because they are found somehow inadequate to the task of doing history. However, for all its realist aspirations, historical knowledge is also, like photographs, 'impressionist' in that it is an act of translation. If historical documents function as evidence of what the past might have been like and allows its translation, photographs expand that reach. They translate that past in new ways, with an illusion of historical experience that exceeds other historical sources. That is their seduction, their flirtatiousness, their magic and their potential.

But such boundaries are changing as the visual turn and the rising historical star of photographs demonstrates. Historians are increasingly recognizing these historiographical and methodological constraints. A recent book on photography and African history stated that visual theory had indeed reached the limits of usefulness. It suggested that histories had been framed by a theoretical imbalance that tries to understand African visual histories through normalized analytical genres such as 'political photography' and 'social documentary'. It argues that such categories need to be interrogated and demolished, and even replaced, if the prisms of visual history are to realize their potential. Visual history, they argue, means thinking out beyond these parameters.[22] This is a position and proposition that could be applied more generally as an acknowledgement of both the demands of, and disturbances by, photographs.

My intention throughout this book is to foster a set of fluid historiographical sensibilities, applicable across a wide range of historical practices, rather than a methodology as such. Certainly, this connects to the very real and commendable desire to use photographic sources, but all sources demand a robust engagement with their historiographical and methodological nature at the intersection of process and practice. Photographs with their dynamic complexity, instability, fluidity and multiple forms perhaps need this more than most. They need it because their potential is both extensive and ripe. Consequently, I have arranged my theoretically eclectic discussion as a series of short essays or interventions around themes and motifs that inform the commonplaces of historical practices. These themes overlap, and sometimes double back to earlier ones, because at one level they remain entangled, possibly hopelessly so. But the shape of their entanglements is also crucial to the consideration of the work of history in a world in which photographs exist.

I should note that throughout this book I am talking about photographs as a generality within historiographical conditions, a collective mass. There are, of course, a multitude of photographic forms, intentions and uses: family photographs, photojournalism, ID card photographs, colonial photographs, medical, police, art, documentary, pornographic, industrial, scientific, astronomical and so forth. As sources, they may do different things, mean different things and demand differentiated attention from historians to trace out their work. But this search for meaning and evidence is not my primary concern; rather, as I've said, it is the resonance of their multiple historiographical presences, what they do to the practices of history and our sensibilities as practitioners. The diversity of concepts and, by implication,

methods explored here point to both their powers and limitations as they intersect with, and are disturbed by, photographs. Conversely, as I've indicated, the disturbances offered by photographs are not 'new' as such, but differently figured and intensified articulations of the deep conditions and paradoxes of historical practice.

I am going to briefly indicate the direction of travel. A copy-editor for a major American university press once removed an entire 'signposting' section, such as this, from my introduction on the basis that it was 'vulgar'. I have yet to figure out just why it might have been so, so at the risk of 'vulgarity, I am sketching the chapters that follow, before the bibliographic essay that closes the book. This latter is something of a methodological roadmap as I discuss some of my sources because I have kept references to the minimum throughout in keeping with my essayistic approach. Of the essays themselves, Chapter 1, on inscription, is the base of all that follows – the implications for historical thinking of the particular ways in which photographs inscribe the past, and which are vested in the technology of photography itself. All my chapters come back to the inscriptive power of photographs, because inscriptions, in the broad textual tradition of one sort or another, remain the bedrock of historical studies. The second essay addresses another fundamental constituent of historical practice, that of distance, both the distance of time /space relationships and the distance of the historian as an interpreter of the past. Photography is essentially a technology of time, inscribing time and space. As such, photographs throw a particular light and texture on time as a raw material of history and potentially disrupt the assumed relationships pertinent to historical study.

Chapter 3 concerns two aspects of qualitative and quantitative scale. First, the scale of inscription explores the historiographical effects, provided by photographs, of the micro levels of access to the past. I argue that this radically shifts the pulse of the ways in which the past is deemed knowable. The second aspect is the scale of photographic existence and survival, which I term abundance – the plenitude of billions of photographs 'out there'. Photographs, over both these axes, offer historians access to the past in hitherto unimagined ways. What is the impact of this plenitude on historical practice? Chapter 4 on event emerges from this discussion. We all think we know what constitutes a historical event as a temporally and spatially discrete occurrence. However, in focusing attention and framing the moment, photographs bestow the appearance of event on the most mundane occurrences. Photographs, because they embed time, allow for a different scale of recognition and a different pulse to the way discrete historical happenings might be recognized, muddying the waters between fact and event. Following on from this are ideas of presence, which forms

the focus of Chapter 5. I suggest that the concept of presence, when linked to inscription, scale, and time, provides historians with a way in which to interrogate photographs as an inscription of social being and standpoint. They do so in ways that suggest new ways of thinking about subjectivities, agency and ideas of lived experience, a concern that has increasingly defined historical studies in the twenty-first century.

From the sixth essay onwards, the chapters have perhaps a more methodological undertow to them. Chapter 6 itself is on context, the *sine qua non* of historical method. One of the mantras of the historical use of photographs is that they have to be 'seen in context'. But seldom, in relation to photographs, is this category of practice critically examined, rather than just assuming that the surface content of the photograph gives automatic conduit its context. I point instead to the critical double helix of a constraining context and a mobile dynamic context as practices to enhance the historiographical work of photographs. The multiple material forms and uses of photographs demand multiple and shifting contextual work. Consequently, materiality is the focus of Chapter 7. Here I suggest that the innumerable forms in which photographs circulate, and the multiple ways they exist in archives, play a major role in the historical work of photographs. In ways that link to questions of inscription, scale, distance and time, I suggest that material thinking has vastly expanded the kinds of questions that can be asked of photographs, and thus the forms of histories that might be written. The final essay in Chapter 8 considers the impact of the digital, for if the photographic world view was brought into being by technology, so is digital. Digital is increasingly the means through which historians encounter photographs. The digital inflects all the previous chapters because it magnifies the questions discussed thus far – of inscription, scale, presence, materiality – all are translated and transformed through digital encounters. I also suggest that photographs and the digital share problematic status in relation to historical practice. Both are clearly here to stay and make a huge difference – but what exactly?

Of course, historians consider all these things – with subtlety and imagination – one would never claim otherwise. However, photographs and their impact have largely been left out of the everyday critical practices with which historians engage: they are seen as something apart. Yet careful analytical engagement with, and cognizance of, the work of photographs in the historical landscape is, and should be, a process that actively contributes to a rigorous, reflexive and critical practice at all levels, whether individual practitioners are using photographs or not. Photographs raise specific, but widely pertinent, questions about evidence, interpretation, macro and micro relationships, specificity, generalization, and the relations between them.

So, the questions raised here are relevant to the critical role of all historians whatever their particular concerns.

Yet it remains that, despite these debates, and the oft-quoted 1927 statement of Hungarian artist Maholy-Nagy that 'the illiteracy of the future will be ignorance of photography', historians have still not taken the full measure of this statement. As historian John Tosh notes, 'the most one can say is that photography and film are taken more seriously than they used to be'.[23] But it is not simply as sources that photographs need to be taken seriously. At one level, my discussion is necessarily abstract, we are after all dealing with the perceptive and epistemic base of our practice. However, the consequences of both abstractions and photographic existence for the practice of history are also firmly concrete, because they pertain to what historians actually do in, for instance, determining their range and focus, or in producing tangible outcomes from that practice. Consequently, throughout I pull in concrete examples from a wide range of historical work which not only uses photographs as its source material but, importantly, engages with the broader historiographical implications of this. My hope, overall, is that these short essays address not only their specific topics but the interests and historiographical conundra to which they bear witness. An increasing sensibility to the work of photographs is also an increased sensibility to the complexities of the practices of history.

Inscription

The possibility of history is bound to the survival of traces of what is past and our ability to read these traces as traces.[1]

History is grounded in, and shaped by, the inscriptions and traces that reach us from the past. They are the historians' bedrock of evidence – facts, instances, traces – which are assiduously gathered and interpreted as narratives are forged. Historical thinking begins with inscription – a working out with and through sources, that ability to read 'traces as traces'. Although there are shifts in emphasis that go with shifts in historical focus and method, inscriptions of one sort or another, those surviving things and surfaces, are the materials, tools and practices of their trade, the historian's skill. It was ever thus. If ideas of discourse, narrative and rhetoric have, over recent decades, reformulated historical practice, within the broad historical academy there remains, at base, a model of the primacy of the document, that is, inscriptive knowledge. The postmodern debate about the epistemes of representation and the possibility of 'the real' has also made the critical status, theorization and interpretation of inscription fundamental to its interrogation.

In this chapter I am going to consider the impact of photographs as inscriptions, that is something laid down by marks on a surface, in this case by technical processes. After all, the very word 'photography' means drawing, making lines, with light. We'll come back to that. Inscription implies a desire for permanence, a setting down, a chance of longevity. It refers to that which is inscribed on a surface – parchment, paper, stone, clay – or chemical, and now pixels. Such inscriptions involve a huge range of, first, actions - writing, typing, printing, painting, carving, photographing, and, second, forms – letters, charters, etchings, books, lantern slides. The list is very extensive, and I will return to aspects of these forms when I consider materiality in Chapter 7, but inscription is an element in the material world, and an indispensable way in which the past is projected into the future. History is, we could say, constituted by the past of human life quietly contained, stored and transported through inscriptions. Photographs are integral to these fundamental practices, because not only do they inscribed past moments on

surfaces but they massively extend the idea of what historical inscriptions might be. They disturb the surface of the documentation of the past.

Inscriptions are 'wilful marks' that 'fix' action and, with them, meanings of particular social actions: they make durable and suggest significance and visibility. Moreover, inscription, and indeed its survival, suggests a certain intention or agency. For example, the unmistakable desire to record that is implied by the carefully filed court record or diplomatic exchange. Conversely, other inscriptions are of fleeting usage and accidental survival – laundry lists or bills of account. Both are the stuff of history, both are inscriptions even if they work differently. This applies even to some non-human inscriptions – CCTV, speed cameras or NASA visualizations of space, because they are equally the result of human agency and are inscriptive in different ways.

Photographs are, of course, filtered through the view of the photographer. With many photographs one can ascribe an intention to the making of the image, while some remain more opaque. I discuss this more in Chapter 6 on context, but we need to be aware of two crucial points as they relate to inscription: first, that historical actors did not have coherent or consistent views; rather they drew on a multiplicity of attitudes, skills and positions. So, we have to be careful in how we address inscriptive intention. Second, even more important at this point (and central to those inscriptive marks on surfaces), is that what the camera inscribes far exceeds the intentions of the photographer. With the possible exceptions of highly controlled forms such as art photography and advertising photography, the random inclusivity of photographic inscription exceeds intention, a key point to which I shall return, but a crucial one in the consideration of the kind of historiographical disturbances photographs might engender. Of course, one can make this claim for any historical inscription up to a point: they always reveal more than they inscribe. They are also loquacious in their absences and their suggestions of what was not inscribed; this is the stuff of basic source criticism. But photographs introduce an entirely new form of inscription into the historical landscape, and an unruly one at that.

Like history itself, photographs are citational, in that their inscriptions quote and reference the past – what has been. However, photographs offer more than inscription. They are *traces*. This puts a very different complexion on their historiographical activity and impact. The inscriptive trace of photographs is created by light reflected off the physical world and imprinting itself on a chemical receptor carried on a support, usually glass or film, although paper was used in the early period, significantly here, sensitized *writing* paper. This is their unique historical quality. Unless one includes the less encompassing documenting forms of plaster-cast and death masks, for instance, or even the somewhat dubious Veil[s] of St Veronica (one meaning of which is 'true image')

and the Turin shroud, no other historical source provides such directness, nor are other sources premised so insistently on the primacy of its inscribed and marked surfaces. Photographs offer an inscription that, as early practitioners and advocates of photography in 1830s and 1840s claimed, was traced by nature itself through the action of light. It inscribed and held, in apparent entirety, the transitory as it became past. This inscription of the physical world, and claims made upon it, was also guaranteed by known mechanical and technical parameters of photographic cameras as inscribing machines. They brought together inscription, a sense of authenticity and a sense of witnessing. Although historical sources are often referred to metaphorically as traces, traces of past lives, photographs bring a new level of consciousness and imagination to the idea of trace. So we have to ask what these specific forms of inscription and tracing bring to the practice of history and their implications?

This is not, of course, unproblematic and there is a sizable literature exploring, for instance, the semiotic, political, ideological and ethical aspects of photographs, and their manipulation, ratios of truth, or on representation and its production. We can tie ourselves in theoretical knots about the nature and causality of the photographic 'index' (a term borrowed from linguistic semiotics), about what the trace is 'of', how it might relate to the physical world, and how it might signify. Is it representation, replica or resemblance, or what are the workings of traces as signs, icons or symbols? Photographs' action over these categories has been well-argued and convincing, to a greater or lesser extent. For example, there is, on the one hand, a very substantial body of critical theory around power, ideology and representation that has argued why such claims to the real cannot or should not be so. On the other hand, there are historians worried about the way in which photographs can unintentionally, or indeed intentionally, manipulate – that is they are ambivalent inscriptions at the best of times. I mark these debates here, only because they recur continuously in the literature and hover in the background of this discussion. However, I am leaving this huge photographic literature largely aside, because my concern is what happens at the intersection of photographs and historical practice, where effectiveness and historiographical impact is as important as ontology, though as we'll see, the two are entangled. Whatever the nuances, they come down to the essential question for historians, how photographs inscribe the real and to what effect. At the end of the day, if photographs are inscriptions, they are also, like all other historical sources, acts of translation mediating between object and subject, and between worlds 'out there' and their understanding and interpretation.

In terms of historical practice, it is useful to stay with the term 'inscriptions' (rather than traces or indexes) because it aligns photographs

with other predominant sources, and brings photographs' impact into sharp focus. They are very particular forms of inscription. The desire for, or fantasy of, 'photographic inscription', that holds the fleeting moment in order to access past actualities as a historical formation, can be traced back through Western thinking, notably to Platonic and Neoplatonic philosophy.[2] Although the wider conditions of that moment of consolidation are open to debate, photographic registration in the early nineteenth century was effectively a technological rationalization and materialization of a long history of Western metaphysics. Indeed, the very existence of photographs raises a historical question: why does something happen when it does, especially in this case, where some of the science was in place well before the early nineteenth century? Like every other inscriptive form, from Assyrian cuneiform cylinders to type-written documents in government files, photographs carry their own historicity as inscriptions, their own inscriptive modes, which become an essential part of critical approaches to them and their historiographical work. I shall return to these questions in Chapter 6 when I consider the vexed question of that old historiographical war horse – context.

The specific claims of photographs as inscriptions within the historical remit lies in their technology, in their very nature, and many of the other strands I discuss later hinge on the particular inscriptive power to produce a trace that I have just described. The inscriptive connotations of the early cliché and metaphor, 'the mirror with a memory' (the early daguerreotype process of the 1840s had a shiny metal surface, like a mirror), are unmistakable, and this has been the photographs' continuing claim on the historical imagination. The past takes grip and asserts itself through inscriptions, making demands on its historian to read its traces. How much more so with the reality effects of photographs? For all its representational nuances and cultural specificities, and indeed claims to artistic status, photography is essentially a technology of the real. Its validation as historically significant rests on its promises of the visibility and actuality of the past. This is the basis of its claims across multiple and various historical contexts and modalities, for photographs offer both a reach into the past and co-presence. The technical workings of the photographic medium provide its ontological scream: it was there.

There are many caveats around such a statement, entangled with ideas of representation, ideology, intentionality, manipulation and mediation, and ranging from scientific specimen to 'fake news', topics which those writing on photographs as historical evidence have unpacked to great effect. The fact remains, however, that photography as an inscriptive technology works in a certain way, whether England or Egypt, Canada or Cambodia, regardless of how the inscriptions themselves are understood, used and

the meanings attached to them. One should add that the power of these questions reaches into the digital age, and even form a similar focus for anxiety about inscription. Digital inscription is, like analogue photography, produced by the material action of electro-magnetic radiation as light, through which defines the surface shapes of the physical world. Electronic circuits and screens are materially mediating and as naturalized as glass, film or paper. So while the modes of management and intervention in production of traces and reproduction of images might have changed radically, leaving 'fake images' aside for the moment, the essential and formative processes of inscription remain largely, in terms of the physics, not dissimilar.

Various '-isms', such post-structuralism, postmodernism and the new historicism, have reshaped historical narrative and the process of representation over the last four decades, as have the insistent and increasing presence of other historical modalities. These intellectual trends have been equally influential in debates about the discursive regimes of photography, and have undoubtedly had a major impact on history's relationship with photographs. But it remains that, at one level, photographic inscription seems to align with traditional historiography, in that they appear, as I noted in the Introduction, to have Rankean reach into the past, to tell it as it really or essentially was. Their reality effects accord with the historian's desire, even fantasy, for direct conduits to the past. Photographs carry expectations too. More than any other historical form they are contingent on the actuality of the past, with a promise that that reflection of light might illuminate human experience sometimes only glimpsed uncertainly beneath textual documents. Photographs also intersect with temporal and spatial spheres, they carry a sense of immediacy and proximity as a representational form, a closing of distance – 'it was there'. This is integral to referential structure of the historical relationship with photographs, as Roland Barthes famously put it, 'the there-then-here-now' that gives a seductive legibility to the past (points to which I shall return in more detail in subsequent chapters).[3]

These tensions make photographs fluid and ambiguous in ways that perhaps align well with contemporary historiographical concerns, although their potential impact is seldom articulated as such. The excessive and unruly qualities of their inscriptions offer a thickening of historical texture through their inclusive and random inscription. They offer an intensity. Anthropologist Clifford Geertz, many years ago, linked his influential concept of 'thick description' to inscription. He remarks that doing ethnography to like trying to make sense of historical inscriptions: 'foreign, faded, full of ellipses, incoherences, suspicious emendations and tendentious commentaries'.[4] Geertz's notion of 'thick description' positions the possibility of cultural (and here historical) understanding in close attention to the significance of detail

and particularity, and its piled up and knotted inferences. It is well accepted now that the interchange and interpenetration of sources enables a refigured historiography, and that this has bearing on the inscriptions brought into play – those expansions I noted earlier. Further, it has been suggested that to realize this, historians should start their interrogation at points in documents that appear most opaque. An integrated sense of the efficacy of photographic inscription would appear to offer such a site of historiographical experimentation. Photographs build up inscriptive detail, and offer it, observable, for the kind of historical interpretation on which any re-arrangement of the co-ordinates of past experience and its analysis must depend.

However, inscriptions are not static. They leech out into the shaping of a period or event, so shaping the historical imagination. This is not merely in terms of facts or evidence. Photographs as a presence set an unacknowledged tone or mood to a period. This can apply even to non-photographic periods: how, say, manuscripts or architectural remains are presenced in historical texts. The French historian Bernhard Jussen has demonstrated, for example, how photographic representation of objects (traces) from the Carolingian period in history books sets the 'tone' for the interpretation of the period.[5] The ubiquitous presence and intuitive embrace of photographs in heritage interpretations and histories of the twentieth-century wars are similarly a such case in point. Such intensities and immediacies of inscription are disturbing, because, as I shall discuss in more detail in subsequent chapters, they disrupt the sense of distance and thus a certain objectivity on which historical analysis depends. Yet, as inscriptions, they are a crucial part of the grounding of historical analysis in the hard surfaces of life.

Thus, through different forms and intensities of inscription, the existence of photographs in the historiographical landscape allows historical concepts and historical analysis to refigure. The very nature of photographs tensions their inscriptions between what is intentionally made and what might be accidentally found. This is perhaps another site of disturbance. I have already noted the unruliness of photographs between intention and excess – an aspect of inscription that plays out through all that follows. History, for all its sober demeanour and pursuit of certainty, or at least credibility, is a chancy game, perhaps hanging delicately on ideas of survival, causation and consequence as it builds its accounts. Photographs are especially chancy, despite their seductive appearance of certainty and actuality. They offer an entirely new ball-game in the historical ambivalence stakes. Indeed, that relationship between history and photograph can find a sort of analogy with the idea of 'trace' in geometry; that is, something which lies at the boundary of a figure (here history), and which, like photographs, can sit on that

boundary and hold a definition of the peripheral. Perhaps this chanciness, this ambiguity, of photographs is reflected in the assiduous attempts by historians to lay down methodologies for 'reading' photographs. Bringing photographic inscriptions in line with text is perhaps something of a rear-guard action to contain their potential damage. This too will be a recurrent theme in subsequent chapters.

The existence of photographs could be said then to have a profound, if largely unrecognized, impact on the ways in which historians select their evidence and construct their frames of analysis. Their presence refigures what it is to 'represent'. All historical acts, textual, visual or oral, and all photographic inscriptions are, of course, acts of representation, they stand for something or somebody. More broadly, photographic inscription, by its very nature, feeds the desire for representational intimacy and sense of connection. Photographs as inscriptions have stimulated a counter-current to the established practices of historical representational distance. They make historical intimacy and connection appear achievable. One is tempted to ask if the experiential turn of so much contemporary history, marked by a concern not simply for what happened, but what it felt like and how it was experienced, can be attributed, though unacknowledged, to the existence of photographs in the historical landscape and their restatement of historical presences.

As I have suggested, the existence of photographs puts pressure on other forms of historical apprehension, and points to new forms of historical excavation, such as Tina Campt's work on the history of black diaspora experience noted in the last chapter. We are faced with the intensity of the trace that can reshape an understanding of what might constitute a historical source, what is accessible from the past, and how the historian might reasonably respond to such sources. Again, this position puts historiographical pressure even on periods and topics which are resolutely non-photographic – the seventeenth century or even the Middle Ages for instance, because photographic inscription points to the densities of life and experience in the past, the minutiae of the everyday and mundane. While historians have, of course, excavated the mundane from other historical sources and for all periods, the presence of photographs quietly stimulates such a possibility, even if it is not graspable as such; they add just a little weight to imagination, giving it a quasi-photographic dimension. Walter Benjamin said that history is constructed not by stories but from images, and that history 'decays' into images and imaginings,[6] a quasi-photo-montage of dialectical images that reveal new structural forms of its subject matter. Again, this is not a claim to overt causality, but rather points to an effect and atmosphere, a tone and mood, that inflects relationships with the past.

Photographic inscription suggests the possibility of a scale of knowledge. The breadth of the traces of the past, embedded in the chance and contingency of the photograph, confront historians with an actuality that had never previously been encountered. Literary scholars, such as Jennifer Green-Lewis and Nancy Armstrong, have noted how the rapid expansion of photographic availability in the nineteenth century stimulated enhanced forms of realism, mechanisms for the representation of memory, and the work of detail in novels.[7] The same could be said of philosophy in that photographs shifted questions about the nature of 'the real', relations with the truth, and how it might be known, and about the copy and its status in the realms of knowledge. As such, it follows that the existence and presence of photographic inscription is part of the expansiveness of modernity, the intelligibility of the world, and its representational propensities. It fuels the significance of acts of representation. It is significant that photographs, as both inscriptions and mediations, have played a central role in debates around the limits of historical representation of violence, atrocity and trauma, and the ethical conditions of historical visibility, notably around the Holocaust. They shift the historical pulse and bring practices to the surface.

So it is perhaps no coincidence that the massive expansion of foci for historical study in the twentieth century, emerged from the photographic age – the age in which the multiple and seemly infinite inscriptions of photographs expanded the range and distribution of the knowable. It is in the photographic age that time, space, experience and memory were refigured. There was a consequent expansion in legitimate topics for historical study into everyday experience fed through the presence of photographic inscription, and indeed the methodologies such as microhistorical techniques, to address them. While, again, it would be rash to make solid causal claims, it remains that, even if unrecognized, photographs as inscriptions point the way towards changing perceptions of what constitutes the past and thus the practice of history itself in response. New concepts of the relationship between past and present require new approaches. The expansiveness and fluidity of historical focus and method over the last three or four decades, has demanded fresh and equally expansive appraisals of sources. Exemplified in expanded attention to the oral, material and, of course, visual as forms of evidence, such inscriptions and their attendant methodologies have absorbed the influences of, for example, theoretical archaeology and social and material anthropology. The overwhelming empirical presence of photographs, and their fugitive fragments perhaps has served, in part, to direct historical attention away from structures, processes and synthesis towards how ordinary people in the past experienced the world.

This is a historical domain that photographs are supremely well-placed to address. In their detailed inscription and abundance they become almost

'acted documents', inscribed tableaux of existence and experience. While this is more tone and atmosphere than overt causality, it is no coincidence that the rise of visual histories with 'old photographs' emerges at the same historical moment of social and cultural destabilization of the second half of the twentieth century, disciplinary reflection, and the exponential rise of social, cultural and anthropologically inflected histories with their focus on the ordinary and everyday. Photographs here offered that 'trace' which might illuminate the historical periphery. Indeed, it has been argued that many of the excitements, stimulations and anxieties of postmodern historical method are a response in part to the massive expansion of sources from textual into the visual and indeed material realm. The presence of photographs was a key part of this. However, it is strange that while subject to their own extensive post-structuralist and postmodern analyses within visual studies, the presence of photographic inscriptions seldom figure in postmodern discussions of historical practice beyond the metaphorical. This is despite lending themselves to author/reader debates of discursive regimes, power structures of inscription and multiple subjectivities in relation to gender for example. Hayden White, Jonathan Crary and Martin Jay, who have attended to the impact of photographs on broader questions of history, subjectivity, positionality and of vision, are among the few exceptions to this.[8]

Perhaps, in the wider field, photographs' overall lack of narrative made them appear unresponsive to general theorizations of narrative and discourse beyond their own medium specificity. But maybe, and perhaps more cynically, photographs, as a class of historical inscriptions, also had an awkward propensity for drawing attention to the actuality of the past. It is perhaps his realization of what photographs could *do* to history in this capacity that made Samuel somewhat resistant to some aspects of postmodern theorization. Samuel's own theorization of the photograph's historical action might now feel underplayed, but he had a profound understanding of what photographic traces might mean for historical practice and why it mattered. The historical presence afforded by photographs aligned perfectly with the project to rescue forgotten lives from, in E. P. Thompson's famous phrase, 'the enormous condescension of posterity'[9] as presence of the poor, the colonialized, the everyday and the ordinary was mapped across historical inscription on an almost infinite scale. As I shall consider in the chapter of scale, the inscriptive qualities of photographs reinstate what has been pushed aside by other forms of inscription, and those that have escaped the normal and traditional controls of historical practices. Photographs are, again, history's other, the raw materials of the discipline, perhaps like a negative awaiting development.

This returns us to my overall argument, that the very existence of the saturating force of photographs contributed, perhaps unacknowledged, to the

successive disturbances of historical practice and method. They disturbed what is deemed to be historical knowable. Their inscriptive promise is also, however, a source of anxiety – a double bind that shapes their historiographical impact, that tendency to ask too little or too much that I noted in the introduction. In expecting them to show us the certainty of how it really was, a direct conduit to the past, we are bound to be disappointed. Like any historical source, this is indeed too much to ask. Conversely, we ask too little, we are dismissive of their ability to communicate anything of relevance to the historical endeavour beyond the mere 'look of the past' and a mass of unconnected facts inscribed on a surface. So they are dismissed. But such an anxiety relates only to evidential quality not historiographical possibility. It has been argued that we only know historical facts through their effects – which infers that something existed. Photographs can be said to be such effects; they still and inscribe in ways that change the pulse and rhythm of historical endeavour and its categories of analysis. Their traces create inarticulable connectivities between the past and the present. While no historical inscription is evidentially transparent, photographic inscription with its appearance of actuality (however flawed) faces the historian, very literally, with their interpretative responsibilities to produce a credible, well-substantiated and well-sustained argument as a representation of that past. I have often looked slowly at a photograph or series of photographs, looking literally into the face of the past, and thought 'I hope I'm getting you right, I hope I'm being fair.' This position takes on perhaps a certain piquancy in the photographic age because the past cannot remain entirely abstract, its actuality is reinforced, challenging the ways in which we might read traces and understand their impact upon the imagination as historical questions in and of themselves. While the status of the document and of evidence is always ambiguous for historical practice, with such inscriptive forces at work, we are firmly back with the question of what that historical practice might be in the age of photography.

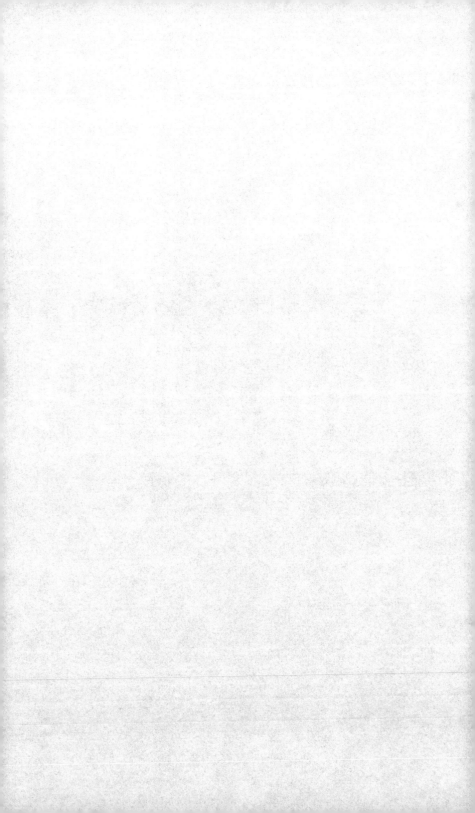

Distance

[Photographs] are a 'kind of "leak" in time through which "presence" wells up from the past into the present ... washed ashore on the plane of the present ... they deserve to be cherished like fossils'.[1]

The distance of time is one of the defining conditions, some would say absolute precondition, of the practice of history and marks both the past and relationships to it. As soon as we glance backwards through and beyond our own experience, our deliberations become those of time and distance. This may seem like stating the obvious, but the work of time within the practice of history and its linear pulses is so naturalized in the general run of things that, outside philosophy and theory of history, it often evades critical consideration or a sense of it being an active player in our deliberations. Two essential meanings and practices of distance weave through this chapter, in which I take distance largely as a temporal marker, but one integrally inflected with the spatial connotations as well. First, the time-space intersection offers ranges of temporal and spatial strategies by which the object of study is defined as the past, the far away and the elsewhere – in L. P. Hartley's famous and much utilized spatial phrase 'the past is a foreign country' rather sums it up. Second, distance is a conceptual metaphor for both the historian's objectivity and positionality, and for their sober analytical engagement. Distance is thus relational and shapes their apprehension of the past.

Photographs cannot, however, be contained on either axis, for photographic time is an impure time. As forms of temporal displacement, they bring both axes into stark visibility and disturb the temporal assumptions that have informed the practice of history. Photographs allow the past to seep into the present in multiple ways that 'well up' and leak through time and space, disturbing distance and the distancing techniques and propensities of practice. This chapter is about those leaks between the past, present and, indeed, future on which photographs insist with such force. This disrupts historical distance in both my senses, in that time and distance are both present and elided. This is perhaps, yet again part of the underlying historiographical and methodological distrust of photographs. They mess up our sense of time.

In order to address this complex and multifaceted intersection, I am going to consider questions of time and distance as they are shaped by the particular characteristics of photographs. Time is the photograph's fundamental and binding link with history. Photographs still time, they intervene in the flow of time, and thus create fragments of time and space, yet they also layer up time, both within them and in their work. The times of photographs are fluid times. This a key site of both their appeal and disturbance. Distance as, and of, time are major historiographical questions that have absorbed many scholars of a more philosophical bent, both in writing about history and about photography. But my concern here is what photographs, as particular orders of time, distance, temporal consciousness and imagination, make possible in historical practice. To this end I shall first consider these intersections, then look briefly at the spatial dynamics that inflect ideas of distance, before looking at how photographs contribute to two different historical modalities around distance and time, namely memory and presentism. Photographs thus raise questions that indicate their disruptive propensity, such as what sense distance do they signal for the historian? How do they present particular horizons of expectation in the relationship between the past, the present, and the future? How do we deal with these particular temporal threads in the present and how, in disturbing distance, do they suggest an expanded positionality? What do photographs do to ideas of linear time, the foundational pulse of historical narrative as it is conventionally thought and practiced? All these questions, and more, cluster around photographs within history, because their temporal range is not neatly linear, nor do they lend themselves to a simple (or even simplistic) dichotomy between past and present. They are created through the moment of inscription and simultaneously uncoupled from it. Photographs point to the complex co-evalness of past and present, as the past is washed up on the plane of the present as Eelco Runia puts it.

Distance arguably constitutes the entire dimension and dynamic of historical practice and provides its underlying intelligibility. It is sometimes difficult to distinguish between questions of temporal distance, the idea of history and the past itself. If so, how much more so when muddled by the very existence of photographs. While photographs themselves are clearly 'of' the past, their immediacy – their 'there-then-here-now' – disrupts the distance assumed to be part of historical practice and its standards of objectivity. In this chapter, I want to explore this historiographically Janus-faced nature of photographs because, despite being marked by their own inscribed historicity, they are double-agents. Photographs are entangled with the distance of the past but also give an unsettling sense of its closeness. They seem to offer an entire temporal continuum from distance to immediacy.

Importantly, both immediacy and distance are instruments of classification which deem what is 'of the past' and what is not. The disturbances to historical time that photographs produce are thus both tensioned between, and productive of, these two modes – distance and closeness, absence and presence – relations which are palpable in their historical work.

One of the excitements around the invention of photography and, part of modernity's emergent historical consciousness, was the bridging, or even elimination, of time and the historically distant. Photography was one of the technologies of the nineteenth century – along with railways, steamships and telegraph – that intervened in time and space. The actuality of the past could be ever-present and projected into the future. The potential for history and archaeology was among the first applications for photography to be articulated in the years after the consolidation of its invention in 1839. At a period when styles and methods of historical writing were beginning to shift, photographs become modalities and mediators which accentuated a self-consciousness in relation to ideas of past, present and future. With their range and inscriptive detail, they enabled new historical actors to jostle with the old. The existence of photographs became rapidly absorbed as a shorthand for relationships with the past, one that is still with us. One only needs to think how, even in a digital age in news reports, the visual trope of turning the pages of the photo album is used to signify absence, loss and the passing of time. The soubriquet 'the mirror with a memory', coined by Oliver Wendell Holmes in 1859, encapsulated the temporal hope and expectation of photography as the medium of the stilled transient. Therefore, from its emergence, photography was inextricably linked to time. It shifted relations with the past towards that moment of rupture, noted in my introduction, from which there is no historiographical return. Photographs become one of the mediating forces of historical time itself, the hammer-blows and pulses of time, endlessly resonating and reasserting themselves on the historical imagination.

Photographs are often described, as another cliché has it, as 'frozen moments in time', extracted from a linear temporal flow that informs ideas of historical narrative. This stillness would seem to put them they resolutely outside the dynamics of history. But really nothing is further from the truth. Photographs are always on the move, shifting temporal relations, inserting other potentialities and pointing to slippages. Thus, thinking through the historiographical disruptions and temporal category blurrings that photographs might prompt requires that the historian, instead, be responsive to the kind of pasts that might be encountered. Such a position requires a temporal reconceptualization of photographs, a consideration of the forms of distance that they offer and the implications

of those forms for historians. Like other media technologies, photographs make it possible for historical subjects, and the historian's interaction with them, to exist together in and through time. While all historical sources do this to an extent, the inscriptive character of photographs makes them of a different order. Photographs demand a different and multiple conception of time that challenges assumed linearities, resisting Newtonian conceptions of inevitable linear time as an adequate explanatory framework for the temporal complexities which they offer, and indeed represent. They reproduce, overlap and fold back time. They offer temporal experiences that work in circles, rhythms, pulses, folds and ripples. These collide, spill, jolt and swirl in ever shifting sets of relationships, constituting and reconstituting the past and its relationship with the present. As a result, in disturbing time and access to the past, they also disturb the values traditionally articulated through historical distance.

This is especially so if we think of photographs not as frozen moments which mitigate against the narrative flows that historians desire, but as bursts or explosions of time that reveal and open up – perhaps the fossils revealed in the blasted quarry face of my opening quote. Literary scholar and historian Ulrich Baer has argued that 'only if we abandon or substantially revise the notion of history and time as inherently flowing and sequential will we recognize what we see or fail to see in [...] photographs'.[2] This is an important insight because it not only complicates the evidential potential of photographs, it is also suggestive of new temporal relations in the historical landscape. Such a position also moves photographs closer to contemporary developments in historical method which address, for example, different temporal structures and the nature of experienced time. Perhaps, the presence of photographs has imperceptibly contributed to these shifts? It's worth thinking about.

It would be overstating the case to claim the photographs alone do this. But they contribute in unnoticed ways. Rethinking time has been part of a historiographical enabling process. Histories better served by cyclical temporal models and the idea social practices across time, are quietly reaffirmed by the presence of photographs and their historical action. Social and cultural histories, for instance, have been inspired through refigured questions of significance and analytical potential around, for example, experience, the everyday, gender or poverty, which coalesce around questions of methodology, politics, identities, affects and subjectivities. Photographs played an important part in formative twentieth-century feminist histories of domestic relations, around questions about gender, memory and patriarchy, for instance. This can be seen in the work of cultural historians such as Pat Holland, Annette Kuhn and Martha

Langford who have looked at the way photographs construct specific narratives of identity relationships in these contexts.[3] As a way of doing history, such topics and their methodologies have their own temporalities, as in social history, and, being 'process-led' rather than 'event-led', do not necessarily respond to linear structures of time. Historian Christian de Vito has argued that microhistories foreground discontinuities in time and space and the importance of historical actors themselves within this. He refigures conflations of micro and macro levels in a process he describes as micro-spatial, a merging of, and action over, multiple scales and times (we'll encounter this in the next chapter too).[4] Photographs would seem to operate in such spaces.

As I have noted all along, this argument is a sensibility to historical practices, relationships with sources and the conditions of knowability, rather than a clear methodology or evidential form. Consequently, sensibilities or possible responses to the intensities of temporal distance are part of disruptions that photographs might bring to the larger historical field. This moves beyond the construction of historical distance as the passage of time and its objective address. Rather it asks how multiple forms of temporality, and the vacillation between distance and closeness, structure our sense of the past and historians' approaches to it. Under what conditions do we recognize 'the past' and its significance? The exact shape of sensibilities is always, to some extent, of its historiographical moment. Initially, in the nineteenth century, photographs appeared as a new, and perhaps historically consoling, stability within the temporal confusion of modernity, just as later, in the twenty-first century their proliferation is seen as a destabilization in postmodernity. In both instances, the very presence of photographs in the historical domain becomes significant in shaping those sensitivities. Distance, especially now in a digital age, becomes a tool of representation in which a sense of time is moulded through a variety of distances, and as a space of making, doing, experiencing and understanding which reflects different ways of engaging with the past.

So, having muddied the waters of historical assumption, I am going to look a bit more at the entangled double-agency of distance and closeness. Distance is part of the historical practices of objectivity. Much has been staked on the objectivity of the historian as an interpreter – her appraising and analytical distance from her subject established in order to form a dispassionate analytical view of the past. Photographs offer, on the one hand, distance and detachment, those frozen moments of time removed and isolated from the temporal flow of history, and, on the other hand, they offer proximity through the immediacy of inscription, a closeness to the reality of an event, happening or experience. The promise of closeness erases

a sense of time and distance. Look quietly at something as mundane as a school class photograph of about 1900, and feel time well up. Photographs draw the historian into the intimate time and being of the past. Not only do investigations feed into questions of scale and detail offered by photographs (as discussed in the next chapter), arguably the very existence of photographs in landscapes of the past have created a hypersensitivity to time, what French historian François Hartog, in discussing contemporary ideas of time, has described as 'the immediate self-historicism [which] is a defining trend of our time'[5] – a time that is saturated with the inscriptions of the past, even in the fleetingness of the digital age.

Photographs at one level restore to a sense of the past, what is lost through distance. Objective historical assessment is premised on distance and the historian's sense of distance from her subject and sources. However, this has the potential to be profoundly disturbed by closeness, which is what photographs, of course, do supremely well. Roland Barthes famous adage of photographs inscription and trace, 'there-then' becoming 'here-now', is above all a temporal, even chronological, dynamic in which photographs reproduce continually what has ever only existed once: what has been appears present.[6] In granting the past immediacy and, as we have seen, actuality, photographs appear to restore a direct conduit to the past – a closeness. History, as a practice, is premised on producing accounts that are, on the whole, as close a 'historical truth' as sources will allow. They are made credible by the demonstration of that closeness, filtered through the 'objectivity' of distance. However, photographs seduce us into the belief of greater intimacy, pushing to the edge and beyond what is conventionally knowable. Faced with photographs, putting things at a distance becomes increasingly difficult – we are back with that class photograph of 1900. Consequently, these shifts are not merely those of historical attention, such as those I discuss in the essay of scale (Chapter 3), but shifts in ideas of distance as conditions of knowledge. One is led to ask, as in the other strands that I am considering, if the presence of photographs is part of the historical naturalization of time, or if a photographic visual presence of the past enhances sensitivity to time. Or both?

In all directions we see distance slipping into closeness through the presence of photographs. As I've said photographs, despite their manifold forms and functions in a multitude of different uses, close the distance, flatten time, make the past immediate, almost graspable, and comprehensible presence. They defy remoteness. They activate subjectivities, disturbing the norms of distance that define historical endeavour and practice, even for those working on pre-photographic topics, because they offer an expandable space to historical imagination, that such closeness is possible, that the past is

knowable on a photographic scale. This is demonstrated through the photo-dependencies of much popular history in which 'closeness' is performed through 'lived pasts', such as *1900 House* (Channel 4, 1999) or *Edwardian Farm* (BBC, 2010) (and remember they had academic advisers). They build their closeness in part through the existence of photographs, giving access and credence not only to the 'look' of an age but also to the impression of knowability, of a graspable 'reality' in a play of closeness and distance.

So far, I have focused on history's major marker, time. But I want to return briefly to the spatial metaphor of distance that I touched on earlier. Photographs inscribe the place and space of experiences, literally tying time to space. The photograph intervenes in the spatial/temporal axis of historical thinking, providing a porous membrane between time and space. The spatial metaphor of distance, and time-space relationship, has long history in Western philosophy and is understood as a condition of both knowledge and social experience. Distance, proximity, immediacy, closeness are all spatial concepts framing the temporal, and are themselves framed by the temporal. Arguably, this sense of physical, that is spatial, nearness is the enduring appeal and seduction of photographs. They have a proximity effect, that feeling of closeness to the subject of a photograph – again the class of 1900. As many commentators have noted, time and space are inseparable modalities. What mitigates against the dominance of temporal distance, the gap between past and present, fact and narrative, is also the spatial immediacy and proximity effect offered by photographs – the space of experienced time held within the space of photographic inscription.

Reflecting the time/space axis in the practice of history itself, photographs function as what Russian literary critic and theorist Mikhail Bakhtin has called 'chronotopes'. Chronotopes are constituted through the interconnectedness of temporal and spatial relationships forged into a concerted whole. This is precisely what happens in the history/photograph interface – and although Bakhtin did not write specifically on photographs, one might observe that he was writing in a photographically saturated world. Photographs can be conceptualized as spaces where, in his words, time thickens 'and takes on flesh', and where 'time becomes, in effect, palpable and visible'.[7] This would seem to describe the temporal work of photographs exactly. This density is also precisely the site of their historiographical disturbance. Photographs make events, occurrences and human experience appear concrete, working in 'the place where knots of narrative are tied and untied'.[8] While Bakhtin describes this as a dialogical relationship outside representation itself, applied to photographs, and thus their imbrication with history, the chronotope becomes a site at which

authors, performances, and users are entangled. It produces a historical density that is concentrated and condensed.

I used this concept to unpick the relationships in a colonial photograph of rival Samoan chiefs and lineage leaders negotiating with the colonial powers on a British gunboat in 1884. Combining a forensic reading of photographic detail (more of this in the next chapter) with ideas drawn from that of the chronotope as a dynamic merging of time and space, I showed how the Samoan groups performed local concepts of time and space within the colonial space of the gunboat. More specifically, I showed that the presentation of the parties to each other was as, if not more, important than their self-presentation to colonial authorities.[9] Certainly photographs endowed these dynamics with a concrete quality but, thinking through the inscription of different times and spaces, alternative voices, perceptions of event and counter-topographies became visible – that is, historically comprehendible.

The double-agency of distance and closeness in photographs, and their chronotopic tendencies bring us to questions of presentism. It is, to reiterate Hartog's comment, 'the immediate self-historicism [which] is a defining trend of our time'. Presentism, defined here as the meanings attached to the presence of the past in the present, depends on non-linear notions of time – those temporally leaking ripples, folds and circles that I alluded to earlier. Photographs contribute to a historical regime of presentism because they raise self-conscious modalities through which the past can be imagined. Part of the closeness and photographic performance of the past in the present is in the way that they contribute to a sense of the ever-present, denying the closure of historical time. In collapsing 'being there' with 'having been there', what presentist discourses yearn for is closeness, and photographs provide it. Vested in representation, they ensure the ever-present past. Here articulations of the past resurface, recode and are continually replayed, subordinated to and at the service of the present. They do not slip away into oblivion. In this, photographs do not merely continually play the past in the present, they present an easy retrievability in which the past is continually alive and temporally collapsed. While much of this is happening outside academic history and in digital environments, such topics are themselves the focus of historical investigation. Thinking about presentism makes evident both the disruption of linear temporal dynamics to which photographs contribute so markedly, and the temporal slippages of photographs themselves. This is particularly so in recent decades, where histories, haunted by trauma and catastrophe, have maintained a strong sense of the past alive in the present.

However, just as there are multiple pasts, there are multiple presents, so the field is always shifting and fragmentary. Photographic closeness,

and the management of historical distance, is important in presentist popular histories in, for instance, contemporary questions of nationalism. The existence of photographs, and those temporal slippages, have played a major if generally unrecognized part in this process, in part because of their ability to work effectively outside models of linear-based time. Photographs are perceived, in such contexts, to be part of a strong sense of history as they endow land, people and historical homelands of one sort or another, with a concrete presence, a history that can be 'taken back'. Significantly, British historian Eric Hobsbawm suggested that the term 'nationalism' first appeared from a long political history in the final decade of the nineteenth century,[10] exactly contemporary, we should note, with the exponential expansion of the circulation of photographs. While photographs became a dominant force in the visual politics of the second half of the nineteenth and early twentieth centuries, in a digital age such narratives produce an increasingly visualized 'strong history' to legitimate, validate and authenticate them in a rapidly changing and interconnected world.

These appeals to photographs in making histories are premised on questions of immediacy, closeness, time and distance, and the consolidation of the past for the purposes of the present. For instance, anthropologist Joshua Bell, working in Papua New Guinea, noted the ways in which communities who had access to photographs related to their past (often taken by missionaries or colonial officers), were believed to be in a more powerful position in asserting identities, in negotiating their place in the modern world, and in the complex inter-community politics around local leadership and resource ownership.[11] In a very different example, Ewa Manikowska has explored the way in which photography, as a chronotopic expression, was used by different ethnic and religious groups to assert, articulate and stabilize different and layered claims to the past in the Polish borderlands in the period before the Second World War.[12] In both cases photographs worked as intersections of distance, time and space, to assert identities through historical articulation. Photographs, and their appearance of directness, are mediators. Acknowledged or unacknowledged, in such discourses, they are one of the mechanisms, and a seductive one at that, that force these dynamics into visibility.

I have emphasized these particular temporal practices because they accentuate not only the interface of photographs and history but the way in which photographic action is imbricated with many foci of investigation in contemporary history. It raises questions as to what extent the existence of photographs with their temporal and distantial

fluidity, combined with extensive circulation and ongoing saliency, is in part, at least, responsible for the relentless presentism of the modern world? To what extent have they flattened the nuance of temporal relations at the expense of other experiences of time? Or have they enhanced them? There are no precise answers here, but these questions represent important critical registers brought into play.

The distantial play of photographs is arguably central to other historiographical shifts, such as those towards subjectivized histories of various sorts, including memory practices, history of emotion and sensorial histories. Photographs play on the emotional registers of the past. Their appearance of the actuality of past experience is possibly yet another root of the historian's anxiety about subjectivities of both topic and practice. The past perhaps becomes too close. However, these temporal dynamics have also stimulated some important historical work. Photographs are seen to function on the borderlines between history and memory and their work in the present. As such they have been major conduits of the historical examination of memory practices. A notable example is Marianne Hirsch's influential concept of postmemory in Holocaust studies, which was developed largely around the work of photographs in the temporal extension of trauma memory to subsequent generations.[13] In a very different perspective, Margaret Hillenbrand, in exploring the entanglements of state and social memory, has demonstrated how the negotiation of ideas of secrecy and the functions of photography create a powerful historical entry point into questions of managed memory, survival, disavowel and forgetting in contemporary China.[14] Both these examples base their historical analysis in managements of time, distance and memory structure, activated and explored through the work of photographs.

Further, in another nuance of the past in the present, photographs also orchestrate and facilitate a desire to re-enter the experience of past, a form of closeness, as I noted in relation to TV 'lived experience' shows. Interestingly this kind of sentimental or emotional history, often manifested through local or family histories, has been seen as superficial, shallow and lacking analytical potential, exactly the accusation sometimes thrown at photographs as sources. Yet the increasing interest in memory, feeling and affect as approaches to the past aligns with the work and presence of photographs. Photographs are seen as a privileged form of closeness across a wide range of temporal and spatial applications, for example family history websites, projects of cultural recuperation, statements of identity, or land rights claims.

Philosopher of history Eelco Runia has noted what he calls an 'ontological homesickness', the desire for the closeness of commemoration and a manifestation of a desire to get into contact with the 'numinosity of history' – a sense of almost supernatural presence.[15] Photographs carry the possibility of putting one in historical touch with the person you are. This closing of distance from the past is possibly the defining desire and interest in photographs. It is what people want photographs to be for them, to provide a defining sense of self through the management of distance and closeness. Here, photographs become temporal markers of experiences lived through, and I shall return to this aspect in Chapter 5 when I discuss presence. Moreover, various distinct genres and purposes of photographs such as family photographs, identity photographs, documentary, born of different temporal experiences can be absorbed into these narratives: ID cards become items of family memory, documentary photographs become national symbols and family photographs become social documents. They are absorbed and recoded in an appeal to distantial forms – from anticipated memory to immediate recognition. At work is a certain range of expectations that photographs demand in relation to time and distance, and which bleed over into broader questions of historical practice.

Yet it remains that such slippages of distance and their appeal to sentiment, while providing rich foci for historical analysis, are perhaps the most concerning to historians. They sit uncomfortably as evidence. Although the interests of different modes of historical narration are now well established, and historical scale and its temporalities are increasingly problematized and renegotiated, many historians are still wary of the immediacy or closeness of such histories. Yet new historiographical practices are challenging this, and slippages are increasingly seen as productive. An example is Craig Campbell's study of the responses of indigenous peoples of Siberia to Soviet rule. He used disruptive archival techniques to reorder and re-temporalize historical deposits as a technique for capturing the complex temporal and spatial relationships on which those historical responses depended.[16] Rather than observing established archival narratives, he adopts what he terms anti-illustrative approaches, where the content of the photographs as such is less important than the way in which their temporal fragmentation creates an analytical entry point into temporally complex Siberian histories. An increasing emphasis on realigned narrative orders and chronologies, and on the exploration of the visual and/or oral for instance, means an address to temporal slippages, and, above all, their potential absorption methodologically and historiographically. As reliance on traditional time/ event sequences become less marked, especially in social and cultural

histories (so often the site of the photograph's historical work), the very presence of photographs as a historical form and source is integral to the necessary reformulations of distance as a historiographical modality.

While new media – printing, photography, film, digital – always imply new textures of temporality (and one must remember that all media were once 'new media'), the photograph's disruption of distance and time is one of its central historiographical presences. That tension and vacillation between distance and closeness that photographs bring to history is at the heart of their destabilizing propensities. Despite the necessity of distance in historical writing, closeness is also seen as having an intrinsic value. Photographs provide and stimulate a counter-current to the established practices of historical distance; that is, they feed the desire for the historical and a sense of connection and, overall, make this seem achievable. Photographs' Janus-faced quality again becomes apparent. While they operate with ease in the discourses of presentism, they also function over those multiple temporalities as a 'conceptual distance which can be diminished or augmented in ways that can fundamentally change our sense of what history represents'.[17] For photographs, like history, are as much about the future as the past – they represent an anticipated memory or need to access the past. This unspoken belief informs much of their creation. If the 'there-then-here-now' speaks to seductive presentist possibilities, photographs also assign a past to the future, in that the present becoming past is inscribed for an imagined future. If photographs leak into and 'well up' in the present, they are also perceived to 'well up' in an anticipated future.

So, in summary, we could say that, in relation to time and distance, photographs are both symptoms and messengers. Photographs are both distance effects, they are ineffably 'of' the past in all senses, and closeness effects, in that they carry a sense of immediacy and action in the present. As such photographs modify and reconstruct the temporal distance of historical accounts, thereby shaping every part of historical engagement. They offer a continuum of historiographical possibility from proximity to detachment which resonates through historical practices. While they suggest a past that is present, they are equally capable of being slippery – not easily grasped, controlled or interpreted despite appearances to the contrary – that is, they disturb. This is not simply a question of rhetorics or temporal poetics of historical representation. Discourses of closeness and distance become key analytical categories, and photographs dynamic actants in historical thinking.

Above all, like inscription itself, distance is ideologically and affectively entangled in ways that both give the past so much of its meaning, and with

the formal structures that make the representation of the past possible. Its temporal contestations offer a flexibility of interpretative possibility. The temporal and spatial resonate with questions of ideology, method, morality and politics, which are photographically inflected, in the making of distance, time and history itself. Photography's temporal dynamic is perhaps the most compelling intervention with the commonplaces of historical apparatus. It also informs others, notably scale and event, which I address in the following two essays.

Scale

it was all too, too colossal and quite horrible to see such potential power, such organization of quantity ... these pictures were like a disease ready to go into the population and penetrate its life. He saw these files as germs of limitless ideas.[1]

Scale has always been of concern to historians, in their critical attention to the scale of the object of study, the range and intensity of sources, and the parameters of interpretation, for instance. One could say that one of history's many contributions to the humanities overall is its attention to scale and the scope of human experience. Scale is part of the structure of historical distance, part of the perception of closeness, part of the definition of extent. As we have seen, photographs have a great propensity to disturb the assumptions and practices of distance and access to the past. However, in the face of ever-expanding and integrated notions of the temporal and spatial units of historical study, from interconnected microhistories to big data and 'deep history', scale is being increasingly discussed within historiographical and methodological debates across problematized macro/micro, global/ local divides, global framings of local and individual experience. While photographs intersect with all these concerns, they also carry a further aspect of scale, that of detail, granularity, a sense of the close-up, or even enlarged view. In this chapter, I am going to explore two interrelated forms of scale which shape the relationship of photographs with the practice of history – scale itself and abundance. While somewhat differently inflected from that larger debate, in that the working of photographic scale is located in inscription rather than historiographical construct, photographs nonetheless intersect with ongoing debates about scale as a global and historical pulse.

Much commentary has been expounded on the relations that such approaches mask or unmask, and the problems that such binaries of scale, such as global/local, insert into the practice of history. In an *American Historical Review* 'Conversation' about scale in history, scale was described as 'profoundly methodological' and being 'quite vast in its implications for how we approach historical experience in very basic terms (and thus

relevant to anyone who thinks about history)'.[2] These debates are relevant to our discussion here because broader questions of inscription, distance or fragment, which have inflected them, are played out in the photographs' historical relations in ways that can be solidified around the idea of scale. Christian de Vito's phrase 'the micro-spatial', noted in the last chapter, offers a perspective through which 'to question scale-bounded discourses ... and provides an alternative to mainstream conceptualisations of the local [that is small scale]'.[3] Such a concept surely creates a historiographically active space for the work of photographs in the processes of history, but at the same time links them to the larger scale. Yet photographs, their manifestations of historical scale and horizons of knowability are, however, usually absent from these discussions, despite the fact that scale has contributed to the idea of photography as a medium of revelation, in ways in which it shifts the dynamics of visibility and legibility.

Always inscriptively entangled with scale – photographs hold, trace and inscribe imperceptible details of the physical world. The photograph's claim to scalar intervention in the past is grounded in inscription. As we have seen, photographs inscribe in both minute and granular detail and with random excess. They record more than the photographer ever intended. As such they allow the surface of things in the past to be seen on a hitherto unimaginable scale. This is another core site of their historiographical disturbances – they intervene in, and shape, historical scale. Photographs also force us to realize overtly something known but too often deeply buried – that there is no historical engagement without a sense of scale. Photographs persistently and consistently return us to the micro level – the conditions of the past's knowability. But this is not merely in their detailed evidential qualities. Their productive randomness of detail and scale alerts historians to the contingent and to chance, in ways that must surely spill over into other historical practices. Perhaps photographs remind us of the fragility of our accounts of the past, and the limits of its knowability.

Photographs thus are arguably part of the apprehension and negotiation of scale as historians might understand it. As we have seen, the very presence and existence of photographs in the historical landscape disturb notions of space, time and distance, and thus resonate through scale. As will have become clear by now, one of the key disturbances that photographs offer to the practice of history is in their granularity of inscription. They reveal what Walter Benjamin described as the detailed structure and cellular tissue of visual worlds.[4] As I shall suggest, the kinds of scale which photographs inject into the historical landscape, both conceptually and evidentially, are a constitutive part of the historiographical atmosphere

in which these debates are formulated. In the face of photographs, scale is not only a debate about local versus global, *longue durée* versus temporal incision and so forth. It becomes one in which the scale of human experience and existence becomes visible, a theme I return to in Chapter 5 on presence. To what extent does the potential role of photographs, as central players in these modes of historical approach, contribute to the shaping of those debates in unarticulated ways by simply 'being there' as a scale of historical engagement and possibility? How do we balance the growing interests in, and demands for, integrated, global multi-scaled histories, and a historiographical world in which big data and deep histories threaten to iron out the micro levels, agency and the way in which historical actors shape what becomes history?

As I said at the start, I am exploring the historiographical impact of photographic scale in two different ways – scale and abundance – both of which have the potential to disturb what is historically thinkable. Scale is qualitative in that it is vested in the granular and plentiful forensic nature of photographic inscription. Conversely, abundance is quantitative – that is, the sheer plenitude of photographs, and indeed photographic-like digital images, in existence and at the historian's disposal as both sources and think-spaces.[5] Scale and abundance are nonetheless interrelated and overlapping in the mass of possibility they offer historians. There is abundance within scale and scale itself is a matter of abundance. So historical processes are not necessarily embedded in one or other form of scale – both work together. However, let's try to keep them separate, at least heuristically.

Both scale and abundance have been talked about, in relation to photographs, as an 'excess' or 'exhoribitance'. This implies a troubling sense of instability and an implicit danger in what is beyond the necessary or proper, and thus a source of accentuated anxiety over the historiographical role of photographs. But there is another view, and one that is becoming a recurrent theme here, that these characteristics and processes might be more positively inflected and methodologically harnessed. Photographs might offer history not a troubling excess, but a scale of plenitude, a generosity of historical potential, and a surplus of meaning which allows sources to refigure, complicate and move forward our historical questions and assumptions about what we think we know. Admittedly this might be suggestive rather than strictly evidential, but this again is one of the challenges that photographs offer. Where is the borderline between hard evidence and credible and productive suggestion? What makes photographs historiographically disturbing, yet rich, are the qualities of scale and abundance – the minuscules and magnitudes of scale.

These are at work not just in terms of sources, but have an incalculable effect on landscapes of historical imagination. They amplify in ways that generate a different order of those historical effects.

The deep structures of scale, at the intersection of photographs and history, is revealed again in the prevalence of visual and photographic metaphors of scale at work in history writing – the enlargement, the close-up, the snapshot – as if photographs and photographic technologies are an unarticulated presence in historical deliberations of scale. It seems an irony that discussion of global history often uses the current phrase 'global optics' to signify the wide view, without a sense how 'photographic global optics' might indeed contribute to this historiographical debate. Playing with optical scale through enlargement and the close-up enables the emergence of new historiographical scales as inscription is magnified and brought into analytical visibility.

Perhaps we should look at abundance first, because this form of plenitude frames questions of scale. In many ways, abundance resonates through this whole book because, as noted in my introduction, the saturating presence of photographs, the sheer and increasing numerical quantity, has an incalculable effect on historical sensibilities at all levels. This has exploded in the digital age as 'our contemporary networked and data-intensive phase of image production adds a further infrastructural layer to earlier questions about reproduction and the multiple'.[6] The number of image files in existence runs into trillions. The most recent statistics, available at the time of writing, suggest that some 450 million photographic-like images are added to Facebook and Instagram alone daily, that's about 63,000 a second (some 180,000 in the time you have taken to read this sentence). These are probably under-estimates – and certainly out of date by now. Simultaneously, the historical deposits of analogue photography, many of which now have digital surrogates, run into billions, filling not only archives of one sort or another but industrial operations, police files, family albums, shoe boxes (apparently the inevitable home of photographs), envelopes, enclosures, publications, illustrated press or displays of all sorts. If the ubiquity of photographs in both the public and private sphere is beyond number, their abundance is formulated not just as a massing of images but as a plenitude of material forms, a significance I shall consider in the essay on materiality.

How is the historian to think about such plenitude? It could be argued that the accumulation of fragmented and saturating detail as 'fact' is, of essence, devoid of the coherence that history demands. However, conversely, the concrete accumulation of evidence, as chronicled by Raphael Samuel, created the abundance of photographs entering the

historical domain through the second half of the twentieth century onwards. This in itself points to a clear sense of historical significance, and, as such, constitutes one of the changing conditions of historical practice. We are conscious of, and have access to, more photographic 'stuff'. Such abundance allows the historian to see patterns, not necessarily of what photographs are of, but of their work in historical and visual landscapes. In response to this abundance, historians are increasingly addressing very large data-sets of photographs. For example, in my own study of the late nineteenth- and early twentieth-century photographic survey movement in England, I worked with a data-set of about 55,000 spread over many archives. Annabella Pollen analysed the shape of a similarly sized data-set in her study of everyday photographic practices as performances of identity in response to a charity photographic competition, 'One Day for Life', held in 1987.[7]

In order to deal with these dual abundances, a close reading of specific photographs as 'critical forensics', and I'll come back to this, has to be tempered with distant looking or pattern-thinking. In pattern-thinking the historian looks not for singularities but shapes, overlaps and absences in both the images collectively and the work they do. This also has historiographical ramifications as 'pattern thinking' is a determination 'to know the world dynamically, to know the ramifying, running pulses of connections amongst every component thing in the energized world'.[8] Abundance becomes productive because the combination of scale and assemblage allows us to see material, literally, in new ways. Maybe the multiple scales offered by photographs and their abundances enable us to claim the middle ground between the theoretically assumed visual regime, for instance, with its reductive and overly causal tendencies, and the details of inscription. I certainly felt this when working on the photographic survey movement. It was the 'pulse' of subjects, the iconographical repetitions and shape of archiving, rather than individual photographs that became telling. Their patterns provided a crucial dynamic that enabled me to move my analysis away from the conventional reading of this movement as nostalgic, as suggested by individual rather picturesque images, towards more complex and, above all, future-facing drivers.[9] Thus scale and abundance offer complementary levels of engagement. While the micro levels of inscription offer scale, abundance points to the way in which, through assemblage, they might be understood as 'units in a series, which reveal the conjunctural variations' within a constant or consistent narrative that reveals an historical process.[10]

This mass of photographs has to be understood as a collective system that expresses complex and linked values. Consequently, abundance demands that 'distant looking', in which significance is vested in the shapes, forms, relations and structures of a whole body of material. In other words, the historical potential of photographs has to be understood in the tensions between macro and micro levels, that is distant looking and critical forensics. What actually holds them together as a coherent statement in relation to any particular historical problem? Of course, patterning is part of any historical method, looking for repetitions, confluences and comparisons. But with photographs, abundance allows us to see the patterns of details imperceptible in other historical sources. Abundance also enables historians to understand the way images work, and thus leave their mark on wider historical questions.

An example of photographic abundance as integral to wider historical effect is historian Catherine Clark's study of the way in which photographs, practices of archiving and dissemination became, in the nineteenth and twentieth centuries, a seminal form through which the city of Paris, its history and identity, came to be imagined and activated. She uses photographs as starting points, as historiographical and methodological indicators, for understanding the way that the history of the liberation of Paris, for instance, has been told, understood and archived. Clark uses photographic abundance as an enabling position in historical practice. The historian may, at times, be overwhelmed by the sheer number of photographs at her disposal. These range from the amorphous masses of vintage photo-postcards or little packets of anonymous enprints encountered in a flea market to the huge image files of newspaper archives such as the *Daily Herald* or the *Black Star* photo-agency,[11] not to mention the historical material scooped up by commercial concerns such as Getty Images. But this abundance is also a historical phenomenon that offers analytical possibilities. Indeed, to return to this fundamental point, for it cannot be overemphasized, in many cases the effect of photographs on our modes of historical imagination resides precisely in their abundance, ubiquity and scale of inscription.

The reproducibility of photographs and their easy circulation is at the heart of questions of abundance. I shall return to this question in Chapter 7 when I discuss materiality, but it needs flagging here because scale and abundance are facets of reproducibility and vice versa. The reproducible nature of photographs, their flow within expansive global image regimes, from colonial photography to international advertising, enables them to operate on a fully global scale – an abundance – while still holding the inscription at the micro level. The idea of material, visual and political economies structuring experience and forming conduits to the past is well

recognized by historians. There have been many studies grounded in the intermedial abundance of images, which range beyond the photographic to other media forms with their multiple analytical demands. Rich examples include Christopher Pinney's study of chromolithographs and photographs in Indian religion and politics, Karen Strassler's study of popular image forms and national modernities in Java, or Sadiah Qureshi's study of human zoos in nineteenth-century Britain; the latter study encompasses photographs, engravings, sheet music, typography and embodied spectacle.[12] The abundance of photographs is therefore not only contained by photographs themselves, they work within even greater abundances.

The energy of abundance is located in the sets of relationships which link together different scales of the past. For within abundance is, of course, scale, as I have defined it, created through the random micro-inscriptive propensities of photographs. It is to this that I turn now. Scale is located in the granular detail (an almost cartographic tracing) and excess of inscription that mark almost all photographs. As we have seen, this far exceeds the photographer's intent, the contexts of making or, indeed, the subject's perspective in the act of photography. Walter Benjamin famously described this as an 'unconscious optics' as 'photography reveals in this material physiognomic aspects of visual worlds which dwell on the smallest things, meaningful yet covert' through which history might reveal itself.[13] Going back to photographic metaphors in history, it was in the close-up of focused attention that Benjamin located his unconscious optics. In this, the smallest things reveal the scale of the past as a knowable entity. As we have also seen in the discussion of inscription and in the spatial aspects of distance, however banal and inconsequential the subject matter, the photograph frames the fleeting instant. The inscriptive detail of photographs, the frayed clothes, dirty fingernails – offer routes into the past which must surely have a profound impact on the scale on which history can be thought. A very eminent historian once asked me if I would prefer a photograph or a sound recording of Oliver Cromwell. He was astonished by my, possibly biased, desire for the photograph. But it was the hypothetical presence of the unconscious optical traces and thus what could be done with photographs that informed my response. They might seem slight on their own, but *en masse*, scale within abundance, such traces form links between the micro level and the shape and texture of an era.

Microhistorians have long experimented with scale, granularity and historical texture. But photographs insert the micro of the human scale into larger-scale histories on an unprecedented scale (meant literally and metaphorically here). Offering a different scale of historical engagement, photographs insert the telling detail that opens the imagination and informs

thinking about scale, say, global versus local histories, network flows versus individual experience, societal versus experiential dynamics. Moreover, they provide a continual reminder of human experience. It has been suggested that photographs are particularly efficacious in social histories because, as I noted in the last chapter, social history does not necessarily require temporal sequential analysis, one thing following another. Instead it resembles a series of snapshot-like, momentary stillness and focus in non-linear patterns. While again such characterizations of social history are a focus of debate (and indeed the use of photographic metaphors in such a context), I leave that to others, the coming together of scale and abundance results in a proliferation of the ordinary available to historians.

The scale and abundance of photographs adds not only texture to lives lived which can be worked through, analytically, in ways that merge micro accesses and macro questions. Going back to my discussion of distance, at the macro level, scale also adds perspective to formal linear structures as a way into broader questions of being and agency (which I return to in chapter 5). Such questions are central to social historians. For instance, Erika Hanna uses photographs as micro techniques for macro questions in her study of Ireland. She analyses snapshot albums so as to excavate the ways in which people mediated their understandings of larger entities such as nation, state or church within everyday life, or of work of power in the public sphere.[14] Similarly, at the micro level, scale provides a whole new layer of evidential, and thus analytical, possibility and one that is linked to the retrieval of subjectivities in ways that refuse historical reduction. This is demonstrated, for example, in the way in which historian Peter Andersson has used both abundance and scale to excavate the history of bodily gesture. He does this through the traces of, at best, semi-conscious behaviours and gesture, held in the incidental and random inscription of photographs.[15] Andersson uses this scale in abundance to explore comparative habitual body language and gesture, evidenced through repeated and massed inscriptions of, for instance, maid servants standing in doorways with folded arms or farmers at market standing with their thumbs stuck in their waistcoats. Often in the backgrounds or edges of photographs, these inscriptions pinpoint a social saliency of bodily deportment in ways that could not be retrieved and analysed through other means, say, the study of etiquette manuals alone. Both Hanna and Andersson are engaging with both the scale and abundance to substantiate their historical arguments.

It should be noted here, since it crops up in the literature so regularly and is one of the elements of photographic theory that does tend to wander into historical discussions, that the revelatory scale as used by Andersson

differs from Roland Barthes' much quoted notion of *punctum*. *Punctum*, for Barthes, is the random subjective piercing of the social and historical surface of the image by chance detail – a tied ribbon, a shoe buckle – which takes on a full force of subjective meaning.[16] But the scale of incisive detail, as discussed here, is not simply the subjective vertical incisions of *punctum*. For unlike the *punctum*, the scale of traces, as historians might unpick them, have an existence outside the readings of a particular viewer. They have an existence in close attention to evidence and the systematic excavation of detail on a new scale of registration and interrogation.

If such a position does not, then, align with the subjective incisions of *punctum*, nor does it collapse into an unproblematic positivism. Rather, such an approach allows for the analytical significance of apparently unimportant and minor details of scale and granularity to shape both the macro levels and inscribe individual experience. Further, it does so in a way that intersects critically with historical practices, historiographical categories, and the ways in which understandings and interpretations might emerge. This process of critically focused attention informed my methodological concept of 'critical forensics'. I was interested in two photographs of an encounter between the Royal Navy and a group of Melanesian men on a beach in what was then the New Hebrides (now Vanuatu) in 1884. Thinking through the scale and granularity of photographic inscription allowed me, as a historian, to see and think with inscriptions of fingers pressed into flesh, clean uniforms in the tropical heat and old boots slung round a neck, and ask what is the nature of this encounter beyond the meta-narratives of the colonial?[17] This project will keep cropping up as an example, because it was a formative one for me (one of the images appears as final one in this book, it feels like a fitting closure). Many of the ideas which form the basis of this whole book, especially around inscription, scale, time and presence, began to be worked out through the close reading and critical forensics demanded by those photographs taken on a Pacific beach in 1884. Scale is one of the active modalities that has shifted apprehension in historical focus, from events or happenings (I'll come back to this in the next chapter), to the social and cultural textures of experience. By stabilizing the micro level within the macro scale, photographs raise, insistently, an important question of wider historical debate: at what levels does historical significance reside, what kinds of fugitive histories might emerge? For, as we have seen, photographs suggest entirely new historical structural forms. Through them, structures that were previously invisible – a Melanesian experience of colonial encounter for instance, come to the surface. All photographs demand that historians do more than just look at them. They require a systematic engagement that produces not only evidence but critical think-spaces.

However, if there are productive possibilities, there are also, I think, dangers. Anxieties relating the micro-level scale of photographic evidence as historical sources within the conditions of abundance, creep back in. In addressing abundance and patterning, are we in danger of losing the very thing photographs do so well – the small scale, the fine grain of historical experience, the disruptive detail? Anxiety about excess also creeps back. In the face of both abundance and scale, and their apparent unmanageability and ubiquity, the problem isn't only a sense of there being too much 'stuff', but rather that we cease to ask questions of photographs in the way we would for other sources, and just wallow in the detail of the surface. Moreover, there is also an anxiety over what kinds of history are being created by this 'surface', and its validity and significance in the wider field. The persistence of fragment reinforces the association of scale and detail with specific forms of history-making, often those falling outside the academic remit. It is as if the valorization of photographic scale marks a certain kind of history, that of an individualized and atomized sense of the past, in which photographs yield up only affective fragments, thus making their claims to wider historical questions look dubious.

An example of these two facets of scale and abundance in action in producing historical imagination is in relation to modes of commemoration, themselves a focus for historical analysis.[18] Photographs disturb the relationship between an excess of memory and what might be assumed as the natural processes of time slipping by. Arguably the excess of memory that marks public commemoration is manifested through an abundance of photographs, the excess of photographic inscription and the scales of engagement which they elicit. An excellent example is the public commemoration and memorialization of the First World War between 2014 and 2018. This was, to a substantial extent, photographically driven and photographically saturated, as photographs, variously, filled shrines in parish churches, decorated war memorials, were knitted or crocheted into poppies, adorned railway carriages, filled television documentaries and were turned into art works.

This potential, that straddles popular commemoration and historical thinking, is also demonstrated by a series of photographs I had worked with, of Norfolk rural workers photographed in formal studio style in their new uniforms as they headed off to the First World War. These photographs, held in the public library in Norwich and made available online, became an active part of such commemorations. Thinking through the inscription of their large sun-burnt hands, battered nails, and pale white skin above their wrists, shifted the potential historical and experiential knowledge of

recruitment and troop management, of changes of status, of concepts of masculinity and a host of other questions. Yes, we can ask those questions without photographs, but the existence of photographs complicates and expands channels of interpretation. It was abundance and scale that enabled such historical engagement and expanded the historical imagination. The enormity of the First World War as an event became, in part, performed by the abundance of photographic traces. Scale not only individualized, but thickened the empirical base of analytical and interpretative histories. Scale and abundance created productive tensions between forms of commemoration, memorialization and historical practice, because photographs gave the appearance of multiple valid histories, and, here, underpinned commemoration which vacillated between the individual and atomized, the national and collective, the empirical and interpretative.

I would argue that anxieties, such as I have flagged, are located in a restricted concept of what photographs can do historiographically and the productive disturbances they might cause. Photographic intervention in historical imagination is, on the one hand, the result of an expansiveness of feeling and subjectivity in relation to the past, while on the other hand, it offers a conduit into other scales of historical thinking. The tension and fluidity that shape the photograph's claim to historical efficacy lies within the relationships between scale and abundance and historiographical responses to them, for historical understandings are not necessarily tied to one scale or another. Like other sources and other methodologies, scale and abundance come to work through established practices of source criticism and historiographical framing. It is necessary to be alert to these tensions and potential points of fracture. The excessive potential of photographs enables history to be imagined on different scales and provides the possibility of a thickening of historical description. The incisions that scale offers, as Paul Ricouer has noted (in the context of microhistorical technique), are the new interconnections, as he argues 'what becomes visible are not the same interconnections, but rather connections that remained unperceived on the macrohistorical scale'.[19] In this immediacy, photography offers not only the minutiae of scale in its random inclusivity but also affective and ideological proximity that shifts the scale of historical attention and disturbs traditional hierarchies of significance.[20]

It remains, however, that a wider generality of the past is seldom addressed by photographs unless they are forced to do so by an overwhelming use context (see Chapter 6). But this does not mean that they are hostages to scale. They mediate between macro and micro levels, forming crucial players in addressing the flattening effects of larger historical distance. The functions

of scale and abundance are important because they enable historical sensitivities and sensibility that go beyond what photographs show as sources, to reach into possibilities that other sources seldom reach, such as the habits of gesture in the past or the calloused hands of ploughboys. Certainly other sources, such as diaries or letters, have their own particular reaches, and they offer different forms of scale. But photographs shift historical perceptions precisely because they are abundant in both my senses, saturating a sense of the past, contributing a refiguration of thinking and scale to incalculable effect. In their abundance, photographs are always entangled with scale, constant reminders of the scales of experience that make up history. In scale, photographs reveal their own distinctive historical contribution. This characteristic comes into play in my next essay on event.

Scale and abundance are not simply about piling up details but creating a historiographical think-space where they can reveal and activate specific ways of having been in the world. After all, abundance and scale are conditions of the knowable world, and thus the stuff of history. They perhaps present both an awareness and tolerance of the obscure, incomplete and unconsidered, and its challenge to the authority and coherence of a field of study. The challenge, I think, is how we balance the disruptive potential of close readings of scale through a critical forensic, with the equally disruptive potential of 'distant reading' in the patternings of abundance. In this balance is also the noise of unimaginable, unmanageable, almost apocalyptic, abundance of the digital world where abundance offers the promise to illuminate and obscure, that 'of complete visibility and transparency, whether joyfully embraced or worryingly defied'.[21] The richness of photographs as historical sources is in their plenitude, but the abundance of their detail not simply as information and inventory, but as a series of fractures to think with. They are an active part of the orchestration of the shifts from general to particular and back again which marks all historical endeavour. If abundance necessarily delineates a historical landscape, photographs offer a certain kind of fine-grained and serendipitous scale of closeness, an immediacy that not only challenges disciplinary senses of historical distance but challenges the scale and shape of historical thinking itself. That is, and always has been, the challenge and dilemma of photographs.

Perhaps the insistent presence of photographs is an unwelcome reminder how little of the past has been 'seen' by historians, about what lies beyond. Through scale, the presence of photographs maybe points subliminally to the edges of practice and knowledge. A reverse concern is that detail of scale (fragments of atomized past) might threaten representational totalities of account: hence the confusing and anxiety-producing propensities of scale and abundance. However, as Clifford

Geertz noted of micro scales, they give 'a sensible actuality that makes it possible to think not only realistically and concretely about them, but ... creatively with them'.[22] So while historians should, of course, be wary of seduction by scale and abundance, they can also embrace a form of historiographical promise held out by photographs. The promise of alternatives is created through the long reach of molecular scales of the past. They act as correctives to assumptions, and as connections to different pulses. Small signs become historical wonders that arrest us and stimulate questions. Scale matters historiographically, and it has an inclusiveness and long reach.

4

Event

Events can be drawn from many levels, go in divergent directions, recognize different time scales, and crisscross one another. Events do not generate the narrative, but events are selected to cohere to story lines, frameworks or plots that result in intelligible narratives. Selection is crucial here, because events may either be restricted in number or almost infinite.[1]

Event has an almost infinite range of possibilities within history. Everything in history depends on the fact that this or that happened and happened to somebody, good, bad and indifferent. However, event has been a highly contested field, entangled with critical questions of narrative, emplotment, or *durée* for instance, and in debates about 'the past' as opposed to translational acts of history writing upon that past. Likewise, there has been extensive debate about what an event is, what is merely a fact, and under what conditions might facts become recognized as events. Although challenged by experimental and deep histories for instance, events, definable things that happened, have been key building blocks of historical study and the construction of its narratives, even if they are not articulated as such. Events of various sorts and scales have become hinge moments on which accounts are often hung, whether conflict or political change – such as landslide elections, or the emergence of specific projects as disparate as nationalization or the photographic surveying of the peoples of India. In other instances, they are barely more than occurrences, not really events at all. As ethnohistorian Raymond Fogelson notes, quoted above, this involves layers, directions, scales and lines of emplotment. These levels, layers and lines form the crucial underpinnings of my consideration of the work of photographs in these processes, and the ways in which photographs make these processes palpable. As I hope will become clear, and again the leitmotif of this book, photographs do not respect the parameters of 'event' or of 'fact' as imagined in such debates. They do things differently.

What constitutes an event though? Event is a commonplace that has attracted a sizable and complex theoretical and philosophical literature which serves as an undercurrent here.[2] Ideas of event have also bled into politics and

its history, again a field where photographs are active. Event is constructed by the very practice of history and its categories. It registers happenings, reproduces and translates them. It endows them with significance and coheres plot lines, whether we are talking about Waterloo, Peterloo or Ypres. It is something of a commonplace now that photographs, or pictures more generally, create and solidify events. However, my concern here is not only how photographs make events as acts of mass communication and pictorial intervention but also, and in particular, one in which the very nature and presence of photographs blurs the boundaries of events, occurrences and facts. This is because the existence of photographs accentuates, pushes into visibility, and disturbs the temporal assumptions that event comprises a discrete comprehensible, even graspable, happening within the flow of time. Events are both markers of time and markers in time. Events come into historical effect as they posit a state of affairs or account for new states of affairs. Articulated through the language of historians at work they become 'events'.[3] Photographs act in exactly the same way but visually. But as I shall discuss, photographs, visible occurrences, vastly expand the range, and confuse the levels of what might be broadly defined as events and their temporal character.

Event brings together the strands I have considered thus far – inscription, distance and scale and abundance, all of which manifest themselves in this very concrete, yet theoretically complex, practice of history. I am conscious that I am reifying event here, but this helps us see what photographs are doing in historical practice. Much that is thrust into historical visibility by photographs might indeed be perceived more as happening or occurrence. If scale, as discussed in the previous chapter, establishes the visible detail, granularity and molecular structure of the past, event is concerned with the impact and conditions of that visibility within the credible narratives and analyses that constitute history as a practice. Photographs endow happenings, occurrences and events with significance. Grounded again in the random inclusiveness of photographs and their sparks of contingency, this essay could be said to cut scale in a different way. It addresses the way in which photographic scale translates an indeterminate past into the appearance of a discrete happening as an apprehensible unit– what might be called an event. Further, in many instances, the identity of an event is aided and abetted by the circulation of photographs and its impression on the historical imagination. Photographs endow an event with a form of familiarity, this will be a recurring theme here. These processes function both as an actuality and as positioning of an event through which generic plots might be structured. For instance, war, famine or migration, as generic plot structures, are established in part by the ways in which photographs, such as those Biafran or Vietnam wars by

Don McCullin or the Somalian famine of 1992 by James Nachtwa
on the imagination as plot markers of those and comparable events.

The potential of photographs as inscriptions and translations of events is, as I've said, rooted in questions of scale and time. However banal and inconsequential the subject matter, the photograph frames the fleeting instant: it heightens, projects, performs, and pushes into significance and analytical possibility. Even if often unarticulated, what photographs might do becomes absorbed as an unconscious knowledge in historical practice. This is the site of their disturbance, because photographs demand that events or happenings or occurrences – at whatever scale or level we want to think about them – are reconceptualized historiographically, because they offer different and particular forms of apprehension and cohesion. In relation to event, photographs, yet again, stand for both that tolerance of the obscure and incomplete, and that challenge to authority that I noted in the last chapter.

Conventionally, events are historical facts temporally located within the flow of time, but not all historical facts are necessarily events. But I suggest here that the nature and presence of photographs in the historical landscape has both blurred and mediated this distinction and its temporal location. It has been suggested that the emerging photographically minded world of the mid-nineteenth century was also 'the era ... of revolutions, contestation, assault and explosion'.[4] This is an intriguing thought because it suggests a temporal impatience and a sense of the episodic as a burst of energy. It aligns precisely with the ways in which, as we have seen, photographs intervene in time, holding the fragment and the episodic to work across time, rather than an unfolding, linear sense of uninterrupted and gradually maturing passage of time. The implication here is that photographs disturb the relationship between the different levels of reality and time from which the idea of an event emerges. They also, through their random inclusiveness, vastly expand the range of traces that might both constitute and inform a sequence of events – a narrative.

However, photographs not only challenge the sense of event, in inscriptive terms, nor do they simply provide happenings to be grouped as an intelligible narrative. They also constitute the very happening itself. Certainly photographs are made *of* events – of what are recognized in the collective memory as events – photographs of treaty signings, demonstrations, parades, occupations, dole queues for instance. But photographs, and their mediation and circulation, create the event and are part of that event as it is conceptualized. However, there is slippage between the 'photograph of' and the 'photograph as' in the theoretical literature. A lot of theory of event emerged, for example, from the political and civil disturbances in Paris of May 1968 and the rupture that they represented. The presence of the extensive photographic record marked

the coming-into-being of this 'event', and the ways it could be understood in multiple terms. It helped position deep underlying structure, a patterning within the clear visibility of event and matters of the moment. Such conditions of visibility and event also demonstrate, perhaps, one of the routes through which historical re-evaluations of the idea of event assert themselves, especially in the late twentieth century. One is tempted to ask how much of this refigured and reconsidered sense of scale (for that is what it is) and recognition is due to a broad photographic-mindedness and the atmosphere of photographic presence which impressed that sense of the moment so forcibly on historical imagination. So, I come back to my main consideration – what are the implications for the idea of event in a photo-saturated historical world?

Photographs are at one level antithetical to traditional narrative structures of event. Event suggests a linear time marked by recognizable and retrievable moments – that 'one damned thing after another' as someone was meant to have said when describing history (it is variously attributed). The fragmenting propensities of photographs lack context, except for that attributed by the historian, they are short quotations that do not necessarily join up. They are visual incisions without narrative links. Indeed, some would argue that the single image works against the temporality of events, that they are merely facts and 'of' the past. I find this rather unhelpful because this is exactly where photographs, with their translational power and temporal fluidity, disturb the distinction. They contest the assumed identification of event, happening or significance, by holding the atomic structure of time, occurrence and experience clearly in place. They give the appearance of stability to the moment. Yet they are also temporally dynamic as we saw in Chapter 2. Consequently, the challenge is how these fleeting moments that give the look of event, might be mapped onto narrative lines and wider significances: how can we, as historian Alan Trachtenberg put it, 'make random, fragmentary, and accidental details of everyday existence meaningful without loss of the details themselves, without sacrifice of concrete particulars on the altar of abstraction'?[5] Perhaps one way forward is to re-conceptualize photographs as small event-like moments at play within the historical endeavour, ones that infiltrate concepts of event and its temporal assumptions at all levels. As we have seen, photographs compress and implode time. They offer the possibilities of apparent temporal co-existences, fragmentations and openings, that do not sit happily with the linearities and narratives in which events, as commonly construed, tend to function.

The past is largely apprehended as 'things that happen', major, minor and everyday. They happen in a specific time and place that is separated from the infinity of circumstance.[6] Events are happenings and occurrences understood to be outside the ordinary flow of experience, from wars to royal weddings,

and which are warranted significant enough, by some measure or other, to have a visible and comprehensible place in collective memory and narratives of time and place. My argument here is that photographs play a major role in those attributions and definitions of significance, to the extent that they have redefined the concept of what an event might be. Historical events do not, of course, exist outside their inscription; they get trapped through inscription, whether by text, painting or photograph or even oral memory. So, photographs are part of a series of propositions about what might be taken seriously, and be considered as historically significant. A famous example in the annals of historiographical debate about the difference between event and fact (and mediated by scale) is that of a gingerbread seller kicked to death at Stalybridge Wakes in 1850. Is this a fact or an event and under what conditions?[7] In this case, it has arguably become an event through the force of its presence in historiographical debate. Be that as it may, I would ask what would we think of its status had there been a photograph of it? How would we handle it, how would we make our assessment? And as an aside, though far from a modern sense of reportage, occurring in 1850, the fact/event is on the cusp of an emerging photo-mindedness and shifts in knowability, as photographs start to make occurrences morph into the appearance of events. One thinks here of the daguerreotype photograph of the Chartist meeting on Kennington Common, south London, on April 10 1848. The sense of photographic reach into major events of the 1840s, the mass presence gathered on that day and its spatial dynamics inscribed through photographic scale, have made forceful its impression on the historical imagination.[8]

The point I'm making is that photographs muddy the representational and historiographical distinction between fact and event. Photographs are consequently not passive sources, but make demands of the historian. They present moments to be taken seriously, not necessarily in their weight or 'importance', but because they trace moments that existed and were experienced (something I'll come back to in the next essay), and therefore demand historical recognition and engagement. A sense of photographic definition remains, even when the texts that begin to accrue around facts and happenings, begin to do their own work of interpretation and translation. The cumulative photographs of the signing of the Treaty of Versailles in 1919, for example, give us a pretty good idea of what the event looked like, how the spatial dynamics worked, despite being enmeshed in a multitude of historical interpretations. They are obviously not an unmediated window on the world, but they are a fair translation of the event that demands attention.

This process of inscription, time and moment, seems to accord with the idea of event as, as Alain Badiou puts it, is 'something that brings to light a possibility that was invisible or even unthinkable' – a form of historiographical

'becoming'. Badiou terms this process an 'evental site', which is constituted by multiple elements of limitless possibilities, and which create a 'historical situation', whether this is the experience of rank and file troops in the First World War, or the repetitive habits of the everyday inscribed within photographs.[9] Seen in this light we could consider photographs as forms of 'evental site', because they are similarly constituted through multiples of time and historical potential in a situation that is entirely singular – it happened. They bring to light. In framing and constituting the visible entities of the past, photographs bring event-ness to the surface and hold it as a site of possible historical meaning. They are therefore part of the process by which moments become facts, become events, become history and through which they build intensity. It is a version of Susan Crane's observation: 'Nothing was happening, then something happened that was worth noticing so it got remembered and we call it History.'[10]

This is disruptive because photographs, through the nature of their inscription and attendant questions of scale and their fragmentation of time and space, endow transitory and ordinary moments with the look and behaviours of events. As we saw in the discussion of scale, an inexhaustible number of realities and truths, 'separate grain-like elements' and 'staccato structures',[11] come to the surface and to analytical visibility. In this, photographs change the rhythm of the past, they destabilize the scale of historical attention which informs what has been conventionally thought of as historically significant. This is indeed challenging, because it demands thinking in a different way. I have already noted the co-temporalities of the existence of photographs and the rise of social, cultural and microhistories as scales and dynamics of thinking.

Further, the existential recurrence provided by photographs means that they are equally able to maintain a historical pulse of significance over a long period, and through cyclical, plural and multilayered unfoldings of time, and across geographical space. One sees this at work in the tenacity of certain photographic events, for example, of the Jarrow Marches, of the Second World War, or of the arrival of SS Windrush, in which photographs are part of their long reach as events. It has been argued that social history itself is more like photography, in that it is not driven forward by the more filmic flow of events, as is the case in political history for instance. While this might well be another of those uncomprehending photographic metaphors that lurk within the practice of history, the point remains that such a view overlooks the crucial elevation through which the photograph creates a discrete entity with multiple dynamic temporal pulses. That elevation marks photographs as potentially highly active in the attribution of historical significance and the notion of event as a discrete comprehensible unit of the past.

For a moment I want to shift to photographs *of* events. The idea of an eye-witness of events, and of history itself, has often been attached to photographs. Photographs are now familiar accompaniments to events, providing both authenticity and immediacy – how many times have we seen photographs or film and been told this is 'history in the making'? Like photographs, eye-witnesses work from within events: they were there. Like eye-witnesses, photographs are always partial in both senses of the word, in that they can never give a full account (what historical source can?) and they carry a point of view (which all historical sources do). But they both have the force of immediacy and closeness. Although we all know that photographs are not unmediated windows onto past worlds, they nonetheless carry an authority, a cognitive advantage that speaks to the truth of their event. Photojournalism, with its traditional involvement with major 'stories' such as conflicts, revolutions and famines, has been referred to as the first draft of history. The attribution of such an authority to photojournalism, and indeed other forms of reportage and documentary, is interesting because, while arguably most forms of photography (family snaps for instance) are also legitimate drafts, it is photojournalism that is understood to align with what are traditionally recognized as events in historiographical terms. As many commentators have noted, this is to the extent that world events, such as the Great Depression of the 1930s or Vietnam War, become, in the historical imagination, a sum of their photographs – hence my question about the Second World War to my undergraduates noted earlier.

It has become hard to name a modern historical event that is not touched, mediated or defined in some way by photographs and other technical media. Their temporal attestation is so powerful that, from the nineteenth century, and certainly by the twentieth century, an event becomes increasingly defined as something that exists photographically. Indeed, lack of photographic authentication can render an event questionable. One sees this, in extreme form, in the way the denial of photographic evidence is a recurrent theme of Holocaust deniers – deny the photographs, deny the event. Conversely, historian George Emeka Agbo, discussing the image practices around Boko Haram activities in Nigeria, has pointed to the ways in which the circulation and performance of digital photographs forms an integral and powerful 'mythomania'. This enables images to be dismissed evidentially as 'staged representations', yet allows them to act as perpetrators and perpetuators of violence.[12] At stake here is not merely a historiographical sensitivity, but the significance of photographic inscription as it intersects with the concept of event in the politics of historical truth.

As Agbo's argument suggests, the reproducibility and repetition offered by photographs becomes part of the evidential rhetoric of event, as photographic

inscription indicates what can be clustered around a moment or happening and under what conditions. But in historical practice photographic authentication too often tends to collapse into the illustrative – the signing of this or that peace treaty, the meeting of these heads of state, the progress of this, that or the other war – despite the clearly performative propensities, even intentions, of the photographs to make the event. Photographs thus become both confirmatory and constructive. They are themselves events. Politicians' predilection for the 'photo-opportunity' and the restless quest for photographs of 'news' as 'history-in-the-making', betrays this historical consolidation only too well.

Daniel Boorstin, many years ago, talked about what he terms 'pseudo-event' in that it has an ambiguous relationship with underlying realities. Like the photo-opportunity, pseudo-event is not the product of 'natural' lived and experienced time but a synthetic construction, or at least manipulation and performance, of time and of evental sites.[13] Photographs endow pseudo-events with their apparent validity, translating and expanding them into terms that appear to be extracts from the natural flow of time. But, whatever truth value we want to ascribe to such photographs, it remains that such pseudo-events are historically analysable, through their photographs, as integral parts of the photographic matrix of a given past or event. An example is the famous photo-opportunity of Margaret Thatcher in September 1986, begoggled in the turret of a Challenger tank in Germany. Despite being temporally contrived as an event, the resulting photographs are believed to have acted as a key moment in her campaign for re-election. As such they have analytical weight. Consequently, regardless of the nature of an event, photographs shift the expectations that cluster around event dynamics, and formulate the landscapes of both historical imagination and historical analysis.

I want to turn now, in more detail, to the ways in which the scale, and the fragments of time and space which characterize photographs, come into play here. As I have suggested, photographs inscribe differently from other sources, refiguring the ways in which we might recognize an event as something that happened in the past around which values cluster. It has been argued that there is 'threshold of fragmentation' below which event dissolves,[14] that is, a point at which the links and networks of connection that cohere an event are lost or invisible. The resulting fragments are seen to languish as mere anecdotes – 'facts' – void of narrative dynamic. In some ways this echoes critical accusations laid at photography's door. It risks, as we've seen already, collapsing into uncontrollable and ultimately meaningless detail that photographs present uninterpretable surfeits and excesses. As such, the inscriptive contingency of detail in photographs perhaps threatens the

representational coherence, and thus definition, of event that the historian might desire. We have seen this shape of objection before in relation to inscription and scale. But again, as an increasing number of historians have shown, such a position overlooks the dynamic possibilities that photographs enable.

Photographs facilitate a shift in the emphasis of event construction. They move it from something exterior by which the procedures of historical practice or collective memory endow significance in a broader narrative, to something interior, coming from the mode of inscription itself. This is my recurrent question – what kind of histories might emerge from the image itself? The sense of 'interior' is grounded in the unnoticed detail and the individual presences in relation to event. This is a very different historiographical dynamic from that of exteriority. Rather interiority points directly to the experience that somebody lived through, to something that happened. In such ways, photographs provide structural feeds into new or more experimental forms of history production. An example is, again, Margaret Hillenbrand's study of China as she explores the tensions and image mediations between practices of disavowal, managed memory and reproduction around the evental quality of the Nanjing Massacre of 1937/38. I shall return to this idea of experience in my discussion of presence in the next chapter, but just for now, we need to hold the idea as something active within the photographic disturbance of event. This is because, to return to this point, photographs push an instant, an experience and mundane happening over the threshold of historical visibility, recognition and thus engagement.

As I have argued, photographs endow these fleeting and mundane moments with the look of event or happening, as the trace is inscribed, without hierarchy, within the image. The spatial and temporal character of inscription and scale is intensified within the frame, emphasizing the discrete moment, be they engaged with as happening, occurrence or event. Photographs push them forward, demanding attention. So if we see an event as happening in a specific time and place, and as a moment separated from the infinity of circumstance, photographs still that infinity, causing the separation on which the idea of event depends. As I have also noted, photographs excel at description, precision, detail, and the episodic. They are less good, in event terms, at duration and narrative. But crucially, the duration offered by photographs is that of imagination. Photographs, and their performances, imprint that sense of actuality of events onto the mind, they commit them to memory, and give an event duration and longevity within a historical imagination. This is a particular disturbance as photographs create a vital and expanded evental site across multiple temporalities.

In another analytical twist, and in an attempt to frame histories which are not event-driven but that emerge from different intensities of the evental, Raymond Fogelson, with whom I began, has described such moments as non-events. Non-events are not pseudo-events, in that they are marked by natural pulses of time and experience rather than synthetic construction. The idea of non-event, which Fogelson borrows from physics, is a counterfactual to event that nonetheless leaves causal traces. Translated, probably much mangled, into historiography, the concept is useful because it would seem to provide a productive think-space through which to describe so much of what photographs do, as inscriptions and, in particular, their relation to ideas of event. In quantum physics non-events far exceed events, just as they do in the flow of time. Non-events account for things that don't happen in any discrete way but which are simultaneously meaningful – here the banal and everyday absorbed undefined within experience and within different temporal pulses. Stilled and elevated through the photographic frame, they become, as we have seen, nodes for historical consideration. They give shape to happenings that otherwise have 'no properties, physical or otherwise: it is a null or non-event' yet they leave traces.[15] Even if their inscriptions, like non-events, are deemed weak values in terms of significance within the historical universe, they nonetheless leave a historical effect as minimal units of historical analysis, as they translate and shift the perceptible moment between the 'unoccurred' and the occurred.[16]

In terms of history, the photograph is thus a vital and very persuasive part of the translational processes from non-event, the unnoticed and apparently inconsequential, narrative counterfactual, to event – from nothing to something. Indeed, arguably photographs obliterate, or at least confuse, the distinction. In their immediacy of inscription and scale of attention, photographs offer not only the minutiae of scale as 'event' but an affective and ideological proximity that disturbs traditional hierarchies of significance and thus event. At the same time the inscriptive propensities of photographs stabilize events in very particular ways. They retain the unique character of a given event; it was there, it happened.

As I have noted, it is no coincidence that the expansion of legitimate historical focus and the contemporary historical fascination with experience and the everyday happens in the photographic age. Photographs form links between the event of the everyday and the shape of epoch. As I discussed in relation to scale, the existence of photographs has, unacknowledged, shifted the scale and dynamic of the concept of historical happening. It reveals the connections that remained unperceived on the macro-historical scale. The events, small events, occurrences, non-events that shaped individual and community lives are suddenly all around us, as historical detritus forces itself

upon us. Defined in the way I have discussed them here, all photographs become events in the historiographical sense, because, as I have noted, they bestow the appearance of completeness and coherence of experience.

There is a rather odd corollary to all this, and one that I touched on in relation to the denial of event. While obviously, events exist outside the photograph (though decreasingly so in a digitally saturated image world), there is a strange, even anachronistic, desire for photographic confirmation of an event or happening. I am told that people who do family history research commercially can charge extra if they find a photograph. In popular domains, even quite serious ones, photographs are increasingly projected into the memory of an event, even when spurious and ridiculously anachronistic. Photographs become part of the imagination of an event. The desire for them represents a desire for the confirmation and authenticity of historical fact. But such a requirement of historical authenticity is that of an imagined actuality rather than an historical 'factuality' itself. This is demonstrated by the increasing tendency, at least in the popular domain, for an account of an event or historical figure to be accompanied not by, for instance, an engraving or contemporary object, but by a photograph/film still of a media imagining of that event. Henry VIII seems particularly prone to this, as do the D-Day landings, even though there are contemporary photographs of the latter available, and the painter Hans Holbein the Younger did a good, or at least convincing, job on the former.

At one level this is merely an amusing anachronism, temporal slippage or even lazy picture research, that nobody would take seriously as historical evidence. Yet there are even echoes of such photographic consolidation and authentication of event in academic history writing. Photographs, including digitally coloured ones, are used on historians' book covers without a murmur, and appear in their pages as generic markers of the authenticity of event, even though photographs might play no part in their evidence or argument. Conversely though, there are also important instances where such temporal slippages in the representation of event become markers of the conceptual framing of an analysis. An example is Krista Thompson's compelling study of the implications of the anachronistic use of photographs in histories of enslavement. Here photographs, despite their anachronism in strict terms of periodization, stand for the longevity and legacies of the assumptions that cluster round histories of enslavement and the historical imagination that they inform. The photographs are very much outside the event, but still of it.[17]

However, such creative historiographical interventions are few and far between. What is evident here is a complex and mutually reinforcing discourse around event, historical apprehension and photographs. This

might seem like sleight of hand, but it brings us back to my original question – what are photographs doing to the practice of history, what sensibilities (rather than methods) are in play, and how do they relate to questions of historical distance and the desire for intimacy and connection? Photographs purport to make this achievable. They mark events and happenings as memorable, both collectively and personally, as the photographically saturated commemorations of the First World War showed. Such examples point to the infiltration and naturalization of photographs into the historical imagination, into the construction and definition of events, and even into the credibility of events in the broader field. As Hayden White noted, photographs blur 'the very distinction between "historical" facts on the one side and non-historical ("natural" facts, for example) on the other, a distinction without which a specifically historical kind of knowledge would be unthinkable'.[18]

Overall, in giving a visibility to happenings, photography's inscriptive and temporal character align it with that of the event.[19] If event or happening are the skeletal structure and pulse of history, then photographs are likewise the skeletal structure of history – the very physiognomy of historical thought with which I started this book. But one could turn this around and ask what are the implications for ideas of event in a photographically saturated historical world?

There are, as I have suggested, two pulses to the photograph's relation with event. First, the concretization and recording of a happening that already has significance attributed to it, the fall of the Berlin Wall for example. Second, the banal, everyday and unrecognized are stilled and forced into possible significance. Some might argue that these latter are merely the inscription of facts, not events at all. But as we have seen, through the fragmenting, heightening and equivalence given by the photographic inscription, all such 'facts' have the resonance of event. They behave as if they were events and perhaps, as such, become so. Pegging out the washing and signing a peace treaty are inscribed in exactly the same ways. Mapped across the picture plane, they simply leave a different shape of marks on their surfaces. In inscriptive terms, differentiation is in the mind of the historian ascribing values to the content of the photograph. If photographs provide the 'look of event', they do so as discrete and dynamic entities that invite historical engagement. I am not saying that, despite their seductive claims, all photographs are necessarily events in the traditional, and even the theorized, understanding, nor is this a claim for an unsustainable evental relativism. Rather, I am suggesting that photographs should be thought through in terms of how they might structure event, and thus historical responses to it, at all levels.

If one defines an event as a happening significant enough to attract attention, and be a focus for historical substance and historical contemplation,

photographs offer historians the appearance of an analysable unit. They muddy the already fluid boundaries and relationships of fact and event. Consequently, they have a profound role to play in the constitution of event and historical possibility, because they point to what might be, historically speaking. By refiguring the potential of moments, they change the modal possibilities of the past, thus my suggestion, following Badiou, that event itself brings historical possibility to light.

As we have seen with the other commonplace strands discussed, photographs disturb assumed historiographical relations and open up the analytical field because they create events, and stabilize non-events as moments of attention and foci for analysis. By their nature they blur the distinction between fact and event, and become 'evental' sites of possibility, of coming into light. They create events not only self-consciously through the documentation of, for instance photojournalism, but also inadvertently through their random inclusiveness, their stillness, the containment and focus of their frames. They translate temporal flow and moment into fixed sites for historical recognition and the attribution of significance. Photographs shape a moment and project it into the future. In event we see 'there-then' becoming 'here-now' at work with greatest force and lucidity. But more especially, photographs rescue the failures and experiments of human experience that never became 'proper' historical events, the non-events that were not fully realized, and thus were not understood to have been possible, or to have 'happened'. In disturbing the relationship between facts and events, photographs enable more inclusive readings of event because they connect to larger patterns. Photographs push facts and happenings along. Moreover, in relation to event, they have perhaps become a democracy of time and memory. The existence of photographs expands the prism through which a given event is both comprehensible and explicable, and adds others to its matrix of historical plots, story lines and intelligible narratives.

Presence

Photographs compel viewers to think of lived experience, time and history from the standpoint that is truly a stand point: a place to think about occurrences that may fail, violently, to be fully experienced and so integrated into larger patterns ... The scene depicted was, not merely an occurrence, but an experience that someone lived through.[1]

Presence, and the modes of making the past legible in the present, are foundational concepts of history. Historians, by their very actions, aim to conjure up a sense of the past as an explicable entity that has presence. There are two ways in which the concept of presence works at the interface between historical practice and photographs. First is the way in which photographs project the past into the present, the 'there-then-here-now' as I discussed in earlier chapters. Second, is another more conceptual, even ethereal, meaning which is my focus here: that is the way in which photographs hold the presence of historical actors, not merely as physical traces, but in holding their very presence, their social being, and the experiences they lived through – that it happened to them. Photographs become, in this thinking, not simply 'representations' of the past or bearers of surface facts, but rather bearers of 'being' and attendant subjectivities. Photographs, I shall argue, inject a particular form of presence into the historical landscape – those of standpoint and experience. This is crucial to what follows.

The idea of presence rests on the premise that photographs might hold a moment, or aspects of a moment, that was experienced by its subject, either consciously or unconsciously. In ways that connect to my discussion of event and non-event, defined and non-defined experiences, the simply 'being there' has the potential to illuminate any attempt to gain a historical grasp of that experience. This again aligns with recent historiographical trends towards new affective and subjectivist histories. Thinking through the concept of presence not only intersects with established commonplaces of historical analysis, namely subjectivity and agency, it also aligns and contributes to its complication and refiguration in recent years in both history and anthropology. There is now a massive literature on photography, history and

subjectivity across diverse fields, from gender studies to postcolonial studies, to those on modernity and personhood, for example. Photographs are replete with subjectivities and agencies at work within the triangulated relationship of the photographer, the photographed and the viewer, and these are tracked through the literature in the field. In nineteenth-century studio portraits, for example, even very modest ones, the subject performs a little theatre of self for the camera, mediated through social norms and expectations which are expressed and translated through the person of the photographer and the act of photography. Likewise, agency is part of the diffractive and overlapping landscapes of photographic and social action in the ways that subjects might shape events and experiences.

Agency, a concept located in Enlightenment notions of the individual, assumes individual capacity to act within specific social and cultural situations. However, presence as a concept goes further because it is linked to social being itself, the unarticulated cultural forces that make people who they are. Importantly, in this thinking, photographs carry a form of presence, that of a sentient, social being that reaches beyond 'agency' in its classic formulations, in ways that aligns itself with questions of 'lived experience'. Importantly, presence reaches also into spaces of powerlessness such as prison photographs, or ID card photographs, where 'agency', understood as that potential of self-determination, is perhaps severely curtailed. Consequently, if photographs are to realize their interpretative potentials in historical practice, we need to rethink some of those analytical categories, de-reifying agency and subjectivity, destabilizing monolithic theories of the gaze, which act as containing contexts (more of those in the next chapter). While the latter approaches, of course, have their place, applied as analytical norms and naturalized categories they risk channelling the debate into very specific constraints, resulting in a reduction in our possible comprehension of the past life-worlds of people.

Thus, although subjectivity, agency and affect, have their own specific theoretical demands and dialects of debate, here I am clustering and reformulating these historical modalities as 'presence', because presence stands for a matrix of experience, embodiment, standpoint and emotion. In relation to photographs, these possibilities emerge from the random inclusivity of inscription, scale and abundance, which, as we have seen, have the potential to shift historical pulses. Presence, as a concept at the intersection of photographs and historical practice, allows us to productively retool subjectivity and agency as analytical concepts.

Presence is a term that has emerged as an increasingly important concept in the theory of history itself, one which has migrated from philosophy and through intellectual history. The political climate of later twentieth and early

twenty-first centuries has allowed historians to pursue closer emotional and perhaps ideological identity with actants. Such analytical attention marks a broad move away, in historical interpretation, from linguistic and constructivist ideas of historical meaning, to histories that, as noted constantly, are concerned not only with what happened but how it was experienced – what it felt like to be there. Such histories also claim to offer a return to the real, and address oral histories, life-writing work, material culture and visual materials for instance, in ways that resist historical reduction. The role of photographs in such trends is important. Their reality effects inflect the return to the real, immediate, visceral and to affective relations with the past. Again, it is that ontological scream of the medium – 'it was there'. But in my argument here, what is 'there' is presence. Presence offers a different conceptual level through which personhood, identity and experience, all goals of the new historiographies, can be brought to the conceptual and analytical surface.

At this point it is worth reiterating, just in case anyone is in any doubt, that presence as a return to inscription, is not a collapse into naïve realism, or simply unmediated eye-witnessing. It is a concept of historiographical intensity and practical potential that, as both an operative practice and sense of knowledge, emerges from epistemological and sensual specifics in relation to understanding the past. Presence, as simply a way of 'being in the world' (to use Merleau-Ponty's famous phrase), does not necessarily carry a sense of engaged observation, conscious narrative or articulation of unmediated experience associated with eye-witnessing. Nor does it necessarily carry a burden of 'testimony', although the inscription can be all those things too. Similarly, presence is not merely a 'likeness' rooted in a sense of immediacy and connection, although again it can be those things too. Rather presence is an existential connection that simply marks the moment somebody lived through and experienced, banal or momentous, held by the inscription of the photograph. It is interesting, however, that in presence theory in history, photographs, which one would think of as so clear a marker of historical presence, are, on the whole, largely absent from that debate.

Thinking about presence also requires confronting the deep-seated historical and methodological anxieties about subjectivity in the production of the photographs and indeed the subjectivities of historians themselves. Experiences and presences are often manifested through a piling up of inferences, rather than necessarily providing facts in the way that might satisfy historians. As I noted earlier, the concern that an engagement with historical photographs engenders emotion, subjectivity or, heaven forfend, nostalgia, rather than sober analysis, is part of the marginalization of photographs in serious historical thinking – photographs are too raw, too unprocessed by

time, too subjectively invested. Photographs are anxiety-inducing not just because they seem to be animated through their insistent presence but also because they threaten to collapse boundaries between reality and illusion, evidence and conjecture. But if presence is a source of unease, it is also can important critical think-space that can lead to new historical questions.

So, to look more closely at what presence might 'do' at that interface of historical practice and photographs. Presence provides the past with a certain kind of 'being' that points to the role of individual experience and standpoint in the historical domain. It faces us, as historians, with the richness of lived human experience, while simultaneously acting as a site of mediation or translation into the broader historiographical field. A sense of presence permeates shifts in historical focus across multiple scales. The expansion of social history, microhistory and scales of attention that I have noted, and again, above all the broad shift of historical focus from sets of events or strings of happenings, to the texture of experience are part of this. It has been argued that some of the best history writing of recent years has cultivated a more immediate connection to the ordinary and to affective experience. The concept and language of experience is understood here as a subject's history, a site of historical enactment and reconstruction. The presence inscribed in photographs offers a visceral sense of the past, and the experience and standpoint of sentient human beings, who are after all, the focus of historical endeavour.

It has been suggested that experience is too fleeting and subjective to be held in the frame of historical analysis, and that it cannot be subject to source scrutiny. Many would now disagree: as historian Ethan Kleinberg has noted, 'Twenty-first-century trends in historical writing and the theory of history emphasize the return of agency, the primacy of experience, memory, testimony, and, most recently, the importance of "presence" for the project of history.'[2] And this is exactly where photographs, conceptualized as presence, not merely 'representation', might intervene in the historical process. They have the potential to hold and disturb established historical narratives and analytical positions as they institute multiple layers of past experience. This takes us back to the impact of photographic inscription and scale. Presence affords a historiographical opportunity to use photographs not simply mechanically – but to think through the implications of traces of a historical presence in almost infinite detail and, above all, in relation to almost infinite numbers of people: colonial troops in the edges of photographs of the First World War, football crowds, children dancing to an organ grinder in the street, servants hovering quietly in the background. Historiographically, it is possible to 'view each image as potentially disclosing the world – the

setting for human experience',³ a rippling out from the image itself. That is, the image is imbued with not only the presence of the moment but the presence of experience.

The idea of presence, as I am discussing it here, is not new in writing about photographs. Presence is integral to the idea of representation, to make something present again through the depictive trace, a substitute for the absent, and also a pointer to the absent. The most fulsome articulation of such a position is Roland Barthes' famous *Camera Lucida* contemplation of the photograph of his recently deceased mother as a child in the Winter Garden. This brings us closer to the sense of presence that I have in mind here. And an intriguing aside, as we are discussing presence, critics are divided as to whether this photograph, as described, ever existed or whether it is a literary and rhetorical device. It is not shown in the book.⁴ In one of the most famous passages in the photographic literature, Barthes describes the way in which the photograph stabs and wounds him because of the intensity of its rendering of his mother's presence. He describes the failure of other photographs to connect as a failure of presence: 'I never recognized her except in fragments, which is to say that I missed her *being*, and that I therefore missed her altogether', whereas the Winter Garden photograph achieved, utopically 'the impossible science of unique being'.⁵ This is not merely the past in the present but something more experiential, even visceral.

The idea of presence is also well established in the theory of history, and in ways that map onto photography usefully, notably in the work of Eelco Runia. He has attempted to chart and account for the shifts in historiographical desire from meaning to experience, that is, an aspect of those shifts from happening to feeling that I noted earlier. He argues that despite the search for meaning and the understanding of the mechanics of meaning (perhaps in the case of photographs, the fixation with linguistically-derived semiotic models), what is actually wanted is something else – presence. As Runia puts it: 'presence is being in touch, either literally or metaphorically with people, things, events and feelings that made you the person you are'. It is the 'desire to share the awesome reality of people things, events and feelings, coupled to a vertiginous urge to taste the fact that awesomely real people, things, events and feelings can awesomely suddenly cease to exist'.⁶ Such historical thinking offers not only the presence of the past but presence in the past. Photographs are surely right at the centre of this vertiginous historical tension between presence and absence. Photographs reinstate what has been pushed aside or submerged by other forms of inscription, even in sources seen as opening on to subjectivities – letters and diaries for instance. Presence, as a concept, is an active element in such reinstatements.

I started thinking about ideas of presence, as I am using them here, as a way of working through difficulties I was experiencing in trying to imagine,

historiographically, how else we could conceptualize different historical narratives coming out of the photographs themselves. This is where we return again to the nineteenth-century Pacific Islands that have furnished a number of my examples. On the surface one would describe the photographs, historically and contextually, as 'colonial photographs'. But to reduce them to that restricted dynamic seemed inadequate. While the photographs were undoubtedly of colonial making, and the experiences held in those photographs might be dichotomized through analytical grids of power relations, was that all that could be said of them? Was that the only history inscribed there? Why do we assume analytically one experience (the colonial) over another (Islander)? What conceptual tools could help? Through the work of Ulrich Baer and Eelco Runia, I came to presence and its corollaries, experience and standpoint. They enabled me to think about whose presence was inscribed in the photographs and thus to multiply their potential histories.[7] Certainly the colonial relations were inscribed, but so too were those of Pacific Islanders as living, breathing, thinking people, with experiences that certainly intersected with the colonial but were not defined by them. They saw and felt things in their own way. They have presence. Thus, to return to my main theme, we can see disturbances to the established historical narrative, realized through the reconceptualization of photographic inscription not merely as evidence, but as spaces of illuminating interpretative suggestion. In this instance, while acknowledging the framing power of the colonial, the photographs open up our historical understanding to other histories and experiences inscribed in no other way. The Islander perspective, what it might have been like for them, is certainly absent from British colonial documents, beyond the fact that there was such an encounter (noted briefly in the logbook of the Royal Navy ship involved).

I want to turn briefly to questions of historical scales, atomization and individualization which have woven their way through these chapters. A recourse to presence, and related questions of agency and affect, is above all, in historiographical terms, an individualizing of the past. It suggests that individual affective histories are inscribed and reside within photographs as they frame, fragment and focus attention. It might be argued that this individualizing in relation to photographs is merely another manifestation of the photograph's qualities of description over narrative, micro and fragmented over macro and coherent. However, the process belongs to a wider historiographical trend in which deconstruction as a source of meaning (which has tended to dominate historical approaches to photographs through the grids of, for instance ideology, power or gaze), has been rebalanced by that contemporary historical fascination with experience that I have noted. Going back to Runia's characterization of presence as 'being in touch' with

'the person you are': the search for experience as an individualizing of the past, and the inscriptive presence of the moment, is something to which photographs, with their intersubjectivities, their appeal to the imagination, and their recodability, contribute very markedly. This sense of individual experience also feeds collective negotiations of the past. The massing of individualized experience represented through photographs transforms into powerful collectives, as individual experience becomes absorbed as collective experience, of, for example, trauma, contested nationhood or just being of a community. In this we see how presence also feeds into larger-scale histories. As I have already noted, photographs have infiltrated themselves into historical consciousness to such a degree that they carry an intimate suggestion of, very literally, 'the face of the past'. Even when confronted with their apparent unknowability, photographs restore presence and subjectivity as possible historical modalities.

Obviously photographs are not alone in this. But to realize the power they have as presence, marked by the mechanisms of photographic inscription, one only has to think of unknown soldiers in the trenches of the First World War, and mill workers streaming from factories, staring back into the camera as they go about their business. The excess of inscriptive trace in photographs, their historiographical unconscious optics, forms what Runia has described, with suitably nautical flourish, bearing in mind my Pacific example, 'a stowaway' hiding within the planes of time.[8] It is within those inconspicuous details, 'spots of contingency', that presence might be located in networks of relationships, experiences, and world views condensed within the frame. Thus, to reiterate this crucial point, what is present, inscribed in the photograph, is the trace not merely of surface bodies, but of their own social being, their own perception of the event, of being there – their standpoint. The very existence, of photographs as a historical modality and presence, and the ways in which they invite both critical forensics of detail and emotional engagement, is arguably an unarticulated element in the shifting distantial relations between, for instance, the global, national and local, the personal and collective, history and memory, which has an underlying impact on the intelligibility of the past. Consequently, as my Pacific example demonstrates, presence might foster a conceptual sensibility to a series of potential fissures in the surface 'content' of photographs. This not only complicates evidential dynamics within historical practice but also, as a site of historical reanimation, offers a way into thinking about specific historical questions. It is necessary to find the intellectual space for a little experimentation within expanded historical landscapes.

The closeness offered by photographs and the presence they hold, also bring new concerns about the moral and political relevance and

appropriateness of historical scholarship. For instance, the debates about the limits of representation, and the ethics of seeing/speaking, have been largely driven by visual anxieties, the immediate reality effects of photographs and their work in historical discourse. The visible violence of twentieth-century histories has engendered, in part, scepticism and disquiet about the larger narratives of history and the impossibility of comprehending the enormity of those histories. But again presence comes into play. Photographs stress the reachability of the experience of those events, and of histories from the standpoint, the very social being, of historical actors. Thinking through the grid of presence, both individually and collectively, allows us to restore a sense of their own social being and standpoint to the abject subjects of photographs of, for example, trauma and violence, and where agency is denied such as in police photographs or anthropometric photographs. I keep coming back to this point, but it is fundamental. As historians we not only have to find the intellectual space in our practice to accommodate such possibility and resonance, but presence also places a demand on the historian, making us responsible for a robust engagement with what that presence suggests and reveals.

Such disturbances also demand a critical look at the way in which subjectivities are weighted or privileged in historical writing, and how this might challenge norms of historical interpretation. Related to my comments above, an example of 'presence in action' and the responsibility it demands, is Ulrich Baer's account of the photographic disturbance of narratives of the Łódź ghetto in Nazi-occupied Poland.[9] Thinking through the photographs of Walter Genewein, a Nazi official and thus perpetrator imaging, Baer treats photographs as inscriptions of standpoints and experiences which people lived through, not only as the production of Nazi ideology. The shift in historical strategy and interpretation that such a historiographical position enables, makes it possible to complicate and multiply histories of the Jewish experience of the ghetto. Such an approach neither reduces their experience to a series of doomed tropes, nor condemns them to a misplaced collective passivity, but restores a sense of dynamic personhood, individual experience and standpoint, under profoundly traumatic conditions. In another example, historian Gary Minkley has explored the repressive ID passbook photographs in apartheid South Africa through the analytical grid of presence in order to understand the affective histories within individual photographs: '[h]eld somehow in the frame of the pass image are dreams and desires where, as the sign of permanence, they mobilize landscapes of nostalgia and anticipation, as well as different genealogies of belonging: perhaps a piece of land and some cattle, but certainly a job, a house, a family, a husband, a wife, a love, or the possibility of a different life.'[10] A sense of photographic ontology as presence, and a reading

out of the photographs as historical practice thus moves us towards a more nuanced historical interpretation, in which individual experience and presence has to be at the centre, because photographs force it to be. Yet, at the same time, it explains something of the worlds of which they were part.

However, questions of presence, and by implication, experience and subjectivity raised by photographs, also raises the important question of where do historical facts end and historical imaginings begin (evidence, conjecture or inference?), raising questions about the subjectivity of historians themselves. Context does not help us because context can be built for either or any reading, as I discuss in the next essay. Does this invalidate photographs after all? No, but it makes it more imperative to attend to their subjectivities, both in terms of presence and in the actions of historians. This delivers us firmly back to anxieties about the dangers of emotion and viscerality over analysis and interpretation in historical practice. But to try to shut down those possibilities rather than feel the experimental frisson and danger of historical potential, and to follow its historiographical dynamic, condemns photographs to a marginal relationship with the practice of history.

Presence, as a think-space, potentially restores the being and role of individual experience in the historical domain. It also acts as a site of mediation or translation into the broader historiographical field. The concept of presence opens up a coherent space for the possibility of different cultural narratives of experience within the photograph, the opening up of different horizontal readings that can enrich what is brought to historical narratives, as the examples from Baer and Minkley demonstrate. Some philosophers and historians have written about presence and experience as revelatory subjective moments, and I am suggesting that photographs can act in this way. So, in considering the interface between history, photographs and presence, we need to be very certain of our terms of engagement. Some might argue that presence is merely a version of the vertical incisions of Barthes' *punctum*. But to reiterate and redeploy a point I made in relation to scale in Chapter 3, unlike the subjective incision of *punctum*, the traces that constitute presence, have an existence outside the readings of a particular viewer. Consequently presence, excavated and activated through 'critical forensics', has an existence in the systematic excavation of the detail located in the scale of photographic inscription, which can then be absorbed as evidence and thought with. This is what I was trying to do in my Pacific study noted earlier. Because if we allow photographs to act as disturbing meditators in the practice of history, a presence of the past, the presence of individual experience, and indeed its collective articulations, comes into differential focus.

If we at least entertain the idea that photographs hold an element of the experience and social being of their subject matter, they make that experience more palpable and historiographically robust, even if concepts of presence do not necessarily amount to 'hard evidence' in the rigours of historical practice. It would be foolish to claim that a photograph can capture what people thought (in the way that diaries or letters can), exactly how an event was experienced, or to impute details of feeling. Such is the primrose path to over-reading photographs, especially when they are made to fit generic models of analysis – there are many such examples in the literature to which we must be alert. Nevertheless, presence introduces a vital (in both senses of the word) sensibility, and like all historical practices, it requires critical positioning. Such an assessment is part of the historian's craft. Most historical writing has elements of the conjectural, as practitioners piece together remaining scraps of evidence to make sense of the past, even if we prefer not to admit it. Histories after all are always constructions of the mind to some extent. Perhaps another aspect of presence is that it raises the possibility of *not knowing* through photographs, or not knowing in the sense that historians have conventionally expected their sources to respond. Photographs' immediacy is simultaneously rewarding, frustrating and, on occasion, overwhelming. They are not always generous sources. But this again is where photographs disturb how we balance our historical narratives. One is faced simply with that 'impossible science of unique being' and all that that implies, a tracing of experience and standpoint tantalizingly held towards us.

So, whatever our historiographical predilections, photographs pull us back to the micro scale, to presence, being and experience. The notable historian R. W. Collingwood argued many years ago that the experience of the historian was reflexive, and integral to the ability to write history at all. Photographs as presence become a crucial site of translation and contemplation within this broader endeavour, because they inscribe social realities and challenge the historian's ability as mediator and translator. What is suggested here is a sensibility to historiographical possibility. Presence helps us think in more nuanced ways about the extent to which a photograph might or might not accord with the agency or subjectivity of its subjects. The challenge is to find, through the concept of presence, the objective reality and subjective apprehension that constitutes both experience and the practice of history.

This is why the way in which context is constructed around photographs is so important. Human beings and their communities have spaces of experience out of which they act, and out of which they enable past things to be present or remembered. Such actions occur within specific horizons

of expectations, including expectations about photographs should do historically. If we allow sufficient intellectual space or them, the subjects of photographs, their presence and social being, are inscribed and embodied, and capable of excavation and retrieval within their own realm of meaning. While there are undoubtedly photographs, histories and intensities that resist such actions, presence nonetheless becomes a crucial articulation of thick description. Such a position shifts historical significance, at least in part, from context to significance within the image – to standpoint. Ideas of context have hovered in the background of this discussion, because we have to be aware of what social being might mean in different circumstances. It becomes part of a nuanced historical interpretation. If it can be recognized, conceptually, that photographs inscribe and hold that presence and experience within them, rather than having their historical potential circumscribed externally through context, things begin to look a bit different. Presence confronts our assumptions and the reductionist tendencies of 'contextualism', so that is the focus of my next intervention.

6

Context

Statements are compared with each other without regard to their history and without considering that they might belong to different historical strata.[1]

Historians excel at context. It is one of the major commonplaces of their practice and a core methodology. They make continual judgements about the conditions in which their evidence works to illuminate happenings, effects, the subjectivities of actants and so forth. Their practice is balanced between their sources and context as the very conditions of textual, and here photographic, production. Any inscription from the past will be subject to interpretation and shifts of meaning. It was ever thus, and the construction of context is a key site of both interpretations and shifts. But, while it is a truism that readings change in accord with both the contexts applied and the contexts of reading itself, it remains that context is also a layer of historical representation and meaning making, entangled with questions of source criticism and the like. If context is a judgement of interpretative appropriateness, photographs' complex contextual demands simultaneously highlight both the process of contextualization itself, and the photograph's fragmenting and temporally fluid propensities. This, and the challenges it presents must preclude, I suggest, a simple recourse to context as an explanatory system.

The word context comes from the Latin *contextus,* to join together. Context 'joins up' historical sources with their fields of origination and with their fields of action – the multiple threads that connect things. So historians search out and assess the interconnectedness of facts and interpretative resources available, in order to produce a careful, perceptive structure that validates and authorizes their source material and their accounts of the past as robust and credible. At the same time, while there are of course, regrettably, ways to wriggle round this, rigorously applied disciplinary ideas of context are there to put a check on historians violating their sources, including photographs, in service of eccentric or aberrant interpretations. After all, what a document might say and how the historian writes about it are not the same thing.

But context is also a noun. It implies a thing, something static (rather like photographs in fact), a stilling or holding of connections. This might seem a simple and obvious point about something we do every day when we 'do' history of any sort. It is second nature to us. But second 'nature' slips into 'naturalized' as photographs, and indeed as other sources, attach themselves to unconscious patterns of recognition. When combined with the 'naturalistic' inscription of photographs, this is too often critically invisible. We need to think about it though because constructing a context can too easily be grounded in assumptions, rather than the questions it raises.

The origin and shape of such mantras as 'being seen in context' also reveal much about the relationship between photographs and history and the assumed values of historical practice. The idea that 'photographs have to be seen in context' has become forceful however, in a way that is not heard as continually and explicitly in relation to other historical sources, even though it applies equally. It is as if photographs, above all other forms of historical sources, demand context. All texts to some extent create their own contexts, carrying an implicit range of discourse and action. In the case of photographs, maybe the anxiety about context has its particular roots in the naturalization of Roland Barthes' influential essay, 'The Rhetoric of the Image', in which he delineates two semiotic, and indeed ideological, modes at work within photographs: denotative – content, and connotative, meaning – and thus context.[2] If I had a pound for every historian who has explained to me earnestly and patiently that photographs don't tell the truth and have to be seen in context (as if this is news to me!), I'd be very wealthy. But, more seriously, context is the practice of building an explanatory hypothesis for our materials and ideas, and photographs both require this and challenge how we think about it.

All historical sources have their fluidities and their contextual challenges, and all historical accounts are tensioned between facts and context. These questions have spawned a huge literature, especially, for instance, in relation to the Cambridge School of the 1960s and 1970s and their supporters and critics, and the various ongoing debates in the history of ideas, theory of history and in discussions of methodology. Ideas about context have drawn variously on linguistic models, or perceptual models, constructivist or situationalist models for instance. Like all practices, context has its fashions and these emerge from, and confirm, categories of analysis and their theoretical underpinnings. The ways in which contexts are framed reflects what is deemed suitable and coherent at a given historical moment, as historians respond to shifting demands in establishing the explanatory base of their narrative. So contexts themselves have contexts that need interpretation and stabilization, in a process of infinite regression. An example is the mass of work in the 1970s and

1980s which engaged the 'colonial gaze', 'gendered gaze', and indeed 'opposed gazes' as sites of contestation and contra-narrative. These various analyses of photographs as visual regimes were part of particular emerging historical concerns such as postcolonialism and feminism and their related contextual practices emerged from them. Such positions were, and remain, perfectly valid and indeed vital correctives to the status quo and continue to raise important questions about how the visual works. At the same time, they were sometimes, in their constructions of context, premised on assumptions that constrained as much as illuminated. This will be a recurrent theme here.

So what does context actually mean for us here? Are we trying, as we might, to restore the original meaning to a document or photograph, the who, why, what, when and where of its existence, or are we trying to understand its wider dynamic? Probably both. Are we using it to confirm or challenge established historical readings? All these questions engage different dynamics and bring variously heuristic, theoretical and interpretative tools to the surface. The upshot is that context cannot be seen as a given.

As with any other historical source, the way in which context is conceptualized and used shapes how photographs are able to work in the historical field. As we have seen, photographs do not necessarily work like other historical sources. Sure, there are areas in common, but there are orders of difference. The unusual and persistent insistence on context in relation to photographs, reveals and reflects anxieties about the unevenness of their status within historical work. Unlike the other chapter in this book, this one has more of a methodological feel to it. In what follows I consider context as a method certainly, what we're doing and why. But I also explore the sensibilities that might inflect how we think about 'putting photographs in context' and their implications. Although photographs have contributions to make to the debate about context, they do not necessarily carry the same levels of disturbance that they do in, say, relation to time or scale. However, the ways in which photographs are contextualized within historical work, or are themselves used as context, facilitate or constrain their ability to make disturbances.

The nub of our contextual problems is in the very nature of photographs which makes them too volatile to be usefully constrained. Their random inscriptions and excesses pose particular challenges. Ludmilla Jordanova, in discussing photographs as historical sources, has stressed that photographs need a 'well-chosen framework'.[3] Exactly so, but what are the processes we have to consider in achieving such a goal? Contextual studies identifies two dynamics within context - containment or constraint, and movement. How these two modes are deployed is crucial for the way in which photographs function in the historical field and what they might 'do'. Both are responses

to ways in which photographs work, singly or serially, as intentioned inscriptions or as multiple forms of reproduction and dissemination.

To take containment or constraint first: there is a tendency, perhaps overwhelmed by the pragmatic ends that shape the common historical practices of photographic engagement, that contextualizing practice follows the standard procedures of document assessment – that who, what, why, when and where. Such questions locate it historically, and crucially align it with the standard practices of source criticism. So far so good. While it is a truism, and a trite one, that all sources are products of their time, such contexts can nonetheless become reductive as explanatory systems. While photographs, or indeed other classes of document, are produced within a specific situation and historical location, it is assumed that contemporaneity of time itself provides an adequate context in and of itself. However, this does not mean that intentions and effects can be reduced accordingly. Photographs are too fluid and temporally indeterminate, and often circulate in multiple forms. They belong simultaneously to the same and different historical strata. Consequently, overly inflexible, reifying or unconsidered ideas of context can over-determine photographs, for instance, in cases where ideological concerns are assumed while others overlooked.

The way that colonial photographs have been written about is a case in point. Here questions of agency and presence, inscribed in the micro-levels of scale, tend to be subsumed into ideology as a context. This process effectively closes down other explanatory positions for those photographs, for instance those of contested subjectivities. We saw a similar process at work in the last chapter in relation to the photographs of the Łódź ghetto. So, is a white colonizer family photograph taken in Africa only about colonialism? What about the 'presence' in my sense, of local servants, for instance? Likewise, can a family album from the period of National Socialism in Germany be assumed to be 'Nazi photography', or merely family photographs made during the period of National Socialism? What level of ideological inflection can, and should we, give them? What are the mechanisms for balancing macro and micro levels, between the political and private, and for ascribing significance to one strand over another? Are we as historians, recognizing and interpreting visual regimes or constructing them? Of course, photographs are undoubtedly produced and employed to ideological ends, from overt propaganda to more insidious visual regimes as the cultural capital of photographs is harnessed to ideology. But to what extent are photographs unarticulated responses to ideological conditions and to what extent are they responses to other factors? As I noted in relation to inscription, moments of history are made up of multiple conscious and unconscious attitudes, repertoires and intentions. So, ideology provides only one possible frame of individual action, and

one to which historical actors cannot necessarily be reduced. All historians are aware of such complexities and pitfalls, and in particular those writing histories specifically from photographs. But these practices are balanced on finely nuanced notions of context which are not necessarily worked through as robustly as they should be.

A major stumbling block in contextual practices around photographs is the uncomfortable slippage between content and context. It is as if the surface content of a photograph becomes an automatic and self-evident access to meaning, eliding the constructed-ness of context. This is not to suggest that the content of a photograph is irrelevant; that would be silly. Rather, it is to discourage the expectation that there is an unproblematic alignment, in which the naturalism of the photograph creates an assumed set of external relations, and thus placing it in a specific set of assumed analytical frames. It is extraordinary how in the face of the reality effects of photographs and their narrative resistance, content inadvertently becomes context, as the surface is privileged over the depth of effects. It is through these content-determined mechanisms that photographs can become generalized as unproblematized historical truths; for example, the blanket bourgeois identities assumed to be inherent to, and thus defining of, the nineteenth-century studio portraits. In such a case we see how easily photographs can become absorbed into overly social-deterministic narratives. Such inclinations are often made concrete through the very necessary practices and process of understanding the document – those questions of who, what, why, when and where and the conditions of its production. While such questions are key to positioning a historical document critically, equally, with their privileging of authorial intention, they become a very constraining context, especially in the face of the messy volatility of photographs.

A further complication in their contextual relations is the way in which photographs themselves come to stand for context, giving definitive form to other narratives. Photographs are frequently used over a range of histories – political, military, social and cultural (where we have seen they have more dynamic presences) to give a sense of actuality, life and credibility to accounts reached by other means – it was there, it happened. That is, photographs *as* context are implicitly or unconsciously constructed as a function and tool of the explanation, demonstration or authentication of something that is, in turn, is used to give context to those very photographs. This creates an analytically awkward symbiotic relationship. In ways that resonate with photographs and the creation of generic 'events', for example, an account of the Vietnam War, say, gives credence to the way the extensive photographic record of it might be read. Conversely, photographs themselves have come to stand for the conflict as integral to its definition as an event,

thus creating a double helix of mutual contextualizing validation. The assumptions through which photographs themselves become context tends to create an endless, and ultimately uncritical circle, which again confuses their actual role in the historical landscape. What are they actually *doing*?

This might not seem especially problematic at one level, because this is how contextual practices support all historical endeavours and their sources – one form provides context for another. But the problem emerges from the distinct tendency to make meaning outside the image. The photograph is not treated as an active entity that requires explanatory strategies built from its very existence and presence. Photographs too easily become passive receivers of context, endowed by text or caption for instance, rather than generative of it. It is as if context can't really deal with the messiness of the past presented in photographs, with all their visceral directness and intimacy. This dilemma emerges because, as I've said, of the kinds of context brought into play where photographs are concerned. Critical positioning gives way to a sense of the self-evident – as something potentially stable, clear and self-sufficient emerging from the apparent coherence of generic internal content of the image.

These processes also allow photographs to become icons of particular historical moments. They become understood as encapsulating and standing for condensed social and cultural values through which meaning might be ascribed to an event or occurrence. Again, like the Vietnam War photographs I noted, such photographs become the context, while they themselves are overwhelmed by, and stand for, that context. For instance, to take some Second World War examples, we might consider the raising of the US flag at Iwo Jima in February 1945, the small boy with hands raised during the Warsaw ghetto uprising in 1943, or St Paul's cathedral silhouetted against the flames of the London blitz. Such images are endlessly reproduced, including in some serious historical literature. Part of the visual vocabulary of the past, they provide, simultaneously, a visual summary of complex historical moments and the impression of direct conduits to an actuality. This evasion takes us back to the uncertainty of what kind of history photographs present. How it should be framed and to what end? This is an important question because it has a major impact on the kinds of histories that can be written, regardless of one's sources.

It may seem that there is a contradiction between my claims that, on the one hand, context should be built not from mere content, and that, on the other hand, we should attend to what from what comes from the image itself. But this is not so, because the tension relates to how we think through, balance and weight assumption and category – the bourgeois portrait, the colonial image – and interior and exterior evaluations as we

ascribe context. What is at stake here is how we deal with different strata of inscription and evaluation. How do we allow content to disturb rather than concur with assumptions about categories, genres and thus meaning? As I argued in relation to scale, a critical forensic entails a close yet expansive reading of the inscription, the surface of the image, in minute detail, yet in a way that intersects and disturbs assumptions. Such historiographical actions thus begin to account for what comes to meet us from the image rather than simply what is brought to the encounter and translated as 'context'. These sorts of evaluations of the different historical strata are always part of the historical process. But the problem here is that they are seldom articulated as such, especially in relation to photographs. Faced with the allure of the realistic and immediate content of photographs, the critical practices of context can be seemingly forgotten and that 'disregard for their history', noted by Paul Feyerabend in my epithet, comes into play. This unconscious slippage from rigorous methodology to surface appearance suggests that to know what photographs are 'of' automatically explains what they might mean.

The contextual challenge of photographs, and I have already touched on it in other chapters, lies in their oft-cited weakness of narrative or linear temporal pulse. Their fragmentary nature mitigates against narrative and challenges the desire to establish the causal links that define narratives. There is a sense that photographs have to be simultaneously stimulated into narrative action by context, while their messiness and unreliability is contained by it – creating a double dependency on context. The fragments of the past offered by photographs, and their creation of micro events, present the historian, as we have seen, with a major challenge, namely to discern the assumed values that constitute context and to join them up. But like all exercises in contextualization, there are, as we have seen in my brief mentions of colonial and National Socialist photographs, tensions between micro and macro analysis, between micro event and macro meaning, between singularity as presented in the image and the generality of history and lived experience. The ideological pull on photographic explanation and the danger of reductionist readings are created by such contradictory tensions. While this question of analytical scale is common to all historical sources, photographs, with their play on scale and fragment, seem especially susceptible to the void between them.

Thus, we return to the position I noted at the beginning. The combination of photographic volatility and the uncertainty of what kind of history they represent has arguably resulted in the disproportionate emphasis on context, when compared with the contextualizing practices applied to other kinds of material. It is as if photographs are paralysed by their need for external

validation. It is perhaps easier to slip into context surrounding content, than address the part photographs themselves are playing in interpretation.

This brings me to context as movement because much historical work with photographs is premised not in image content, but in the range of their effects and modalities. As noted above, context is an exercise in controlling time and space, concepts which as we have seen are very fluid in relation to photographs and their historiographical manifestations. Photographs as historical actors, with their multiple historicities, random inscriptions, recodability and fragmentary nature, are always on the move over space and time. These characteristics of photographs break down contained models of context. Reproduced, circulated, reformatted and remediated, through multiple material forms from postcards to posters, albums to magazines, they demand a shifting and fluid sense of connective context to explain their historical activity. These multiple forms represent fluid intentions, actions and uses, and stand between a photograph and its content. This is where the idea of context as movement comes in, a concept that allows for the impermanence and fluidity of any particular horizon and ascription of meaning.

Certainly, other kinds of historical sources, such as letters, also demand both containing and mobile contexts. But, for photographs, the difference between constraint and movement is the difference between, on the one hand, authenticating what is known from elsewhere and, on the other hand, disruption, between closed and open meanings and their historical implications. Consequently, their meanings, and indeed historical potential, are always on the move. They are rarely static, to extent that the basics of contexts, and their required chains of contextual connections, can't hold them adequately. They merely pass through moments of recognizable stability as their possible contexts. So we need both 'different contexts' for these multiple and various performances, as well as a sense of context which can accommodate a sense of movement, of shifting performances, and of a network of dense webs, without collapsing into reifying ideas of visual regimes for instance. This constitutes a form of Clifford Geertz' s 'thick description' that opens out onto divergent and multiple views of the world.

Historians aspire to provide thick descriptions. The more multiple and saturated the contexts, the thicker the description, as more threads of contextual connection become active. This is why models of networks and meshworks, developed in anthropology and the history of science have become widely considered as contextual frames in relation to photographs. Most notable are the ideas of, first, the visual economy and its attendant and entangled political economy of the movement of ideas, images and materials for instance. Both political and visual economies explore the interconnectedness and mobility of forms, practices and ideologies which

both create and purpose images across space and time. Second is the 'photography complex' which explores the material, visual and human interstices of photographic encounter and circulation.[4] In both these models a wider dynamic of audiences, institutionalizations and circulations, for instance, become as important as photographic content itself in understanding the image as a historical form. Influenced by actor-network theory and its reformulations, these models, which stress the formative dynamics of human-non-human relations, have become productive because they eschew a containing sense of context in favour of dense webs of historical connection and meaning. Given that possibilities come in different sizes from the micro to macro-historical, with different gravitational forces, these models produce different effects as acts of historical interpretation. They both enable multilayered strata and concentric contexts to be kept in play while keeping the work of photographs at the interpretative centre as sources and as actants.

Some have argued that, like other historical sources, not all photographs have the same density of possibility, as they carry different political and social weight and different densities of intention and composition and historiographical potential – a family photograph as opposed to a photograph of civic unrest for instance. But this is ultimately a response to the assumed hierarchies of significance attributed to the content of the photographs, and how questions asked of them are framed, rather than what they do over a dispersed field. As became clear in my discussion of both time and scale, photographs, and thus their historiographical impact, are made up of chronologies and temporalities of differing depths. These assumed differential 'weights' are merely demands for different and nuanced contexts to activate them. How this works out in practice is seen increasingly in social, cultural and microhistories that I discussed in relation to scale, and the increasingly productive engagement with photographs in that environment.

Many studies of photographic and visual culture have shown how we might use context critically in different ways in the interplay of larger and smaller scales. They are built ultimately on a dynamic model of movement. Context here is imaginative (in the sense of creative rather than fictional) and reinvigorating, for instance using the detail forensically inscribed in photographs not only to pin down meaning but to open up alternative historical possibilities. Thus, in the photographs of encounter in the Pacific which have furnished a number of my examples, the multiple presences that emerged from inscription and scale, required the contextual emphasis to shift from colonial histories to Islander histories.[5] Conversely, Patricia Hayes has discussed African histories in terms of loosening binaries and resisting determinate contexts, such as the colonial and the oppressive. Not only have

such processes confined explanations of African presences but have also often been archivally codified. She argues that such a challenge to contextualizing practices constitutes an active role for photographs in historical restitution.[6]

Numerous scholars have similarly used close readings of the image to refigure the frames, and thus the questions raised, as the historical impact of photographs worked as both evidence and argument. An example of such contextual finesse, balanced between ideological and political frameworks and a history emerging from the images themselves, is Linda Conze's analysis of photographs of May Day crowds in early National Socialism in Germany. Using photographs and a carefully nuanced sense of critical context, she considers community-formation under early National Socialism in ways that vastly complicate ideas of community behaviours beyond the well-known trope of the state-orchestrated crowd. It is an argument that emerges from the photographs themselves.[7]

A further example is provided by historians working with increasingly large data-sets, and series, and using the kind of photographic pattern-thinking that I noted in my discussion of scale and abundance. These demand a nuanced contextual consideration of macro and micro environments, again balancing, for instance, the subjectivities inscribed within a given image against wider ideological constructs. An example is provided by Catherine Clark's account of the photographic articulation of the liberation of Paris in 1944 which shaped the memory of the event and structured its afterlife through serial repetitions and deployments.[8] Similarly, Vilho Shigwedha's account of responses to photographs of the 1978 Cassinga Massacre in Namibia, including the refusal of photographic evidence, rests not simply on different contextual readings, but on sophisticated concentric circles of context that widen the ways in which photographs can work and therefore ultimately disrupt.[9] In these studies, and many others like them, nested contexts are in play with one another, in ways that allow the photographs to emerge as central movers in historical understanding. They use contexts as networks of historical possibility, that allow movement not merely constraint. Within such processes and practices, photographs can no longer simply be pasted into narratives arrived at by other means, but become part of that narrative both conceptually and evidentially.

Context then, and the way in which it is thought through in relation to photographs, can act as, and lead to, historical correctives and new interpretations. As Ulrich Baer asks, how do photographs go 'beyond extra pictorial determinations and how the excess we find within the image points to something that though not properly outside it [its links to inscription for example] nonetheless unsettles the relations between picture and context'.[10] Complete context can never be recoverable of course, we have to work with

what we have. The knack is to achieve a contextual situation which illuminates rather than constrains. It is a delicate balance. It stands for the viable choices open to the historian through the critical address of content of the image, and a conscious engagement with the way contextualizing practices work. All attribution of context is, in the final reckoning, an act of interpretation, framed through theoretical questions.

Perhaps though, given the demanding relations between history, context and photographs, the mantras of context and the attendant assumptions and slippages, one should ask if we might over-contextualize, or are over-reliant on context in ways that let it do all the talking, not the object of our attention itself? As I noted above, it is important not to allow a photograph to be so enmeshed and constrained by external forces and misaligned strata that we lose sight of what it is actually doing and what it might say. There is a danger that, as a communicative form, it simply becomes invisible. In theory of history studies, Frank Ankersmit has argued that the gravitational pull of context can drain the object of its content, to the extent that the thing itself, and its statement, will be left with little to say, 'emptied of other possible contents losing both its "autonomy and prerogatives".[11] This has important implications here. There are inherent problems, as we have seen, with a simple constraining context located in the pragmatics of the document origination or the privileging of self-evident content. Conversely, photographs can become so enmeshed in a frenzy of multiple strands that it is difficult to keep sight of what they are actually doing. In both circumstances, photographs can be stripped of agency and influence, of causality and impact. Rendered impoverished sources, they can be thus reduced to mere illustration or a condensation of assumed, externally attributed context, rather than an active player in historical analysis. This might feel a little like overstating the case, but it does resonate with the tendency to paste photographs into a particular type of historical understanding, or into a succession of textual props that frame any given account. In such a situation, as we have seen, there emerges an inevitable and often reductionist, circularity in this process between photographs, their content and what is ascribed as context.

A useful corrective to the risk of over-determining and draining ideas of context is Mieke Bal's notion of 'framing'. 'Framing' is an active verb. It points to the actions of admitting, enclosing and supporting, that underpin the placing of a photograph or any other source, while marking the historian's agency in producing an object of study, here a photograph.[12] As Bal points out, this is not merely a nicety of terminology, but one that has implications for the practices, and for validating accounts. Framing demands contextual flexibility that takes account of historiographical energy across place, ideology, experience, expectation and instrumentality. Such approaches

can take account of the temporal movements and affective resonance of photographs in their multiple forms, rather than valorizing a flattening and overly constraining concept of context. Arguably this is another instance of how the existence of photographs in the historical landscape makes an unacknowledged contribution to practices. Photographs change the pulse of such considerations. This is not necessarily in any precisely causal way – we don't want to overplay this – but just by being there and making certain demands. In their different and demanding contextual needs, they bring an awareness of naturalized processes to the surface of practice and into sharp relief.

So, in sum, the idea is not to abandon the notion of context, such an action would be foolhardy indeed, and fly in the face of historical method and propriety. It is one of the reasons that context has attracted so extensive a literature. However, we do need to guard against the self-evident and, instead, consciously generate critical analysis of our practices. In this, it is essential that context is seen and used as a dynamic, critically conscious practice, not as something naturalized and assumed. From this, we might extrapolate and illuminate different approaches and thus different historical accounts. Photographs as sources remain dynamic, recodable, carriers of multiple meanings and suggestivenesses, alternative narratives and contested histories. They can be made to work in multiple ways. One can see this at work in Ariella Azoulay's hefty *Potential History* which, for many of the reasons I discuss in this book, places photographs as central critical drivers of the political and visual economies that create, contest and ultimately must refuse, the longevity and tenacity of imperial knowledge, especially in the constructions of museums, archives and of history itself.[13] Context, and challenges to its assumptions, are key historiographical actions here, and ones requiring a dynamic and sometimes dramatically mutable conceptualization and application.

There is no right or wrong answer to the question of photographs and context, and context has its own history of shifting ideas about how sources – inscriptions – should be made to work. Approached as think- spaces within the historical landscape, photographs do not necessarily submit to the prior meanings which we assume, but generate a world of other questions and possibilities. Both constraint and movement have their limitations, however. Constraint without restraint, so to speak, and adherence to ideas of origination and content becomes a self-stabilizing mechanism that can lose the complex temporal and spatial dynamics that mark photographs. Movement without restraint loses sight of those very conditioning forces, as images swirl around across time and space. As Peter Burke has argued 'There is no one correct context. What can be done is to try to place the narrower context within a wider and wider context that might be represented as a

series of concentric circles, recognizing in principle that an infinite series of such circles may be distinguished, and in practice there is no clear place to stop.[14] In the face of the infinite model of contextual relevance, linked to the mess and multiple propensities of photographs, it becomes even more imperative to be conscious of what is indeed placed beyond the contextual pale, and thus beyond analytical and historical responsibility.

My consideration of the concept and practice of context in relation to photographs in the historical landscape allows us to see that it is not naturally constituted, despite the seductive claims of photographs to the contrary. It allows us to see the different strata in play, each with different demands on photographs and their historical potential. Content, while a constituent player, does not automatically open up to a context, but rather to a range of possibilities. The act of interpretation or framing, as with other historical sources, is used to contain, and to give meaning or coherence to a happening. Photographs are by no means alone in all this, far from it, but they bring to the surface, and require us to pay attention to the questions of naturalization, validation, historical stabilization and the consequences of ascribing significance to one set of strands over others.

Any inscription that comes from the past will be subject to the interpretation of historians, and this shifts original meaning through those acts of interpretation. It was ever thus. But photographs carry an excess of possibilities and pose particular contextual challenges. How we build fluid frames around them allows us, on the one hand, to realise their potential as historical sources without simply pasting them into what we already know and wrapping them up in a predetermined explanatory model. They can become self-referential if the distinction between content (text) and context becomes collapsed, resulting in a danger that what they have to tell us as historical sources is overlooked. On the other hand, such critical awareness of the consequences of our actions contributes to the honing of the analytical and critical sensibilities in wider historical practice and enables us to reflect on the lurking problems of unreconstructed contextualism. Context is ultimately an act of historical imagination, clustered around the intersection of traces of the past and ideas of appropriateness. So, photographs have something to add to the larger debate. They challenge and sharpen the contextualizing antennae. Context is rarely simple or obvious, the nature of photographs alone makes sure of that.

NORM

Charter and

Great Seal of Henry I

Charter and

Entrance to The Bloody Tower

Rufus Stone New For

Hastings

Gateway of Battle Abbey

Materiality

Materiality translates the abstract and representational 'photography' into 'photographs' as objects that exist in space and time.[1]

The material turn in history has brought 'things' into the centre of analysis as active entities in understanding the past. The assumption that photographs, and indeed other images, are merely depictive, providing facts and evidence, has been challenged not only by increasingly sophisticated critical positions but by material approaches. While a 'material turn' or the 'new materiality' has worked its way through many disciplines over recent years, especially influential has been the resurgence of material culture studies in anthropology in the 1980s and 90s, from a moribund remnant of descriptive ethnography to a dynamic, analytical and highly theorized field. This work turn has demonstrated the complex social saliency of objects, expressed through the forms they take and the uses to which they are put in specific and shifting environments. It seems no coincidence that the rise of newly figured and newly theorized material culture studies emerged at the same time as the recognition of the work of photographs. They were both doing similar work in expanding our empirical and analytical base. Also linked to the wider cultural turn in history, material thinking stressed the role of objects in shaping experiences and identities, and attention to their aesthetics, consumption and circulation. And in the same way as we saw in relation to the presence and lived experience in Chapter 6, these material concerns were also part of the push back against the dematerializing propensities of constructivism, narratology and textualism. They re-established connections with 'the real' through the work of things.

As these influences permeated historical work, this 'turn' contributed markedly to expanding historiographical interests in not only materiality itself but also the role of things, variously, in the rise of histories of global interconnection, of the senses (the sensory turn), histories of emotions, affective histories, in questions of identity, and the retrieval of historical subjectivities and agencies, for example. If historians have on occasion found such trends and the insistent presence of objects challenging to

their practices in, for instance, the definition and assessment of 'the document', or of historical and critical distance, such approaches are now epistemologically, analytically and methodologically visible over a wide range of histories, whether we are considering twelfth-century Jewish traders in the Arab World, or consumers of luxury goods in the eighteenth century. Key to such work is the idea that materiality not just about 'stuff' or 'stuff people used in the past'. It encompasses the conceptual work of things in human/non-human relations, and their concomitant practices. What has become clear is that things mattered, and mattered to people in complex ways that not only lead us, as historians, to the concerns and subjectivities of historical actants. They also point to ways in which large-scale histories might be recast and lend specific moods and tonalities to historical practice. This is where materiality's historiographical force resides.

All historical traces are material forms, whether texts, ruins, landscapes, tombstones, potsherds or photographs. Oral histories also have their material supports. Writing itself, a primary access to the past in many cultures, has its materialities, for instance, ink, parchment, paper in multiple forms and formats. The graphicness of writing is a material application, providing the textures, tonalities or pacings of the document. Presentational forms range from letter books and albums to government records and diaries, material accretions include marginalia, crossings out, pinpricks, seals, pressed flowers – the list is almost endless, but all are active pointers of historical potential. Thinking materially is also important because those materialities are not necessarily consciously 'seen', but represent an unarticulated connection between how things are made and what they are meant to do. Material forms are choices that reflect intentions and that were significant for their makers. They also bind photographs to certain moments in their activity. Despite the fact that the material turn in history has brought such considerations to the surface, there remains a slippage in that such materialities are often 'seen through' to mere text, just as photographs are 'seen through' to mere content – as evidence about the past rather than as complex material entanglements and relationships within the past. However, whether we are looking at medieval manuscripts or photographs, materiality gives a tactile quality to historical inscription that has an impact on its assessment as evidence, and which goes beyond informational content alone. History is, of course, as much an interpretative practice as an evidential one; thinking materially provides an interpretative focus in which things become historically activated.

Consequently, and resonating with Marshall McLuhan's famous edict 'the medium is the message' in which interconnections and material

affordances shape human interactions with media forms,[2] debates about photographs and their historical value are also debates about things and about material practices. Photographs, as we have seen, work in multiple material forms, entangled in expansive visual and political economies. Reproducibility, multiplicity and mobility were part of photography's identity, attraction and purpose from its earliest days. So encounters with photographs in the historical domain entail encounters with negatives, print types, with chemistry and optics, or with vastly different presentational forms such as albums, or postcards, or with modes of viewing such as stereographic cards, lantern slides, or embedded in the text. It is also an encounter with modes of reproduction such as photographic copying, half-tone, chromolithographic and rotogravure printing, which have shaped inscription, circulation and thus meaning. To these material technologies, we should add the multiplicity of material interventions in producing the photographic image, such as toning, cropping, enlarging, combination printing, overpainting or retouching. All these material actions and practices mark images as certain kinds of things with certain kinds of effects, all of which are historically, and indeed culturally, located and are salient to what we might do with them as historians. Material choices, like size, shape or the sequencing of a family album, for instance, are affective decisions, the visual and material predilections of historical subjects, which both construct, and respond to, the significances and consequences of things and the human relations to which they are integral.

In this essay I am going to look at the implications of photographic materialities in historical practice, and suggest the importance of material literacy in relation to photographs. This is, of necessity, a more grounded account than some of my other interventions, because materiality brings the historian back to a physically constituted reality of one sort or another. It also raises questions that resonate through history's broad relations with material culture. Are they working as raw materials providing evidence? Are they themselves the focus of historical enquiry or does the material provide an interpretative and analytical conduit to the past in ways that reshape those questions? Photographs as material objects carry the same historiographical challenges as other sources. How can they be read, how do they work with other historical forms? What do photographs, as material things, make historically possible, given that the material turn demands that any adequate account of social relations and social actions also requires an address to its material circumstances, and vice versa? Finally what historiographical disturbances might such approaches bring? My focus is perhaps a little more 'photographic' than other chapters

because photographic materialities themselves are so fundamental to current historiographical trends. Further, thinking on materiality, both within history and within photography, draws on the same body of ideas coming out of material anthropology and archaeology. To that end, discussions of materiality in history have increasingly been part of the discussion of photographic efficacy within history.[3]

Thinking materially brings to the surface the co-presences that enmesh the representational aspects of the photographs. We begin to understand *how* they were used, and what they might have meant for their users. Indeed material literacy informs the ways in which we might negotiate and construct our ideas of context. As I've suggested, materiality is not merely about photographic meaning, but about interventions in the whole historical project, because as historical sources they become simultaneously evidentiary, cognitive and sensory. In this chapter, I also look briefly at the archive as a space of material practice and apprehension. Ultimately all histories are patterned materially in the archive. This is certainly so in Western, Euro-American histories, but increasingly so elsewhere, where the material archive is subject to different pressures, nuances and dynamics. This is particularly so where the conceptual and material practices of the historical archive, textual, visual and oral, have become sites of contestation by, for example, indigenous groups over the ownership and articulation of histories.[4] Archives are sites where material and physical information is absorbed into, and performed as, historical narrative. This is because, first, all historians, except high theorists perhaps, have material experience of archives of some sort or other. Second, photographs have their own particular archival challenges in the way they are rendered sources and evidence through material practices. This has an impact on the kind of historical work they might do.

The integrated media-scape of material forms – text, image, archive, digital – of which photographs are a part, is becoming an increasingly dominant prism for historical investigation, analysis and understanding. For instance, Tom Allbeson's study of post-war reconstruction in Europe centres its analysis on the material performances of photographs in magazines and journals whose own materiality is part of the story.[5] Above all, for us here, materiality stresses the richness and closeness of the trace, of inscription, scale, granularity, immediacy and presence, which as we have seen, are potential sites of photographic disturbance. Central to these discussions are questions of what people do with photographs, or what 'work' is expected of photographs as objects—in albums, on walls, at shrines, in political protest, or as gift exchange for example. Under what

conditions are photographs seen? How do they intersect, as things, with other historical modalities, notably the oral? In what ways are they things that demand embodied responses and emotional affects? How do they reveal the subjectivities of historical actants? As a result, historians are now responding to this multiplicity of material forms as they enact a range of social and cultural desires, whether exploring Egyptian masculinities in the mid-twentieth century, or local responses to dictatorship or colonial experience – all historical topics which have recently been approached through the prism of photographs.

A key concept to have emerged from the material turn is that objects have agency. Materiality is integral to these arguments as photographs become more widely understood as historically loaded 'things', that are not only looked at but elicit responses as they are held, stroked, wept over or sung to for instance.[6] Particularly influential here have been theorists such as Alfred Gell, and his post-structuralist framework for the conceptualization and work of agency, and Bruno Latour and Tim Ingold who have explored the networks and meshworks of human/object relations.[7] These ideas of agency and relationality offer an analytical approach in which objects, here photographs, are dynamic participants in social action. Although not without their critics, and as theories they have been much refined and reformulated,[8] their basic tenets remain of central importance in thinking about photographs and their material forms. They draw analytical attention to the performative and relational dimension of artefacts.

Photographs can be said to have agency in that their inscriptions elicit responses through the materially articulated power of their traces, immediacy and presence. This becomes patently clear when one considers the social practices around everyday photographs, where the encounter with, and comprehension of, the photographic inscription may start with the visual, but cannot be contained or explained by it. Its agentic and networked qualities shape behaviours and beliefs. For instance, stories are told with and around photographs, the image held in the hand, the features of its subject delineated through the touch of the finger, an object passed around, a digital image printed, put in a frame and carefully placed, dusted and cared for. All are sites through which photographic meanings, and thus historical saliency, are negotiated. Material conditions of the past also illuminate – indeed make possible – the consideration of political and visual economies, and of systems of truth production as an historical entity at any given moment. The value of photographs is, as we have seen, revealed not merely through

their representational qualities or their consumption by individual viewers but also through their reproduction, circulation, remediation, possession, collection and dispersal. All these actions are materially constituted, mediated and realized.

Drawing on Gell's ideas, photographs might be described as 'distributed objects', in that they are both discrete objects, yet bound together through their multiple and interdependent forms – a negative and its print for instance. They are spatially separated and acting separately, yet they are linked things which are entangled in different ways. So a single photograph (in terms of production) might exist as a contact print, enlargement, postcard or lantern slide, for example. Different forms have different material qualities – glossy or matte, black and white, coloured or hand-tinted. They are collaged, overpainted and cropped. They are placed in albums, hung on car dashboards, pinned on walls, kept in secret places, written on, exchanged, and sometimes destroyed or defaced. They are framed, reframed, replaced, rearranged. Just as negatives become prints, so prints become book illustrations, ID photographs become family treasures, personal photographs become archives, prints become digital code, private images become public property, and photographs of scientific production are reclaimed as art or cultural heritage. I keep producing these lists, but the material abundance and the impurity of photographs in the historical landscape, institutionally, collectively or personally, cannot be overstated. These distributed objects, separate yet bound together, function in a materially determined political and visual economy, the complexity of which is central to the intersection of historical practice and photographs in ways that might shift historical understanding.

Abundance, discussed in Chapter 4, is thus itself a material condition. Abundant materialities indicate both multiple audiences over time, and dynamic historical visibilities: 'the principle means by which it [the photograph] makes a common world and way of being with others in that world'.[9] Material practices create the conditions of viewing, attention and absorption and thus meanings that carry cultural weight. What did historical actors do with photographs, how should we retrieve it and interpret it? For it is the historian's job to hold and analyse these shifting moments of significance. The huge expansion of visual culture studies has been increasingly integrated into historical studies, for example explorations around the ethics of seeing, the dissemination of scientific ideas such as Darwinism, newspapers and celebrity culture. Such studies are enabled, at least in part, by the material turn. These ideas and approaches can be seen at work in, for instance, the remediation of photographs as engravings for mass circulation, or the rise

of the photo-essay in mid-twentieth-century magazines such as *Picture Post, Die Arbeiter Illustriete-Zeitung* or *Life,* as demonstrated in Allbeson's study of post-war reconstruction noted earlier. The material form of the newspaper or the magazine framed the communicative possibilities of collected images working together. In another example, family *cartes de visite* albums of the nineteenth century assumed forms like family bibles which indicated the preciousness and sanctity invested in the formal studio photographs they contain. As photography became more widespread, the snapshot was linked to informality and leisure; family albums became, in their different material forms, lighter, slighter, embossed with covers promising 'Sunny Memories', for instance. Materiality is marking the social expectations of photographs and their integration into everyday experience.

Photographic materialities also bring us back to questions of time and space, and those of context. Just as the nature of photographs themselves challenge a sense of linear temporality, multiple and divergent material forms of photographs spread out across space and time. In extending the temporal and spatial reach of an image, photographs work across conceptual and material networks of significance. Such agglomerations and networks of image-objects mitigate against the fragmentary nature of photographic inscription because, as distributed objects, they link multiple locations of action. They create relative temporalities and patterns of contemporaneity and simultaneity that complicate those linear assumptions. A good example here is Jennifer Tucker's study of the visual and, especially, photographic rhetoric of the Tichborne claimant trials in the mid-nineteenth century. The case centred on an imposter who tried to claim the inheritance of a long-lost heir. Much of the court case rested on the interpretation of visual and photographic evidence – was the claimant in the dock the same person as shown in an earlier photograph of the true heir? At the same time, the popularity of the trial generated a huge material presence through a network of photographs and their derivatives, such as engravings and cartoons of the *dramatis personae* (including the legal teams), while elements of the evidence were also widely circulated across multiple material forms.[10] All these social actions and processes were materially determined and the material massing of large series of photographic objects provided, like other historical sources more generally, an infrastructural network of systems of value for historical analysis. Such relations circumscribe the interlinked dynamics of the photograph's social use, material performance and patterns of affect as they are put to work through their material substance. They embrace explicit and implicit connections which reveal unexpected features of broader historical questions, not only about, the Tichborne

case itself, but the experience and performance of mid-nineteenth-century class, masculinity, or identity for example.

The power of materialities also have long and complex reaches. For example, in her discussion of images as public secrecy and public knowledge, to which I have already referred, Margaret Hillenbrand describes what she terms the 'Photo-Form' to account for the powerful and multiple material performances which shape conditions of visibility. Photo-Forms are photographically derived tropes that are spread over multiple visual and material manifestations. They become responses to histories ghosted by silence, yet insinuating themselves into memory as material sites nested within public secrecy. Well-known photographs, from the Nanjing Massacre or the Tiananmen Square protest, become 'cloaked in different material guise'. Full of clues and illusions, occluded through visual camouflage, they are nonetheless instantly recognizable 'logos of events' and signature forms of memory construction. They are 'shadow-boxing the things people find difficult to say aloud'.[11] Materialities here are central to the political economy of survival strategies, historical articulation and its weighty silences.

To return to the specifics of photographic materialities, material traces and forms also point to uses in the past. They reveal themselves almost archaeologically through marks such as traces, folds, tears, material accretions, that disturb the surfaces of the photographic things. Prints, for instance, carry the scars of their use – folded corners, creases, tears, inscriptions, indeterminate stains, marks of touch and other traces of presence. All point to uses of things that mattered, so immediately thicken historical potential. The indications suggested by material marks facilitate, again, the integration of photographs into wider historical questions and inflections. For instance, how did people assess, acquire and use photographs and under what conditions? What were the truth values associated with different kinds of photography and which thus shaped collecting practices? How is this traced in the material archive? In what ways were they disseminated? What were networks of exchange? What were the resonances for viewers of different material forms? Such questions constitute photographs as active players in the historical landscape.

For example, in my study of the photographic survey movement in England, to which I have already alluded, the material values of making and storing the photographs, such as the need to print in permanent non-fading processes, was essential to understanding the values and aspirations of the historical imagination of both photographers and archivists as they gathered photographs as records for the public good.[12] The desire for future

efficacy was vested in the material forms of the photographs themselves. In another very different example, some of the albums collected by the Red Cross in Dutch Indonesia during the mop-up operations after the Second World War have pages and photographs ripped out. What are the conditions of this absence? What do such excisions suggest historically?[13] Material properties, traces and markings create historical knowledge in addition to, or instead of, words. Elements that were not written down in the traditional historical sense are inscribed materially, through arrangement, texture, appearance or institutionalization (to which I'll come back). They place photographs as objects in the realms of subjective experiences. These are not necessarily expressed verbally, but they are nonetheless realms that are historiographically reachable. In the hands of historians, such objects become especially rich because they combine the evidential potential of the photographs themselves with the historical deposits of usage through their presentational forms.

Consequently, the intersection of photographic, material and historiographical thinking enables us to shape our historical questions. However, as I've noted throughout, there is always that tension between macro levels of interpretation and micro levels of photographic evidence. While one can seldom recover articulated subjective responses to specific photographs, a sense of usage can be excavated in ways that provide an evidential pattern – like the missing album photographs. Materiality is an entry point to understanding effects not only as an abstract but as something experienced and a site where subjectivities are realized.

One sees the historical grasp and impact of material qualities when one considers the ways in which the subjectivities and desires that cluster around photographs are translated into digital realms as acts of history-making. Although I am coming back to the digital in more detail in the final essay, it needs to be marked here because materiality informs the digital in significant ways – and not only because the digital has its own materialities. This is especially so around the digital presentation of family history and memory pieces where a sense of 'the old' becomes an important part of discursive frames. Softwares, such as VintageScene, PhotoShop Retrolook or simply colour filters on an iPhone, are specifically designed to address or make explicit, the social and material desires that activate the photographic image in certain ways. They provide an anticipatory infrastructure that informs and validates a sense of the past.

Consequently, the signifying properties of material forms are used extensively in digital reproduction, such as the simulated material practices of placing photographs in albums, scrapbooking, vignetting and toning.

These are used to restore the affective tones of the historical object and the actions it engenders. Material qualities, often described as 'vintage effects', such as sepia toning, *carte de visite* mounted photographs, or the jagged deckle edges of a 1930s Velox print, become irreducible markers of the past. They are intended to produce particular responses, as photographs are made to work in specific emotional environments and affective histories. Material reference attempts to recuperate the historical power of the analogue photograph and is fundamental to the quest for a more direct or authentic form of communicating a sense of past. At the same time as potentially expanding interactions and presentational habits, their very structuring also reaches back to, and evolves from, the material desires that have entangled photographs and informed their historical efficacy for a long time.

I want to turn briefly to questions of the archive, not only because, as I've noted, institutionalization is a key site of the material inscription of historical sources, but also because archives are obviously key tools in the discipline. Moreover, archival debates have been central to the material turn. Archives, encountered materially by users, are built on concepts of historical significance. It is something of a historical truism that all histories, whatever their modalities, are patterned by the shape of their archiving, but it is nonetheless so. Archival shape relates not only to what survives and what does not, in a mixture of intention and serendipity, but is structured through highly significant material practices such as document descriptions and file forms, metadata development, and presentation. These practices are not merely instrumental but rather hermeneutic tools that shape epistemic and mediating knowledge practices within history.

Like much in this book, this is a field that has received extensive attention from the theoretical to the psychoanalytical to the practical. These have both fostered and addressed the many stereotypes of the archive, for instance, as gathering the dust of centuries, a source of fever, a site of taxonomic and self-evident meaning, an ideological performance, or an embarrassing legacy of past interpretative and methodological follies. These include, on the one hand, such interventions as Jacques Derrida's much-quoted *Archive Fever*, and the instrumental arguments such as Allan Sekula's famous, and now much-contested, essay 'The Body and the Archive'.[14] On the other hand are robust analytical counters from archival practices themselves. The work of archival scholars, such as Terry Cook and Joan Schwartz, excavates archival assumptions, values and practices in detail. From this wealth of literature, my particular interest here is in the ways in which the material archive, and the growing debate around material literacy in historical practice, is shaping historical approaches to photographs within that practice.

Photographs have very dispersed archival presences. While many are archived as the X or Y collections, many others lack the systematic accrual and management which marks, for instance, government papers, literary correspondence or judicial records. Certainly, such records are subject to weeding and serendipitous practices, but overall they enjoy a coherence which is not guaranteed for photographs. Photographs are often materially separated, even separately managed, as 'photograph collections' or 'image collections', housed separately within archives rather than integrated with the other forms – such as letters, reports or technical assessments – in which their original purposes were embedded. Instead they are re-embedded in archival practices themselves. This material and archival fragmentation mirrors the fragmenting propensities of photographs themselves, a scatter of historical potential. Further, archival practices and values have tended to privilege the facts of raw content over analytical or discursive potential. While the latter might be seen as outside the archival remit (which, broadly speaking, is to preserve objects and contexts and give access to those archives and contexts), the material practices of the archives frame the object and the historian's encounter with it in ways that echo my discussion of context. How is significance attributed? How is this framed materially? For example, practices of description tend to privilege and embed some narratives and suppress the dynamics of other histories that emerge, as I have noted, through the processes of scale and inscription, for instance. If keywording in electronic systems has expanded routes into photographs and other documents, results tend to reduce the photograph to a series of fragmented 'contents', a single image on an album page for instance, rather than an integrated historical object.

Likewise, practices of storage are material framings of the historical landscape. Boxes, for instance, are not neutral spaces, nor merely pragmatic tools of taxonomic performances. As innumerable commentators in archival theory have noted, the archive has been mediated at every stage of its existence, constituting the process of archiving as a form of narrativizing in itself. The form and character of boxes is part of the very nature of the institutional existence of the archive and part of its constitution and meaning. It has been suggested that the act of making history starts when the historian engages with archival material and begins to interpret it. This overlooks the material practices of the archive in shaping history. Even allowing for rigorous archival principles of material respect, such as maintaining original use structures, the act of historical engagement arguably starts when the archivist puts things in boxes, creating juxtapositions and series relationships. Groupings of photographs, separated out into boxes or filing cabinets and framed by

finding aids, for instance, have been selected and made to perform certain coherences, thus mediating historical possibilities.

Material manifestations in archives can be understood as a set of affordances and appropriateness which shape the meaning of photographs and their uses. These are not merely abstract affordances of an ideological instrumentality of the image or of the archive, but rather a set of affective relations that make demands on users, and are thus constitutive and productive of historical and social relations. And this is more than simply photographs meaning different things to different people, at different places and times, according to the knowledge brought to them. It is an engagement with the spatial and material practices that make photographs, and which are actants in the production of cultural knowledge.

Archival materiality is also sedimented. The material forms of prints, presented on mounts, contained by labels, ordered in boxes and in files, and engaged within archival search facilities or print study rooms, create an affective space in which objects play out that role in historical practices. Seen here are both subjective and objective registers of historical concern, cohered at the surface of the mounted print in a box or file. But they are not necessarily static. Archival practices themselves are entangled in shifting sets of values from institutional to affective engagements with users. Things are placed in certain ways, mediated as sites of successive, layered and overlapping agencies. Archival and photographic assemblages work in specific temporal planes, obscuring other times and places from which constituent material parts come. Just as photographic images are dispersed across multiple material forms, so photographs often undergo serial re-boxing over time, refiguring the patterns of containment, and thus their narrative and historical dynamics. For instance, series of photographs might be broken up and dispersed to serve content-driven agendas, or, as many have been, removed. All these material practices intrude into the practice of history itself and make a difference to how historians can work, what they can find and how they might interpret what they find.

Given that archives tend to embed traditional evaluations of significance, the material practices of the historical preservation of photographs, from description to storage, are arguably merely a reflection of their marginalization, and the ambiguous status of visual evidence in the historical landscape until relatively recently. They are positioned, as it were, in archival peripheral vision, both metaphorically and materially. Conversely, the growing influence and demand generated by the 'visual turn' in history, and the desire for photographic access to the past, have brought an increasing number of photographs into the archival domain,

with an associated cognizance of the historiographical significance and potential of materiality, seriality and sequencing. For instance, the 'One Day for Life' photographic competition archive, which I noted in Chapter 3, was taken in by the Mass-Observation Archive at the University of Sussex.[15] This new and increasing abundance and plenitude is shifting both archival and historiographical assessments of what counts as historically significant, and the scales of historical encounter.

But, even within these developments, it remains that material practices continue to shape access and thus approaches to the photographic archive – what can be seen, what has been remediated,– copyings, croppings, digitalization – all transforming the original document, often without documentation. It is often to the detriment of those material accretions and scars that mark all archival survivals. One of the frustrations of working historically with photographs is being told, on enquiring of an archive, as I have been on a good number of occasions, that there is no access to original material photographic objects. I am told that that the 'originals' aren't available for consultation ('for conservation reasons') and anyway all can be seen online. Except they can't – photographs that are considered 'boring' or 'bad' (by what criteria pray?) are left out, the reverses are not digitized, mounts are cropped out, captions not transcribed verbatim and so forth, again all without documentation. Sometimes original sizes and original processes are not even noted, as photographs are reduced to grey rectangles on a screen.

Of course, many archives have very much better material practices in place, for instance, the beautifully documented digital facsimiles of travel albums from Venice, Egypt, Japan and India produced by the Isabella Stewart Gardner Museum in Boston.[16] However, it remains that things happen to photographic materialities that, visited on any other class of historical object, would be considered a scandal. These material decisions in the archive, analogue or digital, assume certain patterns of significance. They shape the kinds of histories that can be written, how visual evidence is assessed and, ultimately, the interventions photographs might make in the practices of analytical history.

Materiality is thus a vital site of both historical and photographic disturbance. Materiality changes the conditions of how photographs are understood, while at the same time the material turn has had a crucial impact on the conditions under which photographs are able to work, contribute and disturb within historical practice. This is not a collapse into some form of technological determinism – for little is actually precisely 'determined' through materialities, its evidence, or even in its little bursts of narrative. Photographs, as we have seen, are seldom definitive but

always suggestive and potent. Weighing and assessing the suggestive – the thin line between certainty (the seductive realism of photographs perhaps) and conjecture (the credible possibilities they suggest) is part of the historian's craft, as it is for all sources.

Thinking materially offers a suggestive route into those experiences, desires and subjectivities which might be the object of our study. But they are also suggestive of the ways in which we, as historians, must position ourselves objectively, indeed distanced, in order to make those fine-grained assessments. Thinking materially removes photographs from being simply 'visual sources' to being complex material objects that work over time and space and that transcend content. Thinking photographically also helps us conceptualize material agency through time. Incidentally, archaeologists deal likewise with fragmented and dispersed material traces of the past. They have a lot to teach those of us trying to work with photographs. It is worth reading some of them. As I have noted, material agency through time also takes us back to the question of multiple and mobile contexts as mechanisms through which to activate both photographs and photographic thinking within historical practice.

Further, materiality, in relation to historical disturbance, makes manifest what might have been concealed within inscription, scale or presence. Through their different forms and scales, the materiality of photographs, or indeed other historical sources, also brings us closer to what it was to be human in the past, indicating what people wanted photographs to do for them, as photographs are made in certain ways, selected and ordered into, for instance, the desired narratives of event, experience or self. Material forms shift interpretative spaces and create trajectories that demonstrate, and account for, unfolding and dynamic temporalities within larger historical questions. Materiality also stresses the nested sets of practices – from the archive box to the computer screen – that create the historian's relationship with their sources. However, if materiality is central to human experience in the past, the photographic encounter itself, and the historian's encounter with those photographs, is increasingly through digital environments, in which the material certainties of archival and visual economies give way to something altogether more fluid. It is to these I now turn.

Digital

Too much polyphony, and too much monotony; it's the Scylla and Charybdis of digital humanities. The day we establish an intelligible relationship between these two, a new ... [historical] landscape will come into being.[1]

I began this book by posing the question: what is it to write history in a world in which photographs exist? How do new technologies and tools for knowledge production shape, and leave marks not only on the knowledge so produced but on the very conceptualization, categories and assumptions that frame a given field of knowledge? If photography was one such technology, and a point of no historiographical return, the digital is surely another. The photographic and the digital are possibly the major disturbances of the practices of history in the last 150 or so years, changing 'behaviours, expectations, patterns of work and mindsets', in other words, how we conceptualize and undertake our research.[2] History itself has moved through, and absorbed, many influences – psychology, anthropology or statistics for example – but the digital presents both a way of doing things and a way of thinking on an unprecedented scale. But if the all-saturating presence of photographs is challenging, digital now makes them even more ubiquitous and taken for granted. Together they constitute a double assault on traditional practice.

The digital represents a sea change in what photographs might do, or not do, in history. It provides powerful tools for assembling, transforming, editing and communicating photographic inscriptions. In this chapter, I am not going to consider the ins and outs of digitization, of software and technologies, of websites, digital sources, digital preservation and reconstruction, digital assets, its ethics or the wider implications of 'digital humanities', a term which covers a multitude of practices and assumptions. Nor am I going to consider the digital challenge to realist and literalist assumptions about photographs. All these are fast-moving and dispersed fields where open-endedness, provisionality and evolution are inherent within both system structures and interpretative strategies. They are also highly theorized, especially in the fields of visual media and communication studies. So

although 'digital humanities' and questions of practices and methodologies for this infinitely expanded 'archive' hover in the background, I am going to look, in particular, at how applications of the digital bring to the surface the intersections between photography and history that I have been exploring in each chapter here – how they persist and how they transform and challenge.

In many ways the ongoing debates about digital histories mirror those I have been discussing in relation to photographs and the practice of history. They are subject to the same shape of anxiety and disruption. Given that many historians are still ambivalent about photographs and their potential and impact, how much more so the veritable tsunami of sources, methods and data of the digital world. Included in that tsunami are, of course, photographs, billions of them.

Photographs and the digital also share expectations in some ways. The internet promises a complete and instant access which in some way 'grasps the past' and 'history'. One merely has to think of the huge image data-sets that cluster around, and are part of, the construction of the reality, and thus significance, of what we see as 'events', worthy of historical notice – from presidential elections to world pandemics. Photographs carry very similar expectations of a whole truth, which as we have seen, is doomed to disappointment. However, if plenitude and abundance are often mistaken for completeness, this is no less true for digital environments than it is for photography.

In relation to history itself, there are extensive debates about modes of source delivery, methods for expanded archival possibilities, new forms of dissemination, the blurring of boundaries between disciplines and modalities, and even the implication of digital publication for historians' career tracks. There are also questions about how we transcend the technological determinism that tends to frame debates, to ask and answer different questions, and to open onto potential histories and fresh narrative forms. While there has been, on the one hand, broad-sweep attention given to the wider implications for the conceptualization of history itself and its apparatus, and, on the other hand, the structural effects on technologies of the visual within this particular debate, the historiographical place of photographs, beyond making them available, has been largely overlooked. Where does photography, as a site of disturbance, fit into this refiguration of the historiographical landscape? Does the existence of photographs and their mass-presence push scholarship in new directions? Does it open up interpretative possibilities that analogue analysis has failed to reveal or suggest? Or does the drift towards big data, quantitative, statistical, global and deep-temporal studies, which, enabled by digital methods and their

numerical reductions, serve to marginalize the non-narrative and micro scale in which photographs excel?

Arguably, beyond resource development, photographs caught in this trend are in danger of been pushed back to mere illustration, a point to which I shall return. For while digital humanities, offers new and productive techniques, such as visualizing historical networks, whether those of Angouleme in 1764 or the Royal African Company,[3] many projects have tended, often following the funding, to privilege the canonical and conservative disciplinarily attributions of significance – for instance, Shakespeare, early printed books, D. H. Lawrence texts, or, in photography, the correspondence of William Henry Fox Talbot or photographs from Tibet (rather than Chad or Uruguay say).

Many digital projects are both intermedial and visually led, for instance the analysis of trends or distributions presented as interactive maps and other forms of visualized data. These often have photographs forming another layer, such as in studies of urban landscapes. However, there is a larger danger that the free-floating assemblages of photographs that can be pulled together, engender not radical approaches to photographs in their relationship with history, but a return to profoundly conservative ones.[4] Such provide uncritical topic clusters around, for instance, the American Civil War, local histories ('Bygone' where ever), resources for teaching curricula, which are not necessarily driven by the source and critical needs of academic historians (in the broadest sense). The technology might be different, but digital environments are often used to make older methods and categories easier to work with, rather than challenging those fundamental procedures, categories and assumptions. Despite the massing of photographs, they become assembled fragments of fragments.

In this scenario images are leafed through and cherry picked, through the practices of side-glancing – a moving laterally through multidimensional possibilities – from a sea of similar images in the massive ethereal picture library. While this is a function of the recodability of photographs that has always been with us, in digital environments it becomes exacerbated at methodological and historiographical expense. Such practices do not maintain accounts derived from a detailed thinking through at the level of the image, its patterns of embeddedness or modes of circulation for example, but rather from a surface alignment of content with whatever topic might be desired. Its results, to go back to a comment I made in relation to context, simply paste photographs, as unproblematic little clusters of grey-toned pixels, into understandings and narratives arrived at by other, usually textual, means. The solidity of photographs, such as it was, has gone. This problem

is of long standing within historical practice, but it takes on an entirely new dimension in the digital environment. The disturbances of the digital world make a critical awareness of the work of context, in relation to photographs even more pressing if photographic potential is not to be flattened in a welter of visualizations, rendered incapable of the disturbance it promises. This assault on the practices of context brings us back to the other historiographical commonplaces that have been my focus – the evaluation of inscription, scale, event formation or materiality.

Perhaps the question is now becoming not so much what is it to write history in a photographic age, but what it is to write history in the age of visual incontinence? I have argued throughout this book that the existence of photographs has a productively disturbing effect on the practices of history - time and distance, event, scale and abundance, context, and materiality. The digital is attracting ongoing debates about the critical engagement with the technology and its historiographical implications which cuts across all the strands that I have discussed. This is especially so as digital encounters might appear to allow the polysemous and porous nature of photographs to come into their own, producing the kind of disturbance to historiographical assumption that they always promised.

However, one is led to wonder about the possibility that it is these productive disturbances which are, themselves, being disturbed, and above all contained, in the digital environment. Much of the historical photography in digital environments focuses on the massive expansion in available sources through digitization of archival collections, not to mention increasingly born-digital assemblages. The debate appears constrained historiographically, because it is not always clear what this adds to the historical endeavour beyond making more 'stuff' available, especially as search' (finding more 'stuff') and a core modality of digital environments, is often confused with research (understanding 'stuff'). While material thinking about photographs has undoubtedly led to increasingly accurate scanning and digital presentation, to the point when 'scanned old/vintage photograph' is becoming its own material category, too often photographs are flattened to a sameness. This severs the connective tissue that carries with it the potential for the disruptive 'think-space'. Photographs become neutralized, pushing them back into the role of unproblematized sources. The content of the historical world might be presented as accessible Flickr streams for example, but such a mode fails to engage the analytical potential in historiographical terms. The disruptive possibilities of photographs, their messiness and agitation are quietened and submerged through keywords and algorithms.

Perhaps the key, and most obvious, characteristic of the digital world is, like photographs, its abundance, but as Franco Moretti, with whose words I started this chapter, notes, it is an abundance that can give onto monotony, a tiring repetition of forms. The dynamics of the digital also have an impact not only on history or photographs but on the history/photograph interface that I have been exploring. There is a danger that photographs are easily dislodged and decentred even as sources, never mind as sites of disturbance. The digital is an environment of almost paralysing abundance, of almost limitless scale and density – the infinite archive. However, it is also responsive to the knowability of the past on whatever scale desired, creating history, and response to the past, as a new landscape of possibility. The digital, with its rapid development and expansion, sets up new forms of mobilization and network that emerge from new scales of abundance.

Significantly, these new scales and abundances are not merely a matter of technological change. Abundance cuts two ways here. First, digital abundance invites different forms of focus. It is not simply a matter of looking at more photographs, or of having more at our fingertips. The dispersed and endlessly re-assembled corpus of photographs within history requires new forms of attention, without collapsing into, or being overwhelmed by, the visual noise of unmanageable abundance. It also demands new and complex ways of thinking through both potential and challenge. However, abundance is also where monotony, the huge range of almost indistinguishable image possibilities, resides. But that monotony can also be fruitful. The comprehension and communication of large-scale bodies of data has been at the conceptual heart of digital humanities. For instance, I have always thought it would be interesting to use (in a modest way) big-data cultural analytics methods on photographs from European colonialisms to see if photographic styles, foci and institutionalizations reflect different styles of colonial ethos.[5] These different styles and institutional foci are something I have felt intuitively; however, digital methods might provide the required levels evidence, argument and proof for historical analysis. Image search techniques (or at least those available outside the security services) have yet to reach the efficiency of text searching through large data-sets, as anyone who has used Google Images knows, the messiness of photographs fights back. But it remains that ideas of distant looking and patterning, as techniques at the interface between history and photographs, become important as large data-sets, critically assembled, reveal themes, tropes and systems in ways that cannot necessarily be confidently extrapolated from close readings of a limited number of photographs.

Second, and despite these possibilities, large data-sets lose something vital to the photographic disturbances I have described, namely the scale

of inscription and the photograph's granularity of historical potential. They are lost in a sea of images. Nonetheless, if the digital has brought tensions between distant and close looking to the surface, there is still a place for the latter. Its engagement with inscription and scale allows the small-scale efficacy of photographs room to breathe. At a practical level, digital files can enhance close, granular readings. Attempts to bring close readings into the centre of a critically engaged micro analysis can be enhanced by digital technologies. High-resolution scanning can be remarkably effective in opening up photographic granularities of inscription. I was able to undertake my critical forensics of the Pacific colonial/islander encounter, already noted, precisely because of such a technique. Without digital enhancement, I am not sure I would have been able to 'see' the detail of marks in the sand, fingers pressed into flesh, the dirt on sleeves, which opened on to larger historical questions about presence and balance within historical inscription. The larger point here is that digital techniques both enhance and constrain the work of photographic scale and abundance in ways that have historiographical implications. The big question is what, and how, might large digital image sets enable us to see differently, given the multiple and complex demands of photographs as forms of evidence, narrative and imagination, and to do this in ways that do not collapse into an unproblematized reading of content. Both are possible, and both bring their own dynamics to the practice of history, but we need to think about that relationship critically, and the way it informs research practices, rather than collapse in a mere mass of content.

Time and distance also have work to do in a digital environment. The digital has its own temporal structures and forms of immediacy which, in many ways, enhance those of photographs. In mediating time (and indeed temporalizing media) in new ways, digital forms provide new techniques and infrastructures for temporal mediation and the intersection of photographs and historical practices. In this, photographs reposition historical entities and enact multiple translations and displacements. For instance, digital translations and environments accentuate and enhance the photograph's temporal slippages. They blur the boundaries between past and present through practices of circulation and reproduction, again like photographs themselves.

Digital environments foster affective and atomized histories as photographic assemblages are gathered on the plane of time – the present. Such a temporal movement is enhanced and reinforced by the material experiences of looking. These trends are also profoundly linked to ideas of presence, social being and the subjectivities of lived experience, manifested as a self-conscious desire for historical identity and power over those

subjectivized, individualized and atomized histories. These historical modes – community histories, local histories, special interest histories, and desires for historical homelands of one sort or other, have led the way through the early stages of web development in relation to history. This is because they are forms of historical engagement that work well with new and developing communication technologies. They are comfortable with the privileging of content over other forms of historicity, and are sites where users are able to build personal infrastructures premised on subjectivized historical desires.

In this process, digital artefacts have themselves become forms of memorializing practice. Significantly, many of these are photographically driven, as we saw in relation to First World War commemorations in Chapter 3. Photographs reposition historical entities and enact multiple translations and displacements. They furnish new processes of positioning the past as an active entity in the present. These are dynamic configurations in the historical imagination, manifested through the immediacy and realist claims of the photograph. However, simultaneously, digital management enables an emphasis on the real that collapses time and distance, and reduces photographs to pure content in an unproblematised and free-floating notion of context. The language of the real becomes reinforced, however inappropriate.

In this desire for an immediately apprehensible past in the present, and its appeal to popular historical imagination, it is worth pausing to look at the growing fashion for digitally colourizing photographs, and indeed film, which is inserting itself into the historical field. The practices of colourization, and resistencies to colourization, tell us much about the intersection of historical imagination and photographs, and what the digital does to history. Colour, time, morality and representation, the tensions between the 'true', 'the real' and the cosmetic have long and entangled histories of affect and historical saliency. Until at least the 1970s 'real', and by implication 'truthful', social documentary photography was deemed to be black and white photography, not colour. While colourization practices raise questions about the material integrity of the archive, most significantly, they play on time, distance and presence in interesting ways. Colour has become a metaphor for a history that is 'alive', and even more so, 'relevant'. If much of this activity is in popular rather than academic history, it is creeping in not only in the colourized book cover but the illustration of reviews in serious-minded general-interest journals, infiltrating the historical imagination without comment. I have recently seen, for instance, portraits of Charles Dickens, Charles Darwin and Anton Chekhov presented like this, without comment. Likewise, in popular histories, press stories and television advertisements colourization is becoming increasingly common. For example, the television and press

advertisements, for the family history resource *Ancestry.co.uk* feature a monochrome photograph that morphs into digital colour, signifying both the desired identity-affirming 'aliveness' and closeness that is to be experienced in finding one's ancestors and a narrative of discovering the 'real'.

Furthermore, commercialized pastness and nostalgia is being channelled by BigTech firms with apps, such as 'TimeHop' and 'On this Day' which harness old social media 'memories' to shape individualized and emotional relations with the past. Even more animated is the application of controversial 'deepfake' technologies (of the kind used to create fake news) to 'bring your ancestors back to life'. In 2021 the popular family history platform MyHeritage began offering 'deepfake nostalgia' software to animate family photographs (or any photographs or images for that matter – portraits of famous composers and Rembrandt paintings have been 'deepfaked') in order to 'experience your family history as never before'. Although this offers only animation, not speech, it has also produced deep fake and digitally coloured audio images of Abraham Lincoln, Queen Victoria and Florence Nightingale.[6] While serious historians might naturally eschew such gimmickry, and it is meant as a bit of fun that brings a whole new meaning to romantic and 'resurrectionist' histories (what would Ranke and Michelet think!), the fact remains that such engagements with the inscriptions of the past are 'out there' in the larger historical landscape, part of the digital vocabularies of the present, and thus part of our broader concern. That this might indeed be a concern is demonstrated by the fact that a serious form of public history (which have their academic advisors), such as the POLIN Museum of the History of Polish Jews in Warsaw, uses animated still photographs extensively in its displays, or did when I visited in 2015.

Instances of colourization are also perpetrated by archives themselves, on serious historical sources as diverse as at the excavation of the tomb of Tutankhamun in 1922, the US Civil Rights movement, or, more troubling, the colouration of photographs of those murdered in Auschwitz.[7] What is interesting about all such projects is that they claim to close historical distance, 'to make the past come alive', effectively restoring the world as people in the past saw it (always a spurious claim whatever our means of access to the past), and to people as they would have been. They become, in this discourse, resurrected presences which confuse reanimation with witnessing, yet 'what is also evaded with the colouring of history is the realization that photography and film are not a restoration of the past, but evidence of its historicity'.[8] These digital remediations and realignments of historical distance into closeness are shaping the kinds of history made visible, and the nodes of visibility in historical imagination. Colour has come to fit the historical imagination and stands for the possibility of empathy

with things past. It marks photographs' emphatic ability to be rekindled. Like the 'nostalgia apps', it plays with distance and delivers a desired closeness that accords with the needs of a subjectivized and atomized historical desire.

Like questions of time and presence, increasingly the institutional contexts and materialities that pattern collections and the availability of sources that I noted in the previous chapter, are being loosened in a digital world. However, in relation to photographs, the potential of that availability and fluidity for the historiographical disruption remains very much dependent upon choices made about the digital, and upon the kinds of histories they articulate. I noted earlier how abundance should not be mistaken for completeness or even representativeness. A check between an institution's catalogue descriptions and its digital offer is often a useful corrective here. Beyond the digitization of photographic assemblages for specifically focused research projects, digital offers are often born of convenience and availability, rather than of critical centres of gravity and calculation (to use Latour's term). I once asked the head of an institution why a certain collection had been digitized, it seemed a strange choice of resource allocation for that institution. The reply was: 'they are all the same size, we could scan very quickly and meet our digitalisation targets'. Certainly convenient rather than critical, but an approach which will, through simple availability, force this particular set of photographs to the top of the historiographical heap and, as the processes of history writing kick in, endow with historical significance through that very digital visibility.

Moreover, although digital environments and methods offer new ways of thinking and excavating old historical problems and formulate new ones, the flexibility and potential of the digital access to photographs, and consequently the work they might do, is controlled by layers of organizational categories enacted through complexes of algorithms, filters, tagging, keywords, the absorption of new data and the overwriting of the old, for instance. Softwares are powerful epistemic and far-reaching apparatus, they are not merely tools. Their functionality is designed to produce data in certain ways, which in turn shapes what can be extrapolated from it. Softwares produce algorithmic assemblages from algorithmic photographs in ever-evolving relationships, while computational organization, management and storage completely reformulate any quaint notion of 'the archive' that we might have had. Materialities also play their part as screens and software (both as data management and design) shape and regulate size, colour values and so forth. They constantly and fluidly mediate the ways in which photographs are encountered, adding yet more layers to an already highly mediated and unstable historical form. Consequently, the technical nature of digital environments, their structures and interfaces are also questions of authority,

authenticity, ownership and, ultimately, a responsibility that shape what photographs can 'do' as sites of historiographical disturbance.

The uneven yet expanded flow of images, unimpeded and uninformed by a rigorous address to the historiographical and epistemological suggests a bleak future for the relationship between photography, history and the historiographical. It is one in which we are pushed back into fiddling about with what photographs are of, rather than what they do. This has massive methodological implications. My concern is the way in which we are seeing historical photographs shift from being sources of analytical potential, central to conceptual and analytical thinking (and this was a hard-won battle), to being once more simply resources to be managed and made available, their connective tissue disturbed and rendered impotent in historical terms. As such, photographs become mere tools of expression, circulation or authentication, rather than generating historical narrative from the image itself. In other words, an old problem in a new form.

The extent to which this position is so, of course, depends on individual projects, the levels of photographic/historiographical sophistication and awareness brought to the analysis. But digital projects of, say, changes in the urban landscape or assemblages of photographs on the American Civil War, present photographs of events with little cognizance that the photographs themselves structure and mediate the historical understanding of that event. This again effectively pushes photographs back to being an unmediated window on the world. While as I have noted throughout, this is not a position to which many would now subscribe, there is a danger yet that it reasserts itself in the multimedia explosion of digital environments. For instance, many digital research projects use photographs on their appealing home pages. They look as if they engage historically with photographs. But, if one digs deeper, one realizes that the photographs play little role in the actual research. We are back with the illustrative and decorative.

So far I have painted a somewhat negative account of the digital, in which the potential of photographs as a site of historical disturbance is decentred. This is not because I am especially sceptical about digital futures in historical practice, but because hard-won methodological green shoots of serious engagement with photographs are in danger of being swamped by a slide back into the uncritical. However, there are signs that the digital prominence of the visual, including photographs, is carrying an increasing historiographical and epistemic weight. For example, the website *Photogrammar* offers multiple ways into the photographs of the US Farm Security Administration, 1935–45, which documented agrarian distress through the Great Depression. The resource unpicks the acts of inscription, sense of time and practices of context, in which the photographs are embedded through places, original

captions, and acts of inscription, in ways that greatly enhance their critical historical potential.[9]

Digital environments also offer the possibility of more experimental forms of analysis with photographs, as they blend narrative source development, historiography and interpretation. Digital environments allow shifts away from dominant textual forms and enable other historical forms, notably sound and visual, and routes to alternative historical narratives to be privileged. Often the result of experimental historical work, blending sound, graphs, maps and other expansive historical sources, the digital suggests new materialities, surfaces and performances that refigure inscriptions and produce new frames of analysis and forms of gravity and calculation. They cause disturbances as photographs become central to new ways into historical narratives because they bring to the fore, and integrate, them, allowing them to make a mark. Digital assemblages of photographs, with other media, can break down assumed linearities and geometries of historical practice, and forge connections with other historical forms as both evidence and argument.

An example of this, and redolent with a sense of presence, is the project *Returning Photos: Australian Aboriginal Photographs from European Collections*, which in its merging of oral and visual modes, facilitated the retrieval and articulation of cultural memory for Aboriginal communities seeking access to their heritage.[10] Another example of digital enablement is *[Re]: Entanglements* which presents diverse responses to photographs taken in Nigeria and Sierra Leone by early twentieth-century colonial anthropologist, Northcote W. Thomas. Notably, in the sub-section *Faces/ Voices*, the project reveals historically and culturally located patterns of embrace, challenge and rejection of photographs, both because of, and in spite of, their colonial inscription.[11] Identities are articulated within the project in ways that bring listening, speaking and watching photographs to the analytical and affective surface through oral, visual and haptic histories. As such, the project shows the complexities of photographs at work in a historical domain, here the colonial, which simultaneously open up broader questions of ethics and voices in historical representation. The approaches of such projects constitute a robust intellectual recognition of the intersection of photographs and historical possibilities in the digital as an environment that facilitates expanded historical forms and narratives. Here photographs are used as a way of thinking, and ways into understanding and articulating pasts.

Yet another good example in relation to the questions that interest us here is a digital history project *Invisible Australians*.[12] This project explored the experiences of early twentieth-century non-European migrants to Australia – Japanese, Chinese, Indian, Afghan, Syrian and Malay – in face of the White

Australia Policy. Building on facial recognition techniques, the photographs on immigration and other official papers become the initial and central entry point into the project and the histories it articulates. One reaches the text only through the prism of photographs. This creates a specific pulse to the project. Time, distance, scale and presence are able to resonate through it, as the user excavates variously atomized, synoptic and collective histories.

Nonetheless, there are slippages. Historical identities are restored to individuals by initial entry points, the home page of the project. But these entry points use only the full-face photograph from the original pairing of full face and profile. This removes them from the dehumanizing implications of anthropometric and identity card photography. While one click will take you to the original archival documents, this intervention passes without comment. But that click reveals the multiple material traces of the experience of migration – official stamps, printed forms, manuscript notes in various hands, and on occasion, palm prints, like photographs, direct traces from the physical world. However, like the projects noted above, the stress on individual encounter is important to the ways in which the narrative is signalled, premised and delivered - individual histories entangled within state ideology and apparatus. This web resource furnishes a good example of the way material mediations are used to shift the intermedial historical work of photographs and thus the dynamics of the narrative. Like the *[Re]: Entanglements* project, with its associated blog, the project has stimulated historical, archival and personal or affective debates, bringing together in a rich matrix of historical and memory forms. While this is a simple and clear instance (many are not), it points to how digital engagements, in which photographs are absorbed as evidence, can be markedly interventionist as they are put to historical work. They shape historical access and interpretation. These are examples of histories where photographs are central as both source and the means of historical incision, where photographs set the parameters of historical enquiry, and act as historiographical anchors while forming multiple layers.

Such projects overall must surely have a knock-on effect in the way that the broader historical endeavour and its questions are shaped. But only if we go back to my original position, that photographs are understood as prime movers in historical practices and historical imagination that are integral to the construction of the historical landscape. This is why such projects are significant here. However, making this assessment requires a robust and ongoing analysis of the common practices of digital media and the capacity of photographs within this. Working with photographs is, in many cases, held out as one of the experimental benefits of the digital (easier access, accumulation, reproduction, and/or dissemination). However, the wider

implications for the practice of history, what kinds of histories are being produced, are seldom discussed.

The validity of digital systems is shaped by, and themselves shape, contemporary sensibilities to historical sources, as photographs circulate and work across social media, mobile phone technologies, and through citizen journalism and activism and so forth. Photographs function, historically, in new configurations of connected experience and presences, which constitute new ways of imagining the world and the past, ones that have their own contexts. Time will tell if we can address that Scylla and Charybdis of digital humanities, if new methods for understanding the past will emerge, and whether photographs are allowed to create a mess, a historical disturbance. It rather depends on how historians come to think of the saliency of photographs within expanded historiographical frames. Is the digital to be a triumph of medium over method, that finally lures them into the seduction of the surface, the atomized, fragmented, side-glanced image as it collapses into illustration? Or will the enormity visual/photographic possibility open coherent ways of thinking about how photographs might contribute to the expansions of scale, and its associated methodologies, such as big-data visual and cultural analysis, that move beyond the traditional practices of history as a discipline.

However, a coda is needed here – because the assumed relationship between the real world and the trace or inscription of photographs is now profoundly challenged not merely by digital making and circulation, or the questions of unending abundance, but by the development of AI systems, robotics and advanced algorithmic functions that merge images and data. These photograph-like images are not inscribed from the physical world in a direct sense of inscription, or of archival location, which has always informed historical practice. Instead, in what has been termed 'soft images', 'photographs' are increasingly software-constructed mergings of hybrid networks of images-types and data about images, where images are not only controlled by algorithms but are themselves inhabited by algorithms.[13] Images, such as JPEGs or those taken every day on iPhones, are described through technical data, stylistically coded, organized through facial recognition and located through GPS, for instance. They are rendered essentially programmable, networked and traceable: 'composed of pixels, keywords, geo-data and technical details, captions, and copyright information, complemented by commentaries and hashtags'.[14] They represent a non-human turn, a departure from the humanistic tradition to which history has always been integral. One wonders how historians of the future will manage with photograph-like images (and we aren't even talking about 'fake images' here) from which direct inscription is effectively stripped out.

The historical is thus rendered ahistorical within a series of patterns created through image-recognition systems and geo-data, rather than the specifics of 'evidence': images that carry not only depictions, as conventionally recognized, but challenge the very basis of what a photograph 'is' and the historiographical expectations and practices that can and should be brought to it. The digital becomes a site of transformation and translation between multiple modes of historical apprehension. For what kind of evidence, and of what, will they come to stand? It's worth thinking about. Only by being alerted to those expectations that cluster around the interface of photograph and historiography that I have suggested, can we begin to understand our historiographical assumptions and how they might be challenged.

Epilogue

The energies that I have attributed to photographs in the historical landscape throughout this book are not necessarily definable, right or wrong. Problems with no clear solution are, after all, important drivers of intellectual questions. Consequently, I have wanted to raise a series of sensibilities about the intersection of photographs and the practice of history and to understand, to some degree, the disturbances that the existence of photographs might cause to the categories and assumptions that underpin those practices. Questions of time, distance, scale, presence are brought into play in new ways, for as Eelco Runia puts it: 'each new strategy of externalization presupposes a transformation, and each transformation makes room for a new proliferation.'[15]

Research methods, of course, do not remain static, and historians are always alert to the practices and intersections in play at any given moment of historical engagement. My concern has been to consider how the existence of photographs might move on research thinking, categories and thus methods. If we are sceptical about some of the more extravagant claims made for the transformative potential of the digital in how histories are researched, written, and disseminated, the same concerns pervade the historiographical engagement of photographs. And both these problems might elicit the same response. If we don't try we might never know. For if digital environments have rendered theories of photography itself increasingly inadequate, they have rendered theories of history equally so. But for all the plenitude, ease, visibility with which the digital has endowed photographs, their Janus-faced quality, with which I started, is still with us. It is working both for and against that historiographical potential. Will it keep the photographic

static – flattened, fragmented and dislodged – its think-spaces neutralized and its historiographical potential for disruption contained? Or will the new opportunities to access gather up the historiographical potential of photographic inscriptions of and from the past to make a difference to what we all do?

We live in exciting historiographical times.

Bibliographic Afterword

An extensive range of literature on history, method, photography and historiography has been absorbed into this book, and as Eelco Runia puts it, it is now 'time to focus on how, in history, as well as in historiography – the exhilarating, frightening, sinful and sublimely new – comes about'.[1]

As I noted in the preface, I could have written a detailed, heavily footnoted, and probably incredibly worthy and tedious tome. I have chosen, for better or worse, a different essayistic approach in which my thinking has absorbed, remoulded, inverted and extended the work of a multitude of scholars to whom I am grateful. I thank them all for their inspiration and for providing sparring partners. As they are too many to cite – my endnotes would be as long as the book itself – I have endnoted only where I have quoted or referred directly to other people's work. Also, conscious that I have inevitably skimmed over very substantial fields, I have, where I have felt it necessary, added a note to indicate a useful pathway into those arguments.

In this bibliographic afterword, I gather those texts which I have found most productive. This is followed by a Selected Reading list which distils this to a range of core readings. Again these are, of necessity, shorter lists than they might be, and perhaps rather idiosyncratic ones. Some works do not even mention photographs or the visual, or they address periods of history predating the photographic age. But they all sharpened both my methodology and my appreciation of how photographs might work at the intersection with those ideas. As such, this essay is akin to a methodological road map, indications of the directions I took.

Most of my underpinning comes not from photographic studies but from history, historiography and theory of history. Throughout, key journals, notably *History and Theory*, *History Workshop Journal* and *Rethinking History*, have been my constant companions. Although it seldom mentions photographs (except Jennifer Tucker's important special issue of 2009), *History and Theory* in particular has provided a vital springboard and corrective throughout. Its rich debates on, for instance, event, writing, affect, temporalities and historiographical trends, have been invaluable, though if I have to pick two contributors who have provided constant food for thought, they would be Eelco Runia and Nancy Rose Hunt. Hunt's account of 'the

sly poetics of historical practice,' a lovely phrase, has much to say to those working with the historiographical tensions of photographs. Ludmilla Jordanova's 2011 review article 'What's in a Name: Historians and Theory' provides a thoughtful assessment of what is at stake, while Ethan Kleinberg's *Haunting History* explores the assumptions and categories that underlie the theory and practice of history, notably a sense of historical ontology and deconstruction. They have similarly shaped my account.[2]

Paul Ricouer's writings, notably his classic *Memory History Forgetting*, have been a constant source of historiographical challenge, and, although quite old now, Dominick LaCapra's *History and Criticism* provides a lucid overview, although, of course, too early for some of the more recent methodological debates and developments.[3] Likewise, François Hartog and various essays by Reinhart Koselleck have been good to think with around questions of time, event, and past and present relations, especially because of the latter's broader engagement with the pictorial.[4] The writing of Ann Laura Stoler, notably *Duress* and *Along the Archival Grain*, has been a persistent influence in her challenge to categories of historical thinking and, above all, historical practice through what she describes as 'concept-work' – what categories and assumptions are brought to historical understanding, in her case, the colonial and its deposits? Mieke Bal's classic *Travelling Concepts in the Humanities* remains good to think with, not least because much of her address to the categories of analysis we use, such as image, intention, or performance, is premised on visual culture.[5]

More generally, it is always interesting to re-read classic writings on history and theory of history, from Richard Evans' *In Defence of History* and Keith Jenkins' *On What Is History* to James Tully's *Meaning and Context: Quentin Skinner and His Critics*, along a 'photographic grain'.[6] This is not only because an acknowledgement of the role of the visual in history-making is strikingly absent but because, read along the photographic grain with the kinds of questions I have asked, it is striking where unarticulated and unrecognized yet productive points of intersection and friction lie – everything from method to imagination. What might such arguments look like when cross-fertilized with photographs? Such questions are addressed by the 2009 special issue of *History and Theory*, edited by Jennifer Tucker. Her introduction provides a helpful discussion of questions of evidence, followed by important essays, especially those by Julia Adeney Thomas and Michael Roth. The issue remains a key source and orientation of the arguments, as it lays out the historiographical stakes of photography and history.[7]

The individual chapters have been informed by a wealth of literature. It is difficult to enumerate it under those individual chapters, as many discussions have much to say of relevance to a number of my themes, so they should not

be read as a tick list. In any case, it can only be indicative of the sprawling literature on all my strands. Anyone interested in pursuing strands should apply themselves assiduously to the bibliographies and citations in all that follows.

There is a huge theoretical literature on 'trace' or inscription, often within discussions of indexicality. Likewise, discussions of inscriptions, often embedded in those on historical facts and historical sources, abound. Specifically on photographs, Patrick Maynard's 1997 *Engine of Visualization*, especially chapter 2 'Making our Marks', discusses photographs as a 'marking of surfaces', that is, an inscribing technology which resonates through my account. Conversely, Janne Seppänen provides an excellent and approachable overview that takes material trace and inscription into the realms of physics. Following Michel Frizot's short 2007 essay 'Who's afraid of Photons?', Seppänen links its rationale to digital environments in useful and expansive ways that question assumptions about trace and inscription in ways that historians would do well to note. Incidentally, this is just one of Frizot's many productive interventions in the field which underpin aspects of my account.[8] They are worth a historiographical detour. Sean Cubitt's *Practices of Light*, in examining the conditions of visibility, provides a detailed and thought-provoking address to many of the questions which run through this book, notably those of inscription, time and materiality. Many authors have addressed the random inclusiveness and contingency of photographs, often emerging from engagements with Roland Barthes and Walter Benjamin. Shawn Michelle Smith's *On the Edge of Sight* (2013), is a helpful orientation and guide through these debates.[9]

Time, and its conceptual co-relate, space, run through all my chapters, because photographs contain and operate within multiple times. At base is Roland Barthes' 'there-then, here-now' as a statement of the temporal insistence of photographs. But there is a huge literature here. Those I have found most useful in orientating my thoughts have been François Hartog's *Regimes of Historicity: Presentism and the Experience of Time*. Although nowhere does he mention photographs or the visual, his ideas concern past/present relations in ways that resonate with the temporal complexities of photographs and their insistent 'there-then-here-now'. Lynn Hunt's *Measuring Time: Making History* is a productive deliberation that links time, technology and other commonplaces of historical method, notably event.[10] There are a number of constructive overlaps in the photography/visual literature: Martin Lister's essay 'The Times of Photography' is especially useful from the photographic perspective, while Mary Ann Doane's sense of the representability of time, event and the imagination of modernity in her *The Emergence of Cinematic Time* are key ways into to thinking about this field.[11]

Mark Salber Phillips' indispensable and thoughtful book *On Historical Distance* and related articles in, for instance *History Workshop Journal*, have been a mainstay, notably on the forms and preconditions of distance and on sentimental histories as their tentacles reach in many directions.[12] My only puzzle is that he so rarely mentions the presence of photographs in the historical landscape when the argument, particularly in the latter chapters, cries out for their disturbances and infiltrations. But then, as I have noted throughout, photographs are strangely absent from many considerations of history writing. Likewise, Chris Lorenz's thought-provoking 2010 essay 'Unstuck in Time' contains much of interest to us here in relation to contemporary history writing. It has, along with Hartog's *Regimes of Historicity*, orientated ideas about the present, which I translate here into the temporal energy of photographs.[13]

Concerning the entangled concepts of abundance, scale and excess, scale has been increasingly discussed in relation to global and local/ regional histories and their interpenetration, although photography rarely figures in these debates. It does, however, resonate through Tucker's special issue of *History and Theory* noted above. Many writers have addressed the abundance of photographs in traditional environments: Annabella Pollen, Craig Campbell, Robert Hariman, John Lucaites and myself. Although I term abundance what they call 'scale', Tomás Dvořák and Jussi Parikki's edited volume *Photography Off the Scale* addresses the ways in which material and computational cultures have transformed the challenges of visual culture.[14] They demonstrate the different approaches that have been useful here, for there is no one way to deal with abundance and the endlessness of photographic scale. Within history itself, contributions to a *Past and Present* supplement 'Global History and Microhistory' (2019), notably essays by Christian de Vito and Jean-Paul Ghobrial, on global history as scale has been useful in many aspects, especially as photographs have been actively, if unacknowledged, mediators in these processes. Christian De Vito's concept of the micro-spatial, as a way of combining microhistories and global scale forms of complex connectedness, rather than as different forms of vertical incision, resonates usefully here. And while photographs are again strangely absent, the *American Historical Review* conversation on scale 'How Size Matters,' and why certain forms of history emerge, nonetheless provides a useful analytical think-space.[15] On ideas of abundance in the public sphere, which must concern historians of the modern period, Robert Hariman and John L. Lucaites' *The Public Image* (especially chapter 7) has provided a hugely productive and rich debate, even if our specific takes on abundance are slightly different. Deborah Poole's classic essay on excess, although focusing on nineteenth-century

anthropology, has much to say in this debate, despite my preference here of the term 'abundance' and 'plenitude' over 'excess'.[16] More generally, I found Simona Cerutti's article 'Microhistory: Social Relations versus Cultural Models' (2004) productive for positioning ideas. Although not concerned with photographs at all, I found her unpicking of the layers and time depths and the way context relates to scale productive to think with as her ideas cross-fertilized across the historical commonplaces that concern me.[17]

In writing on event, Martin Jay's essay 'Photography and the Event' was essential, even if we approach the question from different ends. In ways useful for the non-philosopher, he pulls together the thinking of a number of key French theorists on the nature of event and occurrence, such as Gilles Deleuze and the work of Alain Badiou, notably *Being and the Event*, which itself draws on Deleuze. In general, I have found Jay's work resonates through much of my deliberations. These debates are entangled with those of time, distance, scale, and, as Jay notes in another essay, with context. His ideas on the gravitational force of event have been useful in thinking through what photographs actually do here. But event and its pictorial forms are also inflected with time, and this is usefully explored, especially in relation to Reinhart Koselleck and importantly for us in its historiographical implications, by Britta Hochkirchen's 'Beyond Representational Time'. Susan A. Crane's *Nothing Happened*, which does address photographs in relation her discussion of memory and 'nothingness', also has distinct resonances with my argument, although again we approach the question of happenings and non-happenings from different ends.[18]

To turn to questions of presence: photographs, as I discussed, have always a seductive reality effect. Eelco Runia's classic 2006 essay 'Presence', in which he discusses the 'stowaways on the plane of history', seems to describe the historiographical work of photographs exactly. Photographs are full of stowaways on the evidential plane.[19] Ann Laura Stoler's discussion of presence in *Duress*, noted above, has also stimulated some pertinent questions about the overlays which disguise and submerge historical presences. More broadly, her call to inhabit concepts differently resonates with my account – here concepts such as event, time and context. Presence, as the basis for historical expression, weaves its way through Ethan Kleinberg's *Haunting Histories*, as he links presence to questions of memory, trauma, agency and Frank Ankersmit's discussion of the sublime as historiographical modalities.[20]

There is very substantial literature on the work of experience and historical consciousness which informs here. In relation to photography, Michael Roth's 'Photographic Ambivalence and Historical Consciousness', in *History and Theory*, brings together a number of themes, notably event, presence and memory, to rich effect. For me it was an anchor text. Ankersmit's work around

sublime historical experience, referred to above in relation to Kleinberg, and his discussion of the shift in historiographical desire from meaning/representation to experience, seems to resonate with much of the work now emerging on photography. Likewise, critical analysis of Ankersmit's position, notably Anton Froeyman's paper on Ankersmit and Runia's historical thinking, and Jonathan Menezes' 2018 essay 'Aftermaths of the dawn of experience' are useful contributions to this debate, and photographic relevance can be extrapolated, even if they do not address it as such.[21]

A classic essay on experience and subjectivity as historical modalities, and on which many have built, remains Joan Scott's 1991 paper 'The Evidence of Experience' in which she discusses vision as a privileged form in relation to experience, while Jonas Ahlskog's 2017 paper on R. W. Collingwood establishes as useful the *longue durée* of ideas of presence within history (as opposed to philosophy).[22] The work of the historians in their ontological turn is useful here. A good starting point is Michael Bentley's essay 2006 'Past and "Presence": Revisiting Historical Ontology', while Ewa Domanska's 'Material Presence of the Past' extends the discussion in useful and material ways. Collectively, their critical analysis calls for a return to the very stuff of history, that real things happened to real people in the past, but under what conditions should we understand it? Such a position is the basis for Ranjan Ghosh and Ethan Kleinberg's edited volume *Presence: Philosophy, History, and Cultural Theory for the Twenty-First Century*, which works through ideas of presence. This also includes some address to the work of photographs, notably in Susan Crane's essay which shifts photographs from 'sources' to a more conceptual realm of historical knowledge.[23] Conversely, presence and affect provide core analytical foci for both Lisa Cartwright and Elizabeth Wolfson's special issue of *Journal of Visual Culture* and, while looking exclusively at anthropology, Christopher Morton and Haidy Geismar's special issue of *Photographies*.[24]

In terms of the extensive discussion of context as a concept and method, as Peter Burke pointed out in his essay 2002 'Context in Context', context itself has a history in shifting ideas of the circumstances of a thing or action. It is an interesting exercise to slice photographs across these arguments and how they work as mechanisms of constraint, illumination or opening. Thus, although they are writing on intellectual history, I have found Peter E. Gordon's essay 'Contextualism and Criticism in the History of Ideas' and Ian Hunter in *History and Theory* especially helpful in orientating thoughts on the constraints of context and the tensions between containment and movement.[25] Martin Jay's essay on contextualism and event, noted above, also provides both a useful summary of the debates from Quentin Skinner to Hayden White and beyond, and a robust philosophical address to the issues. Frank Ankersmit's comments of the shifts from centrifugal to centripetal

understandings and the role of context have also been formative here, as well as his discussion of the way context can deflate and empty the thing itself, here a photograph. This consideration of the overpowering claims of context is also taken by another robust critical essay, Rita Felski's wonderfully titled 'Context Stinks'. In addressing the agency and voice of the literary text, it has much to say to those of us working with photographs.[26]

This brings us to questions of materiality. There is again a huge literature on this, ranging from philosophy to archaeology: what are things, as opposed to objects, and what do they do in human relations? Ewa Domanska's essay 'Material Presence of the Past', as noted, also addresses the ontological turn. She both positions the material turn philosophically, and as a 'return to things' in historical practice, provides a useful and incisive overview and case study, while Karen Harvey's edited volume *History and Material Culture* provides a good, but philosophically gentler, introduction, with a good range of essays by historians working with objects. However, like the equally useful *American Historical Review* discussion 'Historians and the Study of Material Culture', there is nothing touching on photographs as objects; indeed, material culture is revealing positioned as an 'alternative' source.[27] Daniel Miller's introduction to *Materiality* gives a broad theoretical sense of the issues at stake and in ways that relate back to questions of agency, presence and subjectivities, while essays by Christopher Pinney and Nigel Thrift in that volume address questions of temporality and digital affordance in ways that extend my argument here. In relation to human/non-human relations, the work of Bruno Latour and Tim Ingold is central as they develop models of analytical connection, while Alfred Gell's *Art and Agency* has become the classic text as an anthropological post-structuralist theory of the effect and affect of things.[28]

On the material properties of archives, Ala Rekrut, from whom I borrowed the term 'material literacy', gives a cogent account of the range and issues of archival materiality, from inks to paper textures, in her 2006 essay 'Material Literacy: Reading Records as Material Culture', while Gillian Rose's classic piece, 'Practising Photography', explores how material and embodied practices of the archive produce the researcher herself. This theme frames Arlette Farge's now classic *The Allure of the Archives* ([1989] 2013). Although her study on pre-revolutionary France is obviously pre-photographic, Farge's account of the fine grain of archival effects has much to say to us here, as does Stoler's *Along the Archival Grain*.[29] Such questions also weave their way through the more specifically archive-focused work of scholar-archivists such as Terry Cook and Joan Schwartz. Good overviews of archival issues, from a huge literature, can be found in Tim Schlak (2008), Cook (2009) and Schwartz (2020) and references therein.[30] In addition to which much of

interest here can be found in the theoretically informed Canadian journal *Archivaria*.

There is a huge and growing literature on the digital in a fast-moving environment, not only in relation to specific historical modes such as memory but in the effects of digital sources on research processes. Nevertheless, much of the literature is concerned with the medium not the method, let alone message, and it remains that the wider historiographical implications are less thoroughly explored. Given the nature of the animal, much of the debate is not in printed form but in blogs and other online fora. While these provide an excellent critical base on, for instance, the workings of algorithms and a cautious approach to digital, even so there is relatively little debate on the conceptual and epistemic aspects of digital worlds in history when compared with discussions about the sophisticated delivery of sources and the presentation of analysis, for instance those made available through sites such as *The Programming Historian*.[31] However, it is a fast-changing field.

Of the analogue printed world, as well as the early (a relative term) classic, Roy Rosenzweig's *Clio Wired*, the most useful have been Lara Putnam's 'The Transnational and the Text-Searchable: Digitized Sources and the Shadows They Cast', *American Historical Review*, especially her notion of 'side-glancing', Ludmilla Jordanova's 'Historical Vision in a Digital Age' in *Cultural and Social History*, and Gerben Zaagsma's introduction to a special issue of *BMGN- Low Countries Historical Review*. They offer accounts of the conceptual consequences of the digital on the practices of history, rather than nuts and bolts, however sophisticated.[32] Seth Denbo's 2018 essay 'Digital History' is a productive critical overview of the issues and his address to questions of scale, institutionalization and historical realignment resonate with mine here, whereas, although not addressing history specifically, both Joanna Zylinska's work on non-human photography and digital image worlds and, again, Dvorák and Parikki's *Photography Off the Scale* on the character and scale of digital image worlds, provides much food for thought.[33] Useful orientating volumes have been Shawn Graham, Ian Milligan and Scott Weingart's *Exploring Big Data History,* and Toni Weller (ed) *Doing History in the Digital Age*, especially Brain Maidment's essay on 'Writing History with the Digital Image' and Luke Tredinnick on the remediation of historical experience; likewise is J. Dougherty and K. Nawrotski's edited volume *Writing History in the Digital Age* and essays therein.[34] Even if their focus is, again, sometimes more on the technicalities, all address major historiographical issues around categories and assumptions at some point. It was this last volume that alerted to me to the parallel shape of debate around the digital and photographs (although it doesn't address the latter) as anxiety-inducing and transformative forms.

On questions of the implications of the increasingly prevalent practices of digital colourization and the visual reinforcement of narrative, Santanu Das' *American Historical Review* piece 'Colors of the Past: Archive, Art, and Amnesia in a Digital Age' provides a lucid account of why this matters, while Peter Geimer, in a 2016 essay, discusses colour and reality effect more broadly.[35]

An extensive range of photographic studies underpin and inflect my account. Many, however good, are limited in this context because they turn inwards to what is specifically photographic, with a lurking sense of medium specificity, rather than looking out to the impact of the very presence of photographs in the historical domain, and the articulation of historians as photo-minded people. There are some notable exceptions. Ulrich Baer's *Spectral Evidence*, in particular, has been especially fruitful. Although he is writing specifically on photography, trauma and Holocaust, his challenging ideas about the time of photographs, his thoughts on the inadequacy of contextualist approaches and his development of notions of presence and inscription were, like the work of Stoler and Roth noted above, key starting points for me. The work of Robin Kelsey (2015) on chance, although specifically on art production, has been useful in thinking about inscription and scale, notably the introduction and chapter 6 where he gets closest to considering chance in relation to history, or at least 'record'. More generally, Gil Pasternak's edited volume *Handbook of Photographic Studies* (2020) carries a wide range of incisive essays on the work and intersection of photographs with a number of themes and disciplines which are pertinent here, from science, archaeology, news reporting or museums to questions of race and gender.[36]

Eduardo Cadava's *Words of Light: Thesis on the Photography of History* on Walter Benjamin's interest in the metaphorical relationship between photography and history, and his recourse to the language of photography in his search for a new vision of history and new structural forms, constitutes a major underpinning here. It provided me with a productive undertow to my approach here. Alongside this is Vanessa Schwartz's useful 2001 essay 'Walter Benjamin for Historians', and of course Benjamin's own essays that I always read together, 'Thesis on the Philosophy of History' and 'A Small History of Photography', while Kathrin Yacavone offers an extended yet approachable comparative discussion of Walter Benjamin and Roland Barthes.[37] Georges Didi-Huberman's powerful *Images in Spite of All*, in which he considers the implications of some of the few surviving photographs of the work of the *sonderkommando*, is an important essay on the nature of photographs, historical nuance and archival patterns. It is also an address to the scales and modes through which we ask questions of photographs, challenging

notions of the limits of representation, and brings to the surface the ethics of historical account in relation to photographs.[38]

Of the historians (in the broadest sense), there are increasing numbers of photographically driven and theoretically informed histories, and where one can see some of my discussion in action over topics as diverse as twentieth-century German history and colonial archaeology. Examples are studies by Christopher Wright (2013), Jane Lydon (2016), Catherine M. Clark (2018), Maiken Umbach and Scott Sulzener (2018), Paul Betts, Jessica Evans and Stefan-Ludwig Hoffmann (2018), Matthew Fox-Amato (2019), Christina Riggs (2019), Patricia Hayes and Gary Minkley (2019), Margaret Hillenbrand (2020), and Erika Hanna (2020).[39] They all, to a greater or lesser extent, are concerned with the questions that I have raised here, namely the kind of histories it is possible to write out of the photographic image, and the kinds of historiographical need that that engenders? As Hayes puts it, such studies are collectively an address to the ways in which photographs 'compress, fold, and unfold different historical layers and possibilities of interpretation'.[40] Likewise, photography has been an important, indeed formative strand in memory work and its intersection with identity, notably in the work of Marianne Hirsch, Annette Kuhn and José van Dijck.[41] This is especially so in considerations of non-textual histories and different global conditions of the work of history. There are exemplary case studies from Canada, the Solomon Islands and Australia, for instance.[42] More broadly, in addition to Pierre Nora's classic work on memory, *Les Lieux de Memoire*, Paul Ricouer's classic *Memory, History, Forgetting*, noted above, provides an important think-space on the nature of history and the shifts to a memory practice, in which photographs have been a constant presence.[43]

There have been a number of productive special journal issues, with both general and specific foci: *History and Theory* (2009) I have already noted; the special issue of *Representations* (2019) 'Visual History: The Past in Pictures', edited by Daniela Bleichmar and Vanessa M. Schwartz, is in part pre-photographic in its focus but is nonetheless useful in addressing broader issues of visual history. The journal has also carried a number of relevant topics over the years. More overtly historiographically minded are Hunt and Schwartz's special issue *Journal of Visual Culture* (2010), *Central European History* (2015) on twentieth-century German history, *Journal of Contemporary European History* (2018) on photography and dictatorship, and *Kronos* (2012 and 2021) on, respectively, documentary photography and critical visual historiographical practices in Africa.[44] There are also dedicated journals within the field of history (as opposed to history of photography) such as the Italian *Visual History: Rivista internazionale di storia e critica dell'immagine*, and those addressing specifically the

intersection of social and cultural history and photography such as *Transbordeur* and *Visual Resources*. The list is becoming gratifyingly long now. All these contain works of worth that contribute, especially, to an empirically grounded working out of many of the ideas addressed in this book.

While for purposes of focus and detailed attention, I have talked only about photographs, largely in their analogue forms or the digital translations of analogue photographs. Photographs, of course, work inseparably with other media and material forms, as exemplified in recent work on 'media archaeology'; Erik Huhtamo and Jussi Parikka's 2011 *Media Archaeology; Approaches, Applications and Implications* is a good starting point. Important contributions to the historical field are Stephen Bann's *Parallel Lines* on the relationship with printmakers in particular, Geoff Belknap *From a Photograph* on photography and etching in the scientific press, and Nicoletta Leonardi and Simone Natale (eds) *Photography and Other Media in the Nineteenth Century*. Likewise Michelle Henning's *Photography: The Unfettered Image* explores the expansive mobility of photographs, while also addressing questions of context, materiality and abundance which have concerned us here. They build up a rich sense of intermediality, an issue also addressed extensively in Hunt and Schwartz's special issue of *Journal of Visual Culture* noted above. Older, and particularly concerned with the material meaning of photographs, is a volume I edited with Janice Hart *Photographs Objects Histories* (2004) which explores photographic meaning beyond the image.[45] Such approaches have become the norm in the intervening years and inflect many studies; for instance, a series of *Photo Archives* interventions edited by Costanza Caraffa and colleagues under the rubric of art history and its photographic archives has consistently addressed questions of materiality from interdisciplinary perspectives

Finally, as has been made clear, this book is not a 'how-to' manual on photographs as historical sources and the methods for extrapolating meaning. There is plenty of good and considered advice on that front, and this book is meant to complement and be used alongside that literature. Peter Burke's classic *Eyewitnessing* is always worth revisiting; while concerned with discourses the visual more generally, photographs run through the larger narrative. Ludmilla Jordanova's *The Look of the Past* has a more detailed and extended address to photographs and their historiographical challenges, while her *History in Practice* provides a useful general introduction to many of the practices I discuss. On photographs specifically, I have always found Penny Tinkler, *Using Photographs in Historical and Sociological Research* useful because she takes a reflexive and grounded position that addresses questions of sources, both theoretically and empirically. All, however, address

questions of method; for instance, the relation between 'facts' and 'evidence' and the parameters of interpretation.[46] Above all, they all discuss why it matters. I always used Burke, Jordanova and Tinkler to teach with for many years, knowing my students would not come to harm, methodologically speaking. Bonnie Brennen and Hanno Hardt's 1999 edited volume *Picturing the Past: Media, History and Photography* was an early entrant into this field, while Martha Sandweiss' 2020 essay offers a solid overview of how historians have used photographs. For a different historiographical angle, parts of Hayes and Minkley's edited volume and the special issues of Kronos noted above tackle the methodological and theoretical challenges and refiguration posed by African history.[47] On methodological approaches, Gillian Rose's *Visual Methodologies*, in its fourth edition at the time of writing, Nicholas Mirzoeff's *Introduction to Visual Culture*, and, though shorter, Jennifer Tucker's, 'Visual and Material Studies' (2018), offer excellent overviews, to name but a few in this very substantial field.[48]

Nonetheless, perhaps the ultimate poetic on photography and the past remains Roland Barthes' *Camera Lucida*, which resonates through this book. His concern with the nature of photographic inscription, its effects and incompatibilities, and the disturbances it might cause, has always been whispering in the background. He provides those sly poetics for historical practice. So perhaps we should finish with his voice:

> Toujours, le Photographie *m'étonne*, d'un étonnement qui
> dure et se renouvelle, inépuisablement.
> [Always, the Photograph *astonishes me,* an astonishment which
> endures and renews itself, inexhaustibly.][49]

Selected Reading

Andersson, Peter K. *Silent History: Body Language and Non-verbal Identity 1860-1914*. Montreal and Kingston: McGill-Queen's University Press, 2018.

Ankersmit, Frank. *Sublime Historical Experience*. Stanford, CA: Stanford University Press, 2005.

Aslanian, S. et al. 'How Size Matters: Questions of Scale in History'. *American Historical Review* 118, no. 5 (2013): 1431-72.

Bal, Mieke. *Travelling Concepts in the Humanities: A Rough Guide*. Toronto: University of Toronto Press, 2002.

Barthes, Roland. 'The Rhetoric of the Image'. In *Image Music Text*, trans. S. Heath, 32-51. London: Fontana, 1977.

Barthes, Roland. *Camera Lucida*, transl. Richard Howard. London: Flamingo, 1984.

Bentley, Michael. '"Past" and "Presence": Revisiting Historical Ontology'. *History and Theory* 45 (2006): 349-361.

Burke, Peter. 'Context in Context'. *Common Knowledge* 8, no. 1 (2002): 152-77.

Cadava, Eduardo. *Words of Light: Thesis on the Photography of History*. Princeton, NJ: Princeton University Press, 1997.

Campt, Tina. *Listening to Images: An Exercise in Counterintuition*. Durham, NC: Duke University Press, 2017.

Clark, Catherine M. 'Capturing the Moment, Picturing History: Photographs of the Liberation of Paris'. *American Historical Review* 121, no. 3 (2016): 824-860.

Clark, Catherine M. *Paris and the Cliché of History: The City and Photographs 1860-1970*. Oxford: Oxford University Press, 2018.

Denbo, Seth, 'Afterword: Digital History'. In Sasha Handley, Rohan McWilliam, and Lucy Noakes (eds), *New Directions in Social and Cultural History*, 253-266. London: Bloomsbury, 2018.

Didi-Huberman, Georges. *Images in Spite of All: Four Photographs from Auschwitz*, transl. S. Lille. Chicago: University of Chicago Press, 2008.

Doane, Mary Ann. *The Emergence of Cinematic Time*. Cambridge, MA: Harvard University Press, 2002.

Dvorák, Tomás and Jussi Parikka (eds). *Photography Off the Scale: Technologies and Theories of the Mass Image*. Edinburgh: Edinburgh University Press, 2021.

Edwards, Elizabeth. *The Camera as Historian: Amateur Photographers and Historical Imagination 1875-1918*. Durham, NC: Duke University Press, 2012.

Edwards, Elizabeth. 'Der Geschichte ins Antlitz blicken: Fotografie und die Herausforderung der Präsenz'. In Herta Wolf (ed.), *Aufzeigen oder Beweisen? Die Fotografie als Kulturtechnik und Medium des Wissens*, 305-326. Berlin: de Gruyter, 2016. English language version, https://www.academia.edu/34363133/Facing_History_.pdf (accessed 7 November 2019).

Ghosh, Ranjan and Ethan Kleinberg (eds). *Presence: Philosophy, History, and Cultural Theory for the Twenty-First Century*. Ithaca, NY: Cornell University Press, 2013.

Hanna, Erika. 'Photographs and "Truth" during the Northern Ireland Troubles, 1969–72'. *Journal of British Studies* 54, no. 2 (2015): 457–480.

Hanna, Erika. *Snapshot Stories: Visuality, Photography and the Social History of Ireland, 1922–2000*. Oxford: Oxford University Press, 2020.

Hariman, Robert and John Louis Lucaites. *The Public Image: Photography and Civic Spectatorship*. Chicago: University of Chicago Press, 2016.

Hayes, Patricia and Gary Minkley (eds). *Ambivalent: Photography and Visibility of African History*. Athens, OH: University of Ohio Press, 2019.

Henning, Michelle. *Photography: The Unfettered Image*. Abingdon: Routledge, 2018.

Hillenbrand, Margaret. *Negative Exposures: Knowing What Not to Know in Contemporary China*. Durham, NC: Duke University Press, 2020.

Hirsch, Marianne. *Family Frames: Photography, Narrative and Postmemory*. Cambridge, MA: Harvard University Press, 1997.

Huhtamo, E. and J. Parikka (eds). *Media Archaeology: Approaches, Applications and Implications*. Berkeley, CA: University of California Press, 2011.

Hunt, Lynn. *Measuring Time: Making History*. Budapest/New York: ECU Press, 2008.

Hunter, Ian. 'The Contest over Context in Intellectual History'. *History and Theory* 58 (2019): 185–209.

Jay, Martin. 'Historical Explanation and the Event: Reflections on the Limits of Contextualization'. *New Literary History* 42, no. 4 (2011): 557–571.

Jay, Martin. 'Photography and the Event'. In O. Schevchenko (ed.), *Double Exposure: Memory and Photography*, 91–111. New Brunswick, NJ: Transaction Press, 2014.

Jordanova, Ludmilla. *The Look of the Past: Visual and Material Evidence in Historical Practice*. Cambridge: Cambridge University Press, 2012.

Kleinberg, Ethan. *Haunting History: For a Deconstructive Approach to the Past*. Stanford, CA: Stanford University Press, 2017.

Kracauer, Siegfried. *History: The Last Things before the Last*, trans. P. O. Kristellen. Princeton, NJ: Markus Weiner Publications, 1995 [1965].

Leonardi, Nicoletta and Simone Natale (eds). *Photography and Other Media in the Nineteenth Century*. University Park, PA: Pennsylvania State University Press, 2018.

Maynard, Peter. *The Engine of Visualization: Thinking through Photography*. Ithaca, NY: Cornell University Press, 1997.

Mitchell, W. J. T. *What Do Pictures Want? The Loves and Loves of Images*. Chicago: University of Chicago Press, 2004.

Pasternak, Gil (ed). *Handbook of Photographic Studies*. London: Bloomsbury, 2020.

Phillips, Mark Salber. *On Historical Distance*. New Haven, CT: Yale University Press, 2013.

Phillips, Mark Salber, B. Caine and J. Adeney Thomas (eds). *Rethinking Historical Distance*. Basingstoke: Palgrave Macmillan, 2013.

Putnam, Lara. 'The Transnational and the Text-Searchable: Digitized Sources and the Shadows They Cast'. *American Historical Review* 121, no. 2 (2016): 377–402.

Rekrut, Ala. 'Material Literacy: Reading Records as Material Culture'. *Archivaria* 60 (September 2006): 11–37, https://archivaria.ca/index.php/archivaria/article/view/12513.

Roth, Michael. 'Photographic Ambivalence and Historical Consciousness'. *History and Theory* Themed Issue 48 (2009): 82–94.

Runia, Eelco. 'Presence'. *History and Theory* 45, no. 1 (2006): 1–29.

Runia, Eelco. *Moved by the Past: Discontinuity and Historical Mutation*. New York: Columbia University Press, 2014.

Samuel, Raphael. *Theatres of Memory*. London: Verso, 1994.

Shawn, G., I. Milligan and S. Weingart. *Exploring Big Historical Data: The Historian's Macroscope*. London: Imperial College Press, 2015.

Stoler, Ann Laura. *Along the Archival Grain*. Princeton, NJ: Princeton University Press, 2009.

Thomas, Julia Adeney. 'The Evidence of Sight'. *History and Theory*, Themed Issue 48 (2009): 151–68.

Tinkler, Penny. *Using Photographs in Historical and Sociological Research*. London: Sage, 2013.

Tucker, Jennifer. 'Entwined Practices: Engagements with Photographs in Historical Inquiry'. *History and Theory*, Themed Issue 48 (2009): 1–8.

Weller, Toni (ed). *Doing History in the Digital Age*. London: Routledge, 2013.

White, Hayden. 'Historiography and Historiophoty'. *American Historical Review* 93, no. 5 (1988): 1193–9.

Zaagsma, Gerben. 'On Digital History'. *BMGN- Low Countries Historical Review* 128, no. 4 (2013): 3–29.

Images

Frontispiece: Woman working as a railway signaller during the First World War, London, 1918. © Getty Images ii

Preface: Herring fishermen, Great Yarmouth, *c.* 1910. Detail from a Tuck's postcard. Collotype viii

Introduction: Archway at Haughmond Abbey, Shropshire, *c.* 1910. Postcard by Wilding's of Shrewsbury. Half-tone print xiv

1 Itinerant photographer. Unidentified, *c.* 1910. Matt silver print 16

2 View of Melrose Abbey from southeast, *c.* 1865. Unidentified photographer. Albumen print 28

3 Small child with miniature tea-set. Unidentified, *c.* 1910. Silver print 42

4 'Queen Elizabeth I with the Earl of Sussex'. Souvenir postcard of a scene from the Warwick Historical Pageant, 1906. Half-tone print 56

5 Couple seated on a car. Unidentified, *c.* 1930s. Selo silver print 70

6 Market Square, Beaminster, Dorset, *c.* 1910. From a postcard by Halletts of Beaminster. Collotype. 82

7 Family album with historical imagery. Oldham, Lancashire, *c.* 1913 96

8 Furness Abbey, Cumbria, *c.* 1900. Silver print, pixelated 2020 112

Bibliographic Afterword: Some of my bookshelves. 2021 128

End image: On the Beach at Malakula, New Hebrides [Vanuatu], 1884. Photographer: Capt. W. A. C. Acland. From the glass negative. © Pitt Rivers Museum, University of Oxford 167

[All images author's collection unless specified.]

Notes

Preface

1 Eduardo Cadava, *Words of Light: Thesis on the Photography of History* (Princeton, NJ: Princeton University Press, 1997), xviii.
2 Peter E. Gordon, 'Contextualism and Criticism in the History of Ideas', in D. M. McMahon and S. Moyn (eds), *Rethinking Modern European Intellectual History* (Oxford: Oxford University Press, 2014), 37.
3 Mark Salber Phillips, *On Historical Distance* (New Haven, CT: Yale University Press, 2013), ix.
4 Christian Metz, 'Photography and Fetish', *October* 34 (1985), 88.

Introduction

1 Scott McQuire, *Visions of Modernity: Representation, Memory, Time and Space* (London: Sage, 1998), 108.
2 Hayden White, 'Historiophoty', *American Historical Review* 93, no. 2 (1988): 1194.
3 Tina Campt, *Listening to Images: An Exercise in Counterintuition* (Durham, NC: Duke University Press, 2017); Elizabeth Edwards, 'Photographs and the Sound of History', *Visual Anthropology Review* 21, nos. 1–2 (2006): 27–46.
4 Alison Brown and Laura Peers, *Pictures Bring Us Messages: Photographs and Histories from the Kainai Nation* (Toronto: University of Toronto Press, 2006); Chris Wright, *The Echo of Things: The Lives of Photographs in the Solomon Islands* (Durham, NC: Duke University Press, 2013).
5 Roslyn Poignant, *Encounter at Nagalarramba* (Canberra: National Library of Australia, 1996), 7.
6 Ariella Aïsha Azoulay, *The Civil Contract of Photography* (New York: Zone Press, 2008), 14.
7 Eelco Runia, *Moved by the Past: Discontinuity and Historical Mutation* (New York: Columbia University Press, 2014), xiii.
8 W. J. T. Mitchell, *Picture Theory* (Chicago: University of Chicago Press, 1994), 13.
9 W. J. T. Mitchell, *What Do Pictures Want* (Chicago: University of Chicago Press, 2004), 7–8; J. Adeney Thomas, 'The Evidence of Sight', *History and Theory*, Themed Issue 48 (2009): 151–2; L. Jordanova, *The Look of the Past* (Cambridge: Cambridge University Press, 2012), 131.
10 Michèle Hannoosh, *Jules Michelet: Writing Art and History in Nineteenth-century France* (University Park, PA: Penn State University Press, 2020).

11 For consideration of these issues, see Cadava, *Words of Light*; Dagmar Barnouw, *Critical Realism: Photography and the Work of Siegfried* (Baltimore, MD: Johns Hopkins University Press, 1994); Vanessa Schwartz, 'Walter Benjamin for Historians', *American Historical Review* 106, no. 5 (2001): 1721–43; Tim Dant and G. Gilloch, 'Pictures of the Past: Benjamin and Barthes on Photography and History', *European Journal of Cultural Studies* 5, no. 1 (2002): 5–25.

12 Siegfried Kracauer, 'Photography', in *Mass Ornament: The Weimar Essays*, transl. T. Y. Levin (Cambridge, MA: Harvard University Press, 1995), 58.

13 Jacques Le Goff, *History and Memory*, transl. S. Rendall and E. Calman (New York: Columbia University Press, 1992), 99.

14 Historians are now working increasingly across the divide. See initiatives such as the 'Historians Collaborate' programme supported by the British Academy, https://historianscollaborate.com (accessed 15 October 2021).

15 Raphael Samuel, *Theatres of Memory* (London: Verso, 1994), part V, 'Old Photographs'.

16 Jane Lydon, *Photography, Humanitarianism and Empire* (London: Bloomsbury, 2016); Erika Hanna, *Snapshot Stories: Visuality, Photography and a Social History of Ireland* (Oxford: Oxford University Press, 2020).

17 Robert Hariman and John Lucaites, *The Public Image: Photography and Civic Spectatorship* (Chicago: Chicago University Press, 2016), 256.

18 Robert Levine, *Images of History* (Durham, NC: Duke University Press, 1989), ix.

19 Ludmilla Jordanova, *History in Practice* (London: Bloomsbury, 2000), 98; *The Look of the Past* (Cambridge: Cambridge University Press, 2012), 131–2.

20 Franco Moretti, *Graphs Maps Trees: Abstract Models for Literary History* (London and New York: Verso, 2005), 91.

21 George Didi-Huberman, *Images in Spite of All: Four Photographs from Auschwitz* (Chicago: University of Chicago Press, 2008), 33.

22 Patricia Hayes and Gary Minkley, 'Introduction: Africa and the Ambivalence of Seeing', in P. Hayes and G. Minkley (eds), *Ambivalent: Photography and Visuality in African History* (Athens, OH: University of Ohio Press, 2019), 1–17.

23 John Tosh, *The Pursuit of History*, 5th edn (London: Routledge, 2010), 257.

Chapter 1 Inscription

1 Cadava, *Words of Light*, 64.

2 Junko T. Mikuriya, *A History of Light: The Idea of Photography* (London: Bloomsbury, 2017), 5–9.

3 Roland Barthes, *Image Music Text*, transl. R. Howard (London: Fontana, 1977), 44.

4 Clifford Geertz, *The Interpretation of Cultures* (London: Basic Books, 1993), 10.

5 Bernhart Jussen, 'Toward an Iconology of Mediaeval Studies: Approaches to Visual Narratives in Modern Scholarship', in C. Caraffa and T. Serena (eds), *Photo Archives and the Idea of Nation* (Berlin: Deutsche Verlag, 2015), 141–65.

6 Walter Benjamin, *Arcades Project*, ed. R. Tiedmann, transl. H. Eiland and K. McLaughlin (Cambridge, MA: Belknap Press), 476.

7 Jennifer Green-Lewis, *Framing the Victorians: Photography and the Culture of Realism* (Ithaca, NY: Cornell University Press, 1996); *Victorian Photography, Literature and the Invention of Modern Memory* (London: Bloomsbury, 2017); Nancy Armstrong, *Fiction in the Age of Photography* (Cambridge, MA: Harvard University Press, 1999).

8 Hayden White, 'Historiophoty'; Jonathan Crary, *The Techniques of the Observer: On Vision and Modernity in the Nineteenth Century* (Cambridge, MA: Harvard University Press, 1990); Martin Jay, *Downcast Eyes: The Denigration of Vision in Twentieth-Century French Thought* (Berkeley, CA: University of California Press, 1993).

9 E. P. Thompson, *The Making the of English Working Class* (Harmondsworth: Penguin, 1968), 12.

Chapter 2 Distance

1 Paraphrasing Eelco Runia, *Moved by the Past: Discontinuity and Historical Mutation* (New York: Columbia University Press, 2014), 67–8.

2 Ulrich Baer, *Spectral Evidence: The Photography of Trauma* (Cambridge, MA: The MIT Press, 2002), 1.

3 Patricia Holland, *Family Snaps: The Meanings of Domestic Photography* (London: Virago, 1991); *Picturing Childhood: The Myth of the Child in Popular Imagery* (London: I.B.Tauris, 2019); Annette Kuhn, *Family Secrets: Acts of Memory and Imagination*, new edn (London: Verso, 2002); Martha Langford, *Suspended Conversations: The Afterlife of Memory in Photographic Albums* (Montreal: McGill-Queen's University Press, 2001).

4 Christian De Vito, 'History without Scale: The Micro-Spatial Perspective', *Past and Present* 42, supplement 14 (2019): 348–72.

5 François Hartog, *Regimes of Historicity: Presentism and the Experiences of Time*, transl. S. Brown (New York: Columbia University Press, 2015), 193.

6 Roland Barthes, 'The Rhetoric of the Image', *Image Music Text*, transl. S. Heath (London: Fontana, 1977), 44.

7 Mikhail Bakhtin, *The Dialogic Imagination*, ed. M. Holquist, transl. C. Emerson and M. Holquist (Austin, TX: University of Texas Press, 1981), 84.

8 Ibid.

9 Elizabeth Edwards, *Raw Histories: Photographs, Anthropology and Museums* (Oxford: Berg, 2001), chapter 5.

10 E. J. Hobsbawm, *Nations and Nationalism since 1750* (Cambridge: Cambridge University Press, 1990), 11–12.

11 Joshua A. Bell, 'Out of the Mouths of Crocodiles: Eliciting Histories from String Figures', *History and Anthropology* 21, no. 4 (2010): 351–73.

12 Ewa Manikowska, *Photography and Cultural Heritage in the Age of Nationalisms* (London: Bloomsbury, 2019).

13 Marianne Hirsch, *Family Frames: Photography, Narrative and Postmemory* (Cambridge, MA: Harvard University Press, 1997); 'Surviving Images: Holocaust Photographs and the Work of Postmemory', in B. Zelizer (ed.) *Visual Culture and the Holocaust* (New Brunswick, NJ: Rutgers University Press, 2000), 215–46.

14 Margaret Hillenbrand, *Negative Exposures: Knowing What Not to Know in Contemporary China* (Durham, NC: Duke University Press, 2020).

15 Runia, *Moved by the Past*, 12–13.

16 Craig Campbell, *Agitating Images: Photography Against History in Indigenous Siberia* (Minneapolis: Minnesota University Press, 2014).

17 Mark. S. Phillips, 'Distance and Historical Representation', *History Workshop Journal* 57 (2004): 124.

Chapter 3 Scale

1 Romana Javitz, 'Picture Collection', *Bulletin of the New York Public Library* 42, no. 2 (March 1938): 246–7.

2 S. Aslanian et al., 'How Size Matters: Questions of Scale in History', *American Historical Review* 118, no. 5 (2013): 1432.

3 de Vito, 'History with Scale', 370.

4 Walter Benjamin, 'A Small History of Photography', in *One-Way Street*, transl. E. Jephcott and K. Shorter (London: Verso, 1979), 243.

5 Harriman and Lucaites, *The Public Image*, chapter 7.

6 Jussi Parikka and Tomás Dvorák, 'Introduction: On the Scale, Quantity and Measure of Images', in Dvorák and Parikka (eds), *Photography Off the Scale* (Edinburgh: Edinburgh University Press 2021), 10–11.

7 Elizabeth Edwards, *The Camera as Historian: Amateur Photographers and Historical Imagination 1880–1918* (Durham, NC: Duke University Press, 2012); A. Pollen, *Mass Photography: Collective Histories of Everyday Life* (London: I.B.Tauris, 2016).

8 R. Gibson, 'On the Senses and Semantic Excess in Photographic Evidence', *Journal of Material Culture* 18, no. 3 (2013): 254, quoting David Mowalajral.

9 Edwards, *The Camera as Historian*, 97–109.

10 Moretti, *Graphs, Maps, Trees*, 27.

11 These archives are at the National Science and Media Museum, Bradford, and Ryerson University, Toronto respectively.

12 Christopher Pinney, *Photos of the Gods* (London: Reaktion, 2004); Karen Strassler, *Refracted Visions: Popular Photography and National Modernity in Java* (Durham, NC: Duke University Press, 2010); Sadiah Qureshi, *Peoples on Parade* (Chicago: University of Chicago Press, 2011).

13 Benjamin, 'A Small History of Photography', 243–44.

14 Hanna, *Snapshot Stories*, 12–13.

15 Peter Andersson, *Silent History: Body Language and Non-verbal Identity* (Montreal and Kingston: McGill-Queen's University Press, 2018).

16 Barthes, *Camera Lucida*.

17 Elizabeth Edwards, 'Der Geschichte ins Antlitz blicken: Fotografie und die Herausforderung der Präsenz', in Herta Wolf (ed.), *Aufzeigen oder Beweisen? Die Fotografie als Kulturtechnik und Medium des Wissens* (Berlin: de Gruyter, 2016), 319–20.

18 Runia, *Moved by the Past*, 12.

19 Paul Ricouer, *Memory, History, Forgetting*, transl. K. Blamey and D. Pellauer (Chicago: University of Chicago Press, 2004), 210–11.

20 Phillips, 'Distance and Historical Representation', 128.

21 Parikka and Dvorák, *Photography Off the Scale*, 4.

22 Geertz, *The Interpretation of Cultures*, 323 (original emphases).

Chapter 4 Event

1 Raymond Fogelson, 'The Ethnohistory of Events and Non-Events', *Ethnohistory* 36, no. 2 (1989): 141.

2 See for instance, Sean Bowden, *The Priority of Events: Deleuze's Logic of Sense* (Edinburgh: Edinburgh University Press, 2001); Britta Hochkirchen, 'Beyond Representational Time and the Relational Time of the Event', *History and Theory* 60, no. 1 (2021): 102–16.

3 Bowden, *The Priority of Events*, 7.

4 Michael Roth, 'Photographic Ambivalence and Historical Consciousness'. *History and Theory*, Themed Issue 48 (2009): 85, quoting Roland Barthes 'The Discourse of History', transl. Stephen Bann.

5 Alan Trachtenberg, *Reading American Photograph: Images as History from Mathew Brady to Walker Evans* (New York: Hill and Wang, 1989), xiv.

6 Reinhart Koselleck, *The Practice of Conceptual History: Timing History, Spacing Concepts* (Stanford, CA: Stanford University Press, 2002), 105.

7 Richard Evans, *In Defence of History* (London: Granta 2018 [1997]), 75–79.

8 See http://www.kenningtonchartistproject.org/2018/06/04/the-chartist-meeting-on-kennington-common/ (accessed 21 November 2020).

9 Alain Badiou, *Philosophy and the Event*, transl. L. Burchill (Cambridge: Polity Press, 2013), 13.

10 Susan Crane, *Nothing Happened: A History* (Stanford, CA: Stanford University Press, 2020), 27.

11 Vilem Flusser, *Towards a Philosophy of Photography* (Göttingen: European Photography, 1984), 51.

12 George Ekebo Agbo, 'Boko Haram Insurgency and a New Mode of War in Nigeria', in P. Hayes and G. Minkley (eds), *Ambivalent: Photography and Visuality in African History* (Athens, OH: Ohio University Press, 2019), 261.

13 Daniel Boorstin, *The Image: A Guide to Pseudo-events in America* (Boston and New York: Vintage Books, 1964).

14 Georg Simmel quoted in Koselleck, *The Practice of Conceptual History*, 106.

15 Fogelson, 'The Ethnohistory of Events and Non-Events', 134.

16 Ibid.

17 Krista Thompson, 'The Evidence of Things Not Photographed', *Representations* 133 (2011): 39–71.

18 White, 'Historiophoty', 1196.

19 Martin Jay, 'Photography and the Event', in O. Schevchenko (ed.), *Double Exposure: Memory and History*, 91–111 (New Brunswick, NJ: Rutgers University Press, 2015).

Chapter 5 Presence

1 Baer, *Spectral Evidence*, 1, 8 (original emphasis).

2 Ethan Kleinberg, *Haunting History: For a Deconstructive Approach to the Past* (Stanford, CA: Stanford University Press, 2017), 14.

3 Baer, *Spectral Evidence*, 5.

4 There is a sizable commentary on this image, and on Barthes and photography more generally. See Kathrin Yacavone, *Benjamin, Barthes and the Singularity of the Photography* (New York: Continuum, 2012), 164–70.

5 Barthes, *Camera Lucida*, 65–6, 71.

6 Eelco Runia, 'Presence', *History and Theory* 45, no. 1 (2006): 5.

7 E. Edwards, 'Der Geschichte ins Antlitz blicken'.

8 Runia, 'Presence', 1.

9 Baer, *Spectral Evidence*, chapter 4.

10 Gary Minkley, 'The Pass Photograph and the Intimate Photographic Event', in P. Hayes and G. Minkley (eds), *Ambivalent: Photography and Visibility of African History* (Athens, OH, Ohio University Press, 2019), 113.

Chapter 6 Context

1 Paul Feyerabend, *Against Method*, 3rd edn (London: Verso, 1993), 106

2 Barthes, 'The Rhetoric of the Image'.

3 Ludmilla Jordanova, *History in Practice* (London: Bloomsbury, 2000), 190.

4 Deborah Poole, *Image Race and Modernity* (Princeton, NJ: Princeton University Press, 1986); James Hevia, 'The Photography Complex: Exposing Boxer-Era China, 1900–1', in R. Morris (ed.), *Photographies East: The Camera and Its Histories in East and Southeast Asia* (Durham, NC: Duke University Press, 2009), 79–199.

5 Edwards, 'Der Geschichte ins Antlitz blicken'.

6 Patricia Hayes and Iona Gilburt, 'Other Lives of Images', *Kronos* 46 (2020): 10–28.

7 Linda Conze, 'Filling the Frame: Photography of May Day Crowds during the Early Nazi Era', *Journal of Modern European History* 16, no. 4 (2018): 463–86.

8 Catherine M. Clark, 'Capturing the Moment, Picturing History: Photographs of the Liberation of Paris', *American Historical Review* 121, no. 3 (2016): 824–60.

9 Vilho Shigwedha, 'Photography, Mass Violence, and Survivors: The Cassinga Massacre of 1978', in P. Hayes and G. Minkley (eds), *Ambivalent: Photography and Visibility of African History* (Athens, OH, Ohio University Press, 2019), 156–78.

10 Baer, *Spectral Evidence*, 11–12.

11 Frank Ankersmit, *Sublime Historical Experience* (Stanford, CA: Stanford University Press, 2005), 279; Rita Felski, 'Context Stinks', *New Literary History* 42 (2011): 573–91.

12 Mieke Bal, *Travelling Concepts in the Humanities: A Rough Guide* (Toronto: Toronto University Press, 2002), 133–8.

13 Ariella Aïsha Azoulay, *Potential History: Unlearning Imperialism* (London: Verso, 2019).

14 Peter Burke, 'Context in Context', *Common Knowledge* 8, no. 1 (2002): 175.

Chapter 7 Materiality

1 Elizabeth Edwards and Janice Hart, 'Introduction: Photographs as Objects' in E. Edwards and J. Hart (eds), *Photographs Objects Histories* (Abingdon: Routledge, 2004), 2.

2 Marshall McLuhan, *Understanding Media* (New York: McGraw Hill, 1964), 9.

3 For example, Elizabeth Harvey and Maiken Umbach (eds), 'Photography and German History', special issue *Central European History* 48 (2015).

4 Evelyn Wareham, '"Our Own Identity, Our Own Taonga, Our Own Self Coming Back": Indigenous voices in New Zealand Record Keeping', *Archivaria* 52 (2001): 26–46; J. J. Ghadder, 'The Spectre in the Archive: Truth Reconciliation and the Indigenous Memory Archives', *Archivaria* 82 (2016), 3–26; Liam Buckley, 'Objects of Love and Decay: Colonial Photographs in a Postcolonial Archive', *Cultural Anthropology* 20, no. 2 (2008): 249–270; Diana

E. Marsh, Joshua A. Bell, Candace Grenne and Hannah Turner, 'Bridging Anthropology and its Archives: An Analysis from the Smithsonian's National Anthropological Archives', *Anthropology Today* 37, no. 2 (2021): 19–22.

5 Tom Allbeson, *Photography, Reconstruction and the Cultural History of the Postwar European City* (Abingdon: Routledge, 2021).

6 Edwards, 'Photography and the Sound of History'.

7 Alfred Gell, *Art and Agency* (Oxford: Oxford University Press, 1998); Bruno Latour, *Reassembling the Social* (Oxford: Oxford University Press, 2005); Tim Ingold, *Being Alive: Essays on Movement, Knowledge and Description* (Abingdon: Routledge, 2011), 70.

8 See for instance, Susanne Küchler and Timothy Carroll, *Return to the Object: Alfred Gell, Art and Social Theory* (Abingdon: Routledge, 2021).

9 Harriman and Lucaites, *The Public Image*, 235.

10 Jennifer Tucker, 'Moving Pictures: Photographs on Trial in the Sir Roger Tichbourne Affair'. In G. Mitman and K.Wilder (eds), *Documenting the World: Film, Photographs and the Scientific Record*, 24–44 (Chicago: Chicago University Press, 2016).

11 Hillenbrand, *Negative Exposures*, 5–6, 25–33, 59.

12 Elizabeth Edwards, 'Photography and Material Performance of the Past', *History and Theory*, Themed Issue 48 (2009): 130–150.

13 These albums are in the collections of the Tropenmuseum, Amsterdam.

14 Jacques Derrida, *Archive Fever*, transl. E. Prenowitz (Chicago: University of Chicago Press, 1996); Allan Sekula, 'The Body and the Archive', in R. Bolton (ed.), *The Contest of Meaning*, 343–389 (Cambridge, MA: The MIT Press, 1989).

15 Pollen, *Mass Photography*, 7, 49–50.

16 For example, https://www.gardnermuseum.org/experience/ collection/17490; https://www.gardnermuseum.org/experience/ collection/16920 (accessed 18 August 2020). At the time of writing these digital resources were being revised.

Chapter 8 Digital

1 Franco Moretti, *Distant Reading* (London: Verso, 2013), 181. Moretti originally writes of 'a new literary landscape' rather than 'historical', but it is most apposite for my argument here.

2 Ludmilla Jordanova, 'Historical Vision in a Digital Age', *Cultural and Social History* 11, no. 3 (2014): 346.

3 These examples are drawn from Harvard University's Visualizing Historical Networks Initiative, https://histecon.fas.harvard.edu/visualizing/index.html (accessed 7 August 2020).

4 Anna Dahlgren and A. Wasielewski have assessed such impacts on art history and heritage; see http://metadataculture.se/publications/ (accessed 5 November 2020).

5 Lev Manovich, 'The Science of Culture? Social Computing, Digital Humanities and Cultural Analytics', *Journal of Cultural Analytics*, May 2016, https://doi.org/10.22148/16.004.

6 Eleanor Peake, 'A Future of Living in the Past', *New Statesman*, 5–11 February 2021, 13–14; MyHeritage, https://www.myheritage.com/deep-nostalgia (accessed 26 February 2021).

7 Discovering Tutankhamun in Colour, http://www.griffith.ox.ac.uk/discoveringTut/burton5/burtoncolour.html; The Civil Rights Movement in Colour, https://unsplash.com/collections/11987944/the-civil-rights-movement-in-color; The Faces of Auschwitz, https://facesofauschwitz.com/gallery/ (accessed 7 August 2020).

8 Peter Geimer, 'The Colors of Evidence: Picturing the Past in Photography and Film', in G. Mitman and K. Wilder (eds), *Documenting the World: Film Photography, and the Scientific Record* (Chicago: University of Chicago Press, 2016), 62, 56.

9 T. Arnold, N. Ayers, J. Madron, R. Nelson, L. Tilton, and L. Wexler, Photogrammar (Version 3.0), 2021, http://photogrammar.yale.edu/ (accessed 31 August 2020).

10 Returning Photos: Australian Aboriginal Photographs from European Collections, https://ipp.arts.uwa.edu.au (accessed 6 August 2020).

11 [Re]:Entanglements, http://re-entanglements.net/faces-voices (accessed 23 February 2021).

12 Invisible Australians, http://invisibleaustralians.org/faces/ (accessed 30 July 2020). This project is discussed in Seth Denbo, 'Afterword: Digital History', 256–7.

13 Ingrid Hoelzl and Remi Marie, *Softimage: Towards a New Theory of the Digital Image* (Bristol: Intellect Books, 2015), 5–6, 71–7.

14 Estelle Blaschke, 'From Microform to the Drawing Bot: The Photographic Image as Data', *Grey Room* 75 (2019): 60–83, https://doi.org/10.1162/grey_a_00270.

15 Hoelzl and Marie, ibid., 6.

Bibliographic Afterword

1 Eelco Runia, *Moved by the Past* (New York: Columbia University Press, 2014), xiii.

2 Ludmilla Jordanova, 'What's in a Name?: Historians and Theory', *English Historical Review* 123, 523 (2011): 1456–77; Ethan Kleinberg, *Haunting History: For a Deconstructive Approach to the Past* (Stanford, CA: Stanford University Press, 2017).

3 Paul Ricouer, *Memory, History, Forgetting*, transl. K. Blamey and D. Pellauer (Chicago: University of Chicago Press, 2004); D. LaCapra, *History and Criticism* (Ithaca, NY: Cornell University Press, 1985).

4 François Hartog, *Regimes of Historicity: Presentism and the Experience of Time*, transl. Saskia Brown (New York: Columbia University Press, 2015); Reinhart Koselleck, *The Practice of Conceptual History: Timing History, Spacing Concepts* (Stanford, CA: Stanford University Press, 2002); *Futures Past: On the Semantics of Historical Time* (New York: Columbia University Press, 2004).

5 Ann Laura Stoler, *Along the Archival Grain* (Princeton, NJ: Princeton University Press, 2009); Mieke Bal, *Travelling Concepts in the Humanities* (Toronto: Toronto University Press, 2002).

6 Richard J. Evans, *In Defence of History*, 2nd edn (London: Granta, 2000); Keith Jenkins, *On What Is History: From Carr and Elton to Rorty and White* (London: Routledge, 2005); James Tully, *Meaning and Context: Quentin Skinner and His Critics* (Cambridge: Polity Press, 1988).

7 Jennifer Tucker, 'Entwined Practices: Engagements with Photographs in Historical Inquiry', *History and Theory*, Themed Issue 48 (2009): 1–8, and subsequent issue essays.

8 Peter Maynard, *The Engine of Visualization: Thinking through Photography* (Ithaca, NY: Cornell University Press, 1997); Janne Seppänen, 'Unruly Representation: Materiality, Indexicality and Agency of the Photographic Trace', *Photographies* 10, no. 1 (2017): 113–28; Michel Frizot, 'Who's Afraid of Photons?', in J. Elkins (ed.), *Photography Theory* (New York: Routledge, 2007), 269–86.

9 Sean Cubitt, *Practices of Light: A Genealogy of Visual Technology from Prints to Pixels* (Cambridge, MA: The MIT Press, 2014); Shawn Michelle Smith, *On the Edge of Sight: Photography and the Unseen* (Durham, NC: Duke University Press, 2013).

10 Barthes, 'The Rhetoric of the Image', in *Image Music Text*, 43–5; Hartog, *Regimes of Historicity*; Lynn Hunt, *Measuring Time: Making History* (Budapest and New York: ECU Press, 2008).

11 Martin Lister, 'The Times of Photography', in E. Keighley (ed.), *Time, Media and Modernity* (Basingstoke: Palgrave Macmillan, 2012), 45–65; Mary Anne Doane, *The Emergence of Cinematic Time* (Cambridge, MA: Harvard University Press, 2002).

12 Mark Salber Phillips, *On Historical Distance* (New Haven, CT: Yale University Press, 2013); 'Distance and Historical Representation', *History Workshop Journal* 57 (2004): 123–41.

13 Chris Lorenz, 'Unstuck in Time: Or; The Sudden Presence of the Past', in K. Tilmans, F. Van Vree and J. Winter (eds), *Performing the Past: Memory History and Identity in Modern Europe* (Amsterdam: Amsterdam University Press, 2010), 67–102; Hartog, *Regimes of Historicity*.

14 Annabella Pollen, *Mass Photography: Collective Histories of Everyday Life* (London: I.B.Tauris, 2016); Elizabeth Edwards, *The Camera as Historian: Amateur Photographers and Historical Imagination 1875-1918* (Durham NC: Duke University Press, 2012); Craig Campbell, *Agitating Images: Photography Against History in Indigenous Siberia* (Minneapolis: University of Minnesota Press, 2014); Robert Hariman and John L. Lucaites, *The Public Image: Photography and Civic Spectatorship* (Chicago: University of Chicago Press, 2016); Tomás Dvorák and Jussi Parikki (eds), *Photography Off the Scale* (Edinburgh: Edinburgh University Press, 2021).

15 Jean-Paul Ghobrial, 'Introduction: Seeing the World like a Microhistorian', *Past and Present* 242 (supplement 14) (2019): 1–22, and subsequent essays; S. Aslanian et al., 'How Size Matters: Questions of Scale in History', *American Historical Review* 118, no. 5 (2013): 1431–72.

16 Hariman and Lucaites, *The Public Image*; Deborah Poole, 'An Excess of Description: Ethnography, Race and Visual Technologies', *Annual Review of Anthropology* 34 (2005): 159–79.

17 S. Cerutti, 'Microhistory: Social Relations versus Cultural Models', in A-M. Castrén, M. Lonkila and M. Peltonen (eds), *Between Sociology and History: Essays on Collective Action and Nation-Building* (Finnish Literature Society Studia Historica 30) (Helsinki: Finnish Literature Society, 2004).

18 Martin Jay, 'Photography and the Event', in O. Schevchenko (ed.), *Double Exposure: Memory and Photography*, 91–111 (New Brunswick, NJ: Rutgers University Press, 2014); 'Historical Explanation and the Event: Reflections on the Limits of Contextualization', *New Literary History* 42, no. 4 (2011): 557–71; Britta Hochkirchen, 'Beyond Representational Time and the Relational time of the Event', *History and Theory* 60, no. 1 (2021): 102–16; Susan A. Crane, *Nothing Happened: A History* (Stanford, CA: Stanford University Press, 2020).

19 Eelco Runia, 'Presence', *History and Theory* 45, no. 1 (2006): 1–29.

20 Ann Laura Stoler, *Duress: Imperial Durabilities in Our Time* (Durham, NC: Duke University Press, 2016); Kleinberg, *Haunting Histories*; Frank Ankersmit, *Sublime Historical Experience* (Stanford, CA: Stanford University Press, 2005).

21 Michael Roth, 'Photographic Ambivalence and Historical Consciousness', *History and Theory*, Themed Issue 48 (2009): 82–94; Ankersmit, ibid.; Anton Froeyman, 'Frank Ankersmit and Eelco Runia: The Presence and the Otherness of the Past', *Rethinking History* 6, no. 3 (2012): 393–415; J. Menezes, 'Aftermaths of the Dawn of Experience: On the Impact of Ankersmit's Sublime Historical Experience', *Rethinking History* 22, no. 1 (2018): 44–64.

22 Joan W. Scott, 'The Evidence of Experience', *Critical Inquiry* 17, no. 1 (1991): 773–97; J. Ahlskog, 'R. G. Collingwood and the Presence of the Past', *Journal of the Philosophy of History* 11 (2017): 289–305.

23 Michael Bentley, '"Past" and "Presence": Revisiting Historical Ontology', *History and Theory* 45 (2006): 349–61; Ewa Domanska, 'The Material Presence of the Past', *History and Theory* 45 (2006): 337–48.

24 Ranjan Ghosh and Ethan Kleinberg (eds), *Presence: Philosophy, History, and Cultural Theory for the Twenty-First Century* (Ithaca, NY: Cornell University Press, 2013); *Journal of Visual Culture*, Special Issue 17, no. 2 (2018); *Photographies*, special issue 8, no. 3 (2016).

25 Peter Burke, 'Context in Context', *Common Knowledge* 8, no. 1 (2002): 152–177; Peter E. Gordon, 'Contextualism and Criticism in the History of Ideas', in D. M. McMahon and S. Moyn (eds), *Rethinking Modern European Intellectual* History (Oxford: Oxford University Press, 2014), 32–55; Ian Hunter, 'The Contest over Context in Intellectual History', *History and Theory* 58, no. 2 (2019): 185–209.

26 Martin Jay, 'Historical Explanation and the Event'; Ankersmit, *Sublime Historical Experience*; R. Felski, 'Context Stinks', *New Literary History* 42 (2011): 573–91.

27 Domanska, 'Material Presence of the Past'; Karen Harvey (ed.), *History and Material Culture: A Student's Guide to Alternative Sources*, 2nd edn (London: Routledge, 2017); 'Historians and the Study of Material Culture', *American Historical Review* 114 (2009): 1355–1404.

28 Daniel Miller (ed.), *Materiality* (Durham, NC: Duke University Press, 2005); Bruno Latour, *Reassembling the Social* (Oxford: Oxford University Press, 2005); Tim Ingold, *Being Alive: Essays on Movement, Knowledge and Description* (Abingdon: Routledge, 2011), especially section 7; Alfred Gell, *Art and Agency* (Oxford: Oxford University Press, 1998).

29 A. Rekrut, 'Material Literacy: Reading Records as Material Culture', *Archivaria* 60 (September 2006): 11–37; Gillian Rose, 'Practising Photography: An Archive, a Study, Some Photographs and a Researcher', *Journal of Historical Geography* 20 (2000): 555–71; Arlette Farge, *The Allure of the Archives*, transl. T. Scott-Railton (New Haven, CT: Yale University Press, 2013 [1989]).

30 Tim Schlak, 'Framing Photographs, Denying Archives: The Difficulty of Focusing on Archival Photographs', *Archival Science* 8, no. 2 (2008): 85–101; Terry Cook, 'The Archive(s) Is a Foreign Country: Historians Archivists and the Changing Archival Landscape', *Canadian Historical Review* 90, no. 3 (2009): 497–534; Joan M. Schwartz, 'Working Objects in Their Own Time: Photographs in Archives', in G. Pasternak (ed.), *The Handbook of Photography Studies* (London: Bloomsbury, 2020), 513–29.

31 *The Programming Historian*, https://programminghistorian.org (accessed 17 November 2020).

32 R. Rosenzweig, *Clio Wired: The Future of the Past in the Digital Age* (New York: Columbia University Press, 2011); Lara Putnam, 'The Transnational and the Text-Searchable: Digitized Sources and the Shadows They Cast', *American Historical Review* 121, no. 2 (2016): 377–402; Ludmilla

Jordanova, 'Historical Vision in a Digital Age', *Cultural and Social History* 11, no. 3 (2014): 343–8; G. Zaagsma, 'On Digital History', *BMGN- Low Countries Historical Review* 128, no. 4 (2013): 3–29.

33 Seth Denbo, 'Afterword: Digital History', in S. Handley, R. McWilliam, and L. Noakes (eds), *New Directions in Social and Cultural History* (London: Bloomsbury, 2018), 253–66; Joanna Zylinska, *Non-Human Photography* (Cambridge, MA: The MIT Press, 2017); Dvorák and Parikki, *Photography Off the Scale*.

34 S. Graham, I. Milligan and S. Weingart, *Exploring Big Data History*, reprint (London: Imperial College Press, 2015); Toni Weller (ed.), *Doing History in the Digital Age* (London: Routledge, 2013); J. Dougherty and K. Nawrotski (eds), *Writing History in the Digital Age* (Ann Arbor, MI: University of Michigan Press, 2013).

35 Santanu Das, 'Colors of the Past: Archive, Art, and Amnesia in a Digital Age', *American Historical Review* 124, no. 5 (2019): 1171–1781; Peter Geimer, 'The Colors of Evidence: Picturing the Past in Photography and Film', in G. Mitman and K. Wilder (eds), *Documenting the World: Film Photography, and the Scientific Record* (Chicago: University of Chicago Press, 2016), 45–64.

36 Ulrich Baer, *Spectral Evidence: The Photography of Trauma* (Cambridge, MA: The MIT Press, 2002); R. Kelsey, *Photography and the Art of Chance* (Cambridge, MA: Belknap Press, 2015); Gil Pasternak (ed.), *Handbook of Photographic Studies* (London: Bloomsbury, 2020).

37 Eduardo Cadava, *Words of Light: Thesis on the Photography of History* (Princeton, NJ: Princeton University Press, 1997); Vanessa Schwartz, 'Walter Benjamin for Historians', *American Historical Review* 106, no. 5 (2001): 1721–43; Walter Benjamin, 'A Small History of Photography', in *One-Way Street*, transl. E. Jephcott and K. Shorter (London: Verso, 1979), 240–57; 'Thesis of the Philosophy of History', in H. Arendt (ed.), *Illuminations* (London: Fontana, 1992), 245–55; Kathrin Yacavone, *Benjamin, Barthes and the Singularity of Photography* (New York: Continuum, 2012).

38 George Didi-Huberman, *Images in Spite of All: Four Photographs from Auschwitz*, transl. S. Lille (Chicago: University of Chicago Press, 2008).

39 Christopher Wright, *The Echo of Things: The Lives of Photographs in the Solomon Islands* (Durham, NC: Duke University Press, 2013); Jane Lydon, *Photography, Humanitarianism and Empire* (London: Bloomsbury, 2016); Catherine M. Clark, *Paris and the Cliché of History: The City and Photographs 1860–1970* (Oxford: Oxford University Press, 2018); Paul Betts, Jessica Evans, and Stefan-Ludwig Hoffmann (eds), *The Ethics of Seeing: 20th Century German Documentary Photography Reconsidered* (New York: Berghahn, 2018); Maiken Umbach and Scott Sulzener, *Photography, Migration and Identity: A German, Jewish-American Story* (Basingstoke: Palgrave, 2018); Matthew Fox-Amato, *Exposing Slavery: Photography, Human Bondage, and the Birth of Modern Visual Politics in America* (New

York: Oxford University Press, 2019); Christina Riggs, *Photographing Tutankhamun* (London: Bloomsbury, 2019); Patricia Hayes and Gary Minkley (eds), *Ambivalent: Photography and Visibility of African History* (Athens, OH: Ohio University Press, 2019). Margaret Hillenbrand, *Negative Exposures: Knowing What Not to Know in Contemporary China* (Durham, NC: Duke University Press, 2020); Erika Hanna, *Snapshot Stories* (Oxford: Oxford University Press, 2020).

40 Patricia Hayes, 'Coda: An Expanded Milieu', in Hayes and Minkley, *Ambivalent*, 307.

41 Marianne Hirsch, *Family Frames: Photography, Narrative and Postmemory* (Cambridge, MA: Harvard University Press, 1997); A. Kuhn, *Family Secrets: Acts of Memory and Imagination*, new edn (London: Verso, 2002); José Van Dijck, *Mediated Memory in the Digital Age* (Stanford, CA: Stanford University Press, 2007).

42 Alison Brown and Laura Peers, *Pictures Bring Us Messages: Photographs and Histories from the Kainai Nation* (Toronto: University of Toronto Press, 2006); Wright, *The Echo of Things*; Roslyn Poignant, *Encounter at Nagalarramba* (Canberra: National Library of Australia, 1996).

43 Pierre Nora, 'Between Memory and History', *Representations* 26 (1989): 7–24; Ricouer, *Memory History Forgetting*.

44 *Journal of Visual Culture* 9, no. 3 (2010); *Central European History* 48 (2015); *Journal of Modern European History* 16, no. 4 (2018); *Kronos* 38, no. 1 (2012) and 46, no. 1 (2020).

45 Erkki Huhtamo and Jussi Parikka (eds), *Media Archaeology: Approaches, Applications and Implications* (Berkeley, CA: University of California Press, 2011); Stephen Bann, *Parallel Lines: Printmakers, Painters and Photographers in Nineteenth-Century France* (New Haven, CT: Yale University Press, 2001); Geoffrey Belknap, *From a Photograph: Authenticity, Science and the Popular Press, 1870–1890* (London: Bloomsbury, 2016); Nicoletta Leonardi and Simone Natale (eds), *Photography and Other Media in the Nineteenth Century* (University Park, PA: Penn State University Press, 2018); Michelle Henning, *Photography: The Unfettered Image* (Abingdon: Routledge, 2018); Elizabeth Edwards and Janice Hart (eds), *Photographs Objects Histories: On the Materiality of the Image* (London: Routledge, 2004).

46 Peter Burke, *Eyewitnessing: The Use of Images as Historical Evidence* (London: Reaktion, 2001); Ludmilla Jordanova, *The Look of the Past: Visual and Material Evidence in Historical Practice* (Cambridge: Cambridge University Press, 2012); Ludmilla Jordanova, *History in Practice*, 3rd edn (London: Bloomsbury, 2019); Penny Tinkler, *Using Photographs in Historical and Sociological Research* (London: Sage, 2013).

47 Bonnie Brennen and H. Hardt (eds), *Picturing the Past: Media, History and Photography* (Urbana, IL: University of Illinois Press, 1999); Martha A. Sandweiss, 'Seeing History: Thinking about and with Photographs',

The Western Historical Quarterly 51 (2020): 1–28; Hayes and Minkley, *Ambivalent*.

48 Gillian Rose, *Visual Methodologies: An Introduction to Visual Methodologies*, 4th edn (London: Sage, 2016); Nicholas Mirzoeff, *An Introduction to Visual Culture*, 2nd edn (London: Routledge, 2009); Jennifer Tucker, 'Visual and Material Studies', in S. Handley, R. McWilliam, and L. Noakes (eds), *New Directions in Social and Cultural History* (London: Bloomsbury, 2018), 129–50.

49 Roland Barthes, *La Chambre Claire* (Paris: Gallimard, 1980), 129; original emphasis (my translation).

Index

absence 18, 31, 47, 75, 105
abundance 8, 13, 43–55, 114, 116–18,
 132–3, *see also* scale
 of inscription 24–5, 72, 125
 of materiality 102, 109
affect 40, 76–8, 99, 103–4, 119–20,
 see also emotion
 as historical modality 2, 32, 38,
 66, 71–2
 of photographs 52, 78, 94, 106,
 108, 124, 135
agency 18, 45, 76, 78, 80, 86, 97–8,
 135, *see also* presence *and*
 subjectivity
 as concept 71–74
 denial of 78
 of historian 26, 33, 36, 93
 of photographs 76, 93, 101
anthropology 24, 90, 97, 100, 113
archaeology 24, 31, 100
archives 14, 46–8, 94, 100, 104–9
 digital 109, 117, 119, 121
 integrity of 119–120
 materiality of 46, 106–10
 practices of 69, 107, 109, 121,
 125
 theory of 106–7
arts practice 2, 12, 18, 52, 102
authenticity 9, 19, 63, 67, 122

biography, *see* methodology *under*
 life writing

camera, *see* technology
captions 6, 88, 109, 123, 125
categories
 analytical 26, 31, 72, 84
 as historical practice 3–4, 11–12,
 19, 51, 115
 organisational 89, 113, 116

circulation, of photographs 37–8, 48,
 58, 63, 91, 99, 125
closeness 29–41, 63, 77–8, 120, 121,
 see also immediacy
 as historical modality 33, 39, 54,
 118
colonial 6, 25, 36, 5, 76, 85, 86, 91–2,
 117, 123
commemoration 39, 52–3, 68, 119,
 see also memory
context 14, 18, 53, 60, 76, 79–81,
 83–95, 100, 103, 107, 116, 125
 as containment 85–9, 93, 108
 as dynamic 85, 90–2
 as framing 93–4
 over-contextualization 93

digital 4, 14, 21, 33, 36, 40, 113–27
 algorithms 116, 121, 125
 colourisation 67, 105–6, 119–21
 humanities 113–5, 125
 manipulation 120
 resources 122–24
 social media 120, 125–6
 software 105, 120, 122, 125
distance 13, 29–41, 54, *see also*
 methodology *under* distant
 looking
 and scale 43, 77, 118
 as space 35–36
 as time 30–5, 118–19, 120–1

emotion, *see also* affect
 effect of photographs 9–10, 79,
 101, 120
 as historical modality 2, 38, 73,
 77, 97, 106
event 13, 22, 57–69, 74, 114
 and imagination 67
 non-event 66–9

photograph as 35, 53, 58–62, 122
photographs of 58, 61, 63–4, 88,
 92, 104
pseudo-event 64
evidence 17, 23, 46, 67, 80, 83,
 see also inscription
 denial of 63, 67
 digital 63, 118, 124, 126
 eye-witness 63, 73
 material 97–99
 photographs as 20–1, 39, 50, 103,
 110–11
ethics 78, 102, 124
experience
 collective 61, 76, 77
 as historical modality 4, 23–4,
 48–9, 71–81, 89
 individual 50–1, 62, 65, 77, 78–9
 materiality 103, 105, 110
 photographs suggestive of 11, 14,
 22, 38, 61–2, 74–5

forensics, *see* methodology

gender 8, 32, 85
gesture 50, 51, 54

happenings 13, 58–61, 62, 65–6, 68,
 95, *see also* event
haptics 2–3, 72, 75–6, 101–2, 124
heritage 6, 22, 37, 100, 102, 120
historical consciousness,
 see imagination
history
 big data history 43, 45, 114, 116,
 125
 contestation of 2, 59, 67, 85, 94, 100
 cultural 33, 45, 114, 116, 125
 global 43, 45–6, 48, 77, 97, 114
 local 8, 38, 43–44, 50
 microhistory 24, 33, 43–44,
 49–50, 53, 89, 91
 oral 2, 3, 24, 39, 61, 73, 98, 100–1,
 123

popular 8, 35, 37, 67, 109, 119
public 8–9, 50, 52, 102, 104, 120
sensory 2, 97, 100
social 8, 9, 32–3, 40, 50, 74
theories of 3, 6, 29, 50–60, 72,
 74–5, 84, 93
Holocaust 11, 24, 38, 63, 78

identity 33, 38, 47, 73, 97, 104, 118,
 120, 123
 identity photographs 39, 78, 102,
 124
 of photographs 79, 99
ideology, role of 19, 25, 38, 72, 76, 86,
 99, 104, 120, 124
imagination
 historical 11, 19, 22, 30, 48, 64–6,
 77, 118
 impact of photographs 5, 20, 32,
 58–61, 63, 68, 124
 popular 8, 52–3, 67, 119–20
indexicality, *see* inscription
intention 18, 22, 64, 86–7, 91, 98,
 106
inscription 13, 17–26, 63–4, 77, 89
 digital 21, 113, 118, 123, 125
 as event 59, 61, 66–8
 materiality of 20, 98, 101, 104,
 106, 124
 randomness of 18, 44, 49–50,
 58–9, 87
 as scale 43–7, 74, 79
 as trace 17–19, 24–5, 49, 65, 73,
 84, 94
 light as 17–19, 21

manipulation, of photographs 19, 20,
 64, 120
materiality 20, 97–110
 of archive 47, 100, 104–9
 of digital 116, 123, 124
 as historical modality 73, 98, 101,
 110
 of photographs 21, 46, 90, 97–106

media 32, 40, 49, 90, 99, 102–3
 film xi, 2, 15, 62, 63, 119, 120
 intermediality 49, 115, 124
 magazines 90, 100, 103
 newspapers 48, 102, 103
 television 35, 119
memory 3, 6, 32, 38, 61, 74, 77,
 see also commemoration
 anticipated 39–40
 collective 59, 61, 65, 104
 and digital 105, 123–4
 excess of 52
 as historical modality 7–8, 24, 38
 post-memory 38
 recuperation of 123
methodology, *see also* criticism *under*
 sources
 anxiety about photographs 5, 8,
 26, 38, 45, 52, 74, 84, 117
 close reading 21, 47, 49, 54, 89,
 92, 117–18
 critical forensics 36, 47–8, 51, 54,
 77, 79, 80, 118
 distant looking 47–8, 54, 110,
 117–18
 facts 26, 59, 61, 68–9, 79
 life writing 2, 73
 patterns 47, 52, 109, 89, 117
 periodisation 2, 7–8, 22, 67
 reading photographs 23, 51, 78–9,
 80, 83, 89
modernity 7, 24, 31, 33

narratives 21, 32, 88, 17, 57–60, 84–5
 and digital 37, 108, 115, 122–4
 meta-narratives 51
 photographs as 25, 31, 64, 76,
 80, 89
networks 64, 90–1, 103, 104
 context as 90–2
 digital 46, 117, 125
 and materiality 101, 103
 meshworks 90, 101
nostalgia 73, 78, 120–1

objectivity
 of historian 6, 22, 29, 33, 34, 108,
 110
 of photographs 2, 11, 30, 19–20,
 63, 80

philosophy 20, 24, 35, 72
photographic content 9, 68, 84, 87,
 100, 103, 107, 110, 116, 118,
 125
 as context 87–95
 as evidence 39, 73, 77, 88–9, 93–4,
 98, 108–9
 as excess 21–2, 44–5, 52, 64, 77,
 92
 granularity of 21–22, 24, 34, 43–5,
 48, 49–54, 58, 64–5, 77, 118
photographs, genres and forms
 albums 31, 46, 50, 86, 100–1, 103,
 105, 109
 documentary 12, 39, 59, 119, 121
 family 38, 39, 67, 86, 100, 103,
 105, 120
 ID photographs 12, 72, 78–9, 124
 materiality of 21, 98–104
 photojournalism 6, 52–3, 58–9,
 63, 69, 88, 105
photography, character of
 as fragment 9, 30, 39, 46, 64, 76,
 89, 107, 115
 immediacy 21, 33–5, 63, 73,
 see also closeness
 of digital 118–19
 random inclusivity 18, 21, 23, 44,
 49–51, 60, 69, 85, 90
 reality effects of 7, 21, 73, 78–80,
 87
 recodability 10, 77, 83, 90, 94, 101,
 108, 115
 remediation of 20, 90, 102, 109,
 120
 reproducibility 90, 99, 102, 105–6,
 124
 theories of 10–12, 50–1, 75

as translation 11, 19, 57, 66, 79,
 118, 126
as 'truth' 11, 17–19, 24, 63, 114
presence
 archival 107, 114, 119
 as historical modality 14, 39,
 71–81, 123
 of photographs 22–3, 32–4, 44, 54
presentism 30, 34, 36–8
punctum (Roland Barthes) 51, 79

race 6, 67, 123–4

scale 13, 35, 43–69, 98, *see also*
 abundance
 and digital 117–18, 125
 of history 33, 44, 74, 76–7, 80, 91
 of inscription 45, 49–50, 62, 79
social media, *see* digital
sound 2, 3, 49, 123
sources 4, 10–11, 17–26, 83, 94
 criticism 4, 11–12, 18, 53, 85–7
 digital 106–7, 109, 123–4
 integrity of 5, 119, 124
 materiality of 17–18, 20–1, 98–100
 photographs as 4–5, 21, 39, 85
space 29, 31, 35–6, 64–5, 90–1,
 see also time
 of archive 106–8
 and materiality 103–110

subjectivity 14, 25, 86, 105, 118–19,
 see also agency
 of historian 26, 38, 53, 71, 73, 79,
 108
 in photographs 50–1, 70–81, 92,
 98, 108
 of photographs 8–10, 34, 74

technology
 digital 115–17, 125
 photographic 7, 13, 18–19, 20
time 6–7, 11, 30–41, 59, 110, *see also*
 space
 contemporaneity 67, 86, 103
 and digital 118, 119, 122–3
 events as 58–9, 64
 fragments of 50, 60, 62, 89
 linear 30, 32, 59, 60, 103
 non-linear 32, 33, 36–7, 62, 103
 and photography 10–12, 50–1,
 75
trace 17–19, 25, 34, 49, 65, 66, *see
 also* inscription
trauma 24, 36, 38, 78

violence 10, 24, 63, 65, 78, 92, 118
visual economy 90–1, 102, 104

war 53, 58, 66, 88
witnessing 19, 63, 73, 120

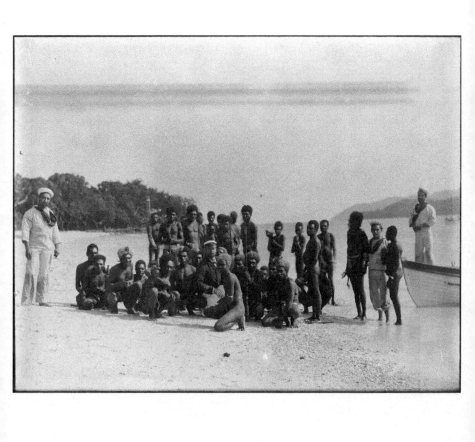